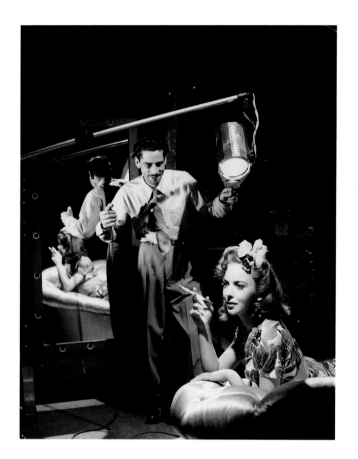

SHOOTING STARS

CONTEMPORARY
GLAMOUR
PHOTOGRAPHY

RICKY SPEARS

STEWART, TABORI & CHANG

New York

This book is dedicated to all the photographers, stars, magazine editors, and art directors who keep the spirit of Hollywood alive. And to anyone who has ever clipped a picture out of a magazine and put it on the refrigerator.

Text and compilation copyright © 1992 by Ricky Spears
Foreword copyright © 1992 by Bert Stern

All photographs copyright © individual photographers as noted specifically on page 214, which constitutes an extension of this page.

Published in 1992 by Stewart, Tabori & Chang, Inc.
575 Broadway, New York, New York 10012

Library of Congress Cataloging-in-Publication Data
 Spears, Ricky.
 Shooting stars : contemporary glamour photography / Ricky Spears.
 p. cm.
 ISBN 1-55670-240-X
 1. Celebrities—Portraits. 2. Glamour photography.
 I. Title.
TR681.F3S66 1992 92-14310
779'.2—dc20 CIP

Distributed in the U.S. by Workman Publishing,
708 Broadway, New York, New York 10003

Distributed in Canada by Canadian Manda Group,
P.O. Box 920 Station U, Toronto, Ontario M8Z 5P9

Printed in Japan
10 9 8 7 6 5 4 3 2 1

PAGE 1: **SCOTTY WELBOURNE** photographing Ida Lupino *1943*

PAGE 2: **BERT STERN** Jessica Lange *1983*

PAGE 6, LEFT: **JEFFERY NEWBURY** Kelly Lynch *1990*

PAGE 6, RIGHT: **CAROLYN JONES** Willem Dafoe *1990*

PAGE 7, LEFT: **ANTONIN KRATOCHVIL** Nick Nolte *1991*

PAGE 7, RIGHT: **JOSEF ASTOR** Sean Young *1989*

PAGE 216: **TIMOTHY WHITE** photographing Shirley MacLaine *1991*

For David

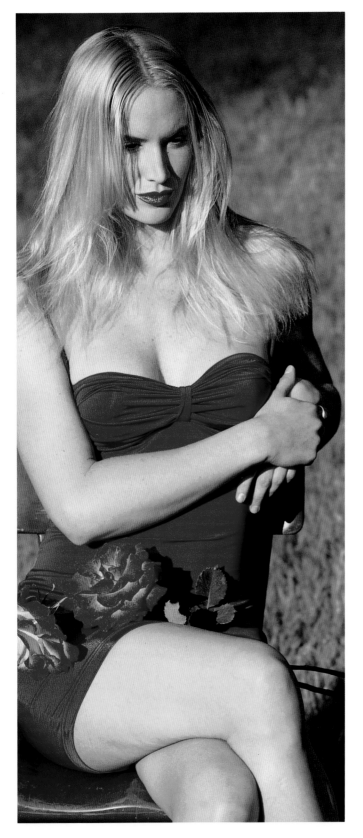

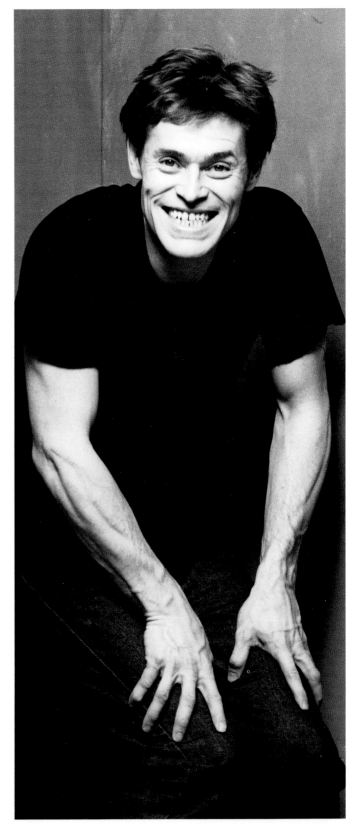

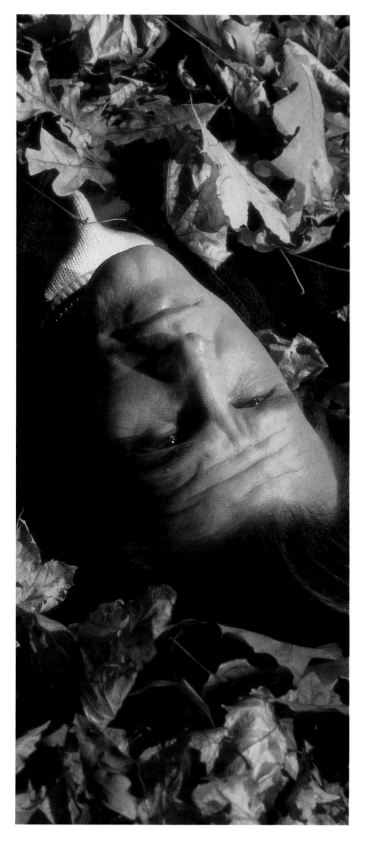

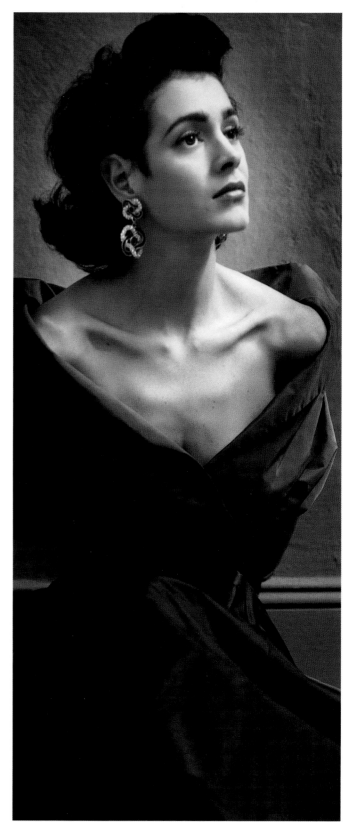

FOREWORD

"The eyes are the scouts for the heart."
—Gurraut de Borneilh

E dward Steichen's portrait of Greta Garbo is my all-time favorite STAR photograph. It became so imprinted on my mind the first time I saw it, at the Museum of Modern Art, that anytime I wish to see it again, I merely close my eyes and there it is. It has all the spontaneity of a 35mm candid, and yet it was made with an 8×10 camera.

I remember reading about this sitting. Steichen was given ten minutes with Garbo on a movie set between takes. When she sat down in front of the camera, he was disturbed by the way her hair had been done for the film. "It's too bad we're doing this with that movie hairdo," he said. At that, she put her hands up to her forehead and pushed her hair away from her face. His response was immediate: he released the shutter of his camera.

"Don't move . . . if you stay exactly as you are without changing anything . . . your hands . . . the expression on your face . . . I will take the greatest photograph anyone will ever take of you."

I don't know if these words went through Steichen's mind at the time or what he actually said to her. I do know that he caught a moment of great beauty on an 8×10 glass plate that changed my perception of women and photography.

The photographs in this book, SHOOTING STARS, are full of this kind of heart. That is because its author, Ricky Spears, chose these photographs with his heart rather than with his head.

—BERT STERN *New York, February 1992*

EDWARD STEICHEN
Greta Garbo *1928*

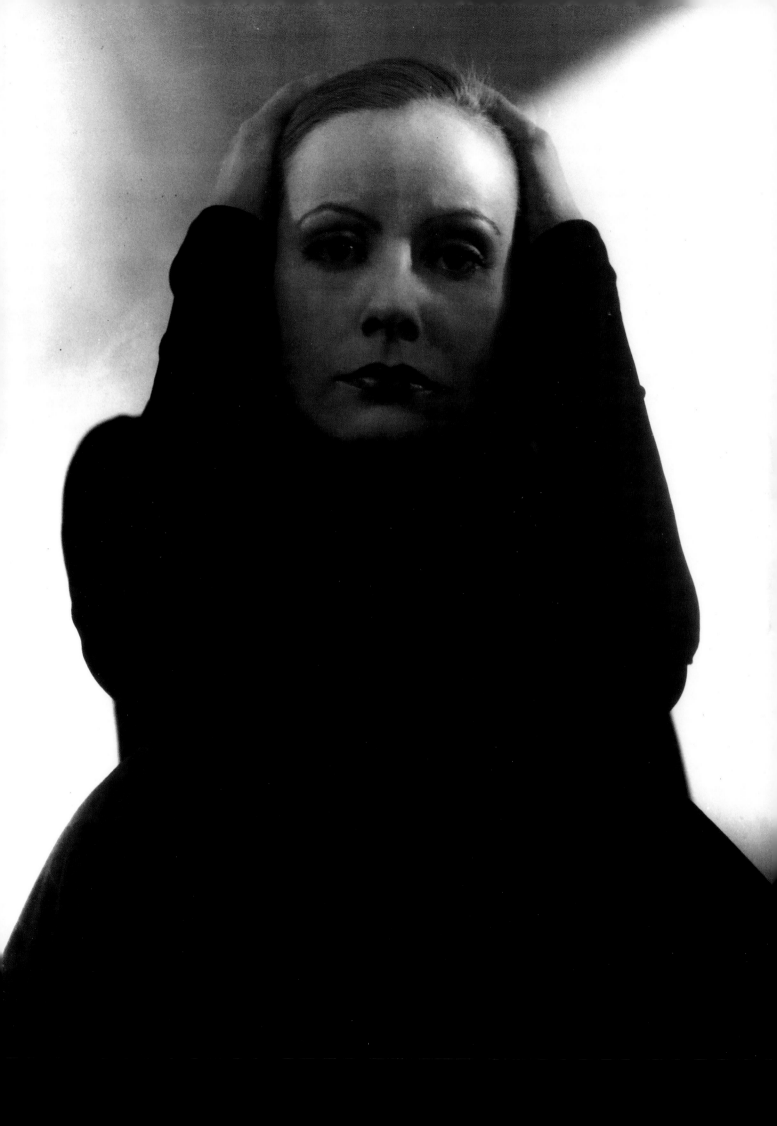

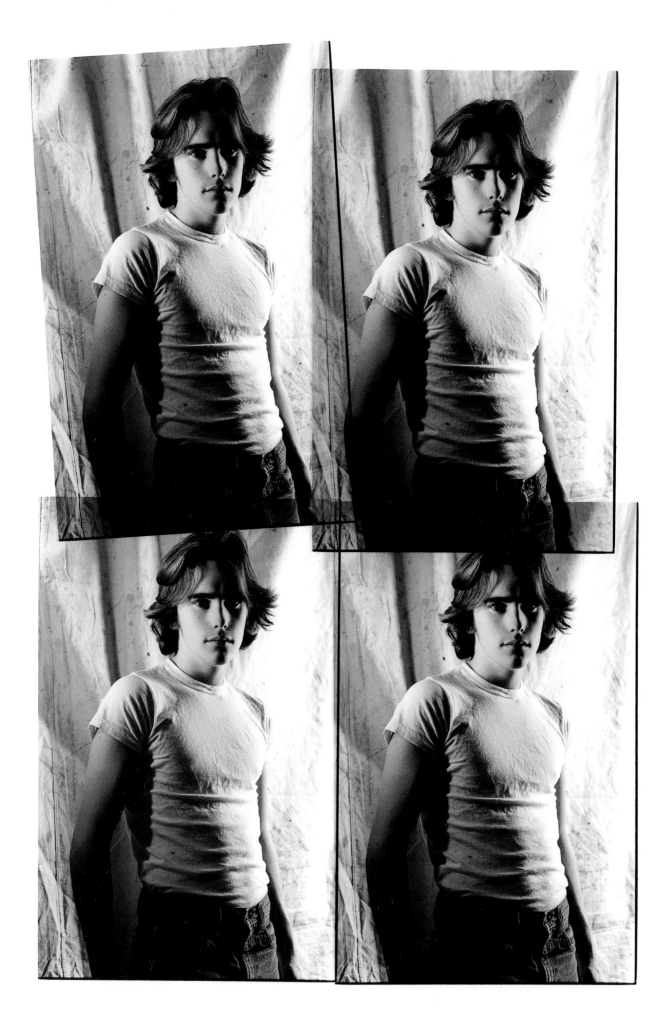

INTRODUCTION

My passion for Hollywood photography began when I was a child. During my youth, in the 1960s, I spent hours cutting and pasting movie magazine images into elaborately embellished scrapbooks. In addition, I made scrapbooks of each long trip my family and I took by car, saving every matchbook, toothpick, and pamphlet I could find. I made several of these books and they, along with the others, are today resting nicely on a shelf in my parents' living room in northwest Arkansas.

While at the University of Arkansas, working on a bachelor's degree in journalism and English, I was given a work/study grant. My job was in the university library, putting the new magazines and periodicals onto their little wooden dowels and later neatly filing them into their stacks in the reading area. It was here that I discovered the NEW YORK TIMES MAGAZINE, Andy Warhol's INTERVIEW, the VILLAGE VOICE, VOGUE, GQ, and the many other magazines of the day. Through these magazines, I discovered New York City and in the mid-1970s, soon after college, I moved east.

As I began working for magazines in New York, my appetite for photography was once again aroused. Too often, I would notice a beautiful portrait sent through production and eventually cluttered with copy, or positioned next to an uninteresting interview. In defense of this, I began a clipping file of particularly sensational portraits gleaned from magazines.

I knew that by clipping the images, I was, in a way, saving the portraits from oblivion. Many would never be published again.

The portraits eventually found their way into a new series of scrapbooks. To keep the books challenging and exciting, I established criteria: the image had to depict a film actor or actress (over the years I allowed a few

CHRISTOPHER MAKOS
Matt Dillon *1980*

11

exceptions: actor/directors such as Spike Lee and David Lynch, and television personalities who occasionally did film work, such as Farrah Fawcett and Maxwell Caulfield); no portrait could be older than 1980; when the portrait was originally published, little or no copy could be spread across the photograph, and, of course, the portraits had to come from a magazine, any magazine, anywhere.

Once, on my way to an evening at Studio 54, I had found a magazine with a particularly wonderful portrait of Jodie Foster. Not wanting to go into the disco carrying the magazine, I hid it outside on the street near some garbage. Upon leaving in the wee hours of the morning, I was all but crazed trying to remember where I'd hidden the magazine with the unforgettable portrait. I found it.

From the very beginning, I wrote the photographers' names in ink under the portraits. Over the years I noticed that my collection, SANS any other text whatsoever, was becoming more and more visually powerful. Many of the photographs recalled the work of the great Hollywood studio photographers of the 1930s, and many captured what I like to call NEW HOLLYWOOD GLAMOUR. Where once a jacket and tie or a silk evening gown were DE RIGUEUR, in contemporary glamour photography, more casual attire will do. Beauty is no longer only skin deep and covered with silk.

I knew from the wealth of beautiful portraits being published in magazines that there had to be a tremendous number of out-takes from the photo shoots: simply gorgeous portraits that had never been published anywhere. Remembering the fate of the great Hollywood portraits—many of them were not considered worthy works of art until forty years after their creation—an idea for a book celebrating the work of today's photographers and this NEW HOLLYWOOD GLAMOUR evolved.

HOLLYWOOD GLAMOUR PHOTOGRAPHY YESTERDAY

By the 1930s, more than half of the American population was going to the movies, and the big Hollywood studios (Metro-Goldwyn-Mayer, Paramount Pictures, RKO, Warner Bros., Twentieth-Century Fox, and Columbia) fed the public's frenzied appetite not just with a wealth of films, but with a flood of gorgeous photographs of their stars.

Hollywood of the 1930s held the enviable position of a bull market, and the movie stars of the day were its

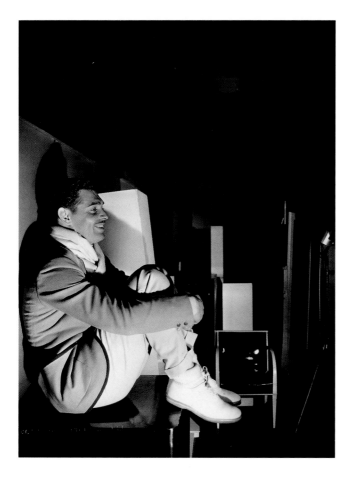

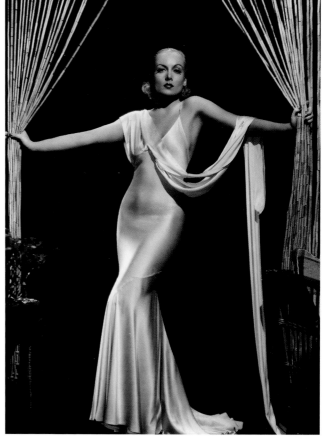

CLARENCE SINCLAIR BULL
Clark Gable *1934*

EUGENE ROBERT RICHEE
Carole Lombard *1933*

premiums. Ravenous for illusion, the American public poured into the movie palaces and clamored for every story, every image, they could read and see of the likes of Bette Davis, Marlene Dietrich, Carole Lombard, Gary Cooper, Robert Taylor, Clark Gable, and the illusive woman known simply as Garbo.

The stars appeased the masses by giving countless interviews that created elaborate personas and biographies, and by spending hours in front of the still cameras of the studio photographers who documented these well-plotted, well-laid personas. The smart studio executives knew that movies alone weren't enough. Fans could not hang a movie on a wall or paste it into a diary. They needed more. Consequently, the studios worked directly with the fan magazines of the day (PHOTOPLAY, MOVIE STAR PARADE, SCREENLAND, and many, many others), maintaining a continuous flow of images.

The stars of the 1930s were national heros and heroines, and the portrait photographers under contract to the studios had a most important job to do. It was in their studios that miraculous dreams were made, created with light and shadow. Directors made movies and portrait photographers made icons. The contract

photographers concocted elaborate illusions worthy of worship. A legend could be created with a single film, but to create a goddess took the magic of a still camera.

The portrait photographers George Hurrell and Clarence Sinclair Bull working under contract at MGM, and their many contemporaries, such as Eugene Robert Richee at Paramount, were masters of magic and atmosphere. Each with his own distinctive style, they created thousands upon thousands of images. Hurrell was a wizard of lighting and design; Bull, a master of mystery.

This interplay of light and shadow turned the stars of yesterday into enigmas. A Connecticut Yankee named Katharine Hepburn may have worn trousers on and off the set, but through the magic of Hollywood and Ernest Bachrach's lens, she was transformed into a chiffon-skirted porcelain doll. Clark Gable may have been a roguish he-man offscreen, but in front of Clarence Sinclair Bull's camera, he was a smiling teddy bear.

Without the great Hollywood glamour photographers there could not have been a true Hollywood. These photographers—Hurrell, Bull, Richee, Bachrach, Robert Coburn, and a host of others—epitomized the very best of an unparalleled decade in film history. It was a time when Hollywood was at its peak and MGM boasted on its logo: "More Stars Than There Are in Heaven."

The glamour photography of yesterday was all about illusion—creating a façade, separating the viewer from the viewed. But at the same time, the illusion was so great, so beautiful, that one need look no further than skin-deep for satisfaction. This enigmatic distance protected the stars from their public and added immeasurably to their allure.

The photographers and stars of the 1930s created Olympian masterpieces.

HOLLYWOOD GLAMOUR PHOTOGRAPHY TODAY

The studio system is gone. Today, the stars are the suppliers, working directly to satisfy the market, the American public, whose appetite for Hollywood photography is as voracious as ever.

Today's photographers work free-lance or under contract to the magazines that regularly feature celebrity

GEORGE HURRELL
Joan Crawford *1931*

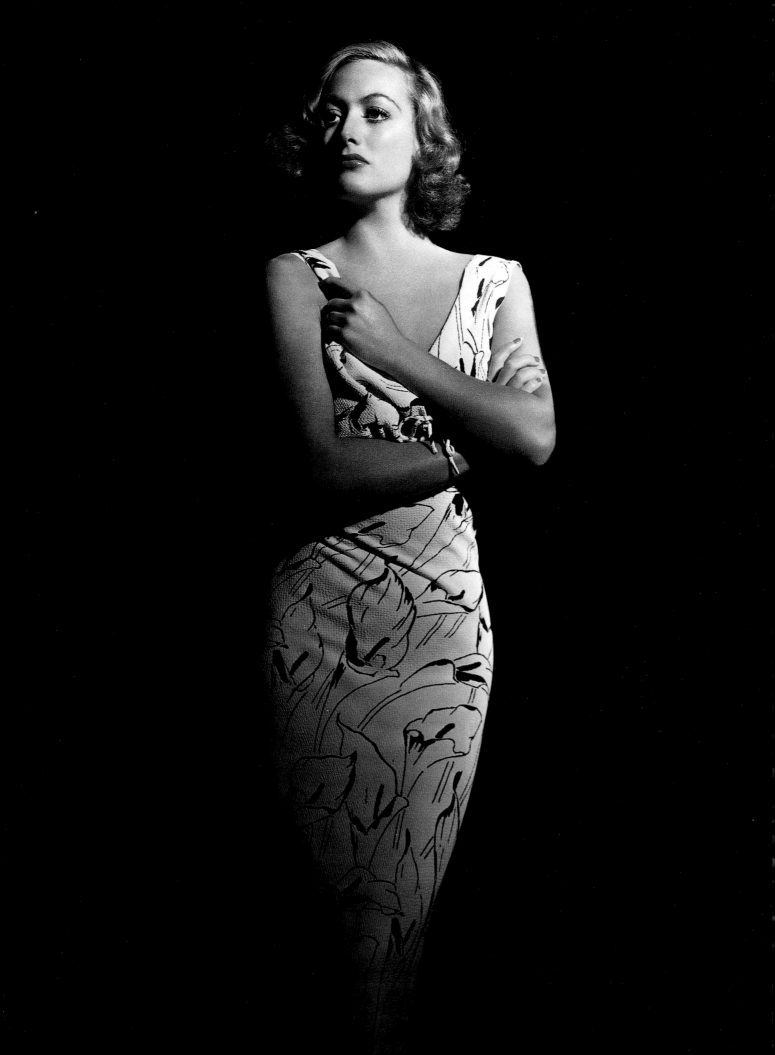

portraits. These contemporary magazines, such as ROLLING STONE, US, PREMIERE, MOVIELINE, INTERVIEW, and VANITY FAIR, provide a slick environment for a continuous flood of celebrity imagery.

Through the 1980s and into the 1990s, much of this photography was created and controlled by a core group of photographers who themselves became famous: Matthew Rolston, Greg Gorman, Annie Leibovitz, Bruce Weber, and Herb Ritts. And, an occasional portrait would appear by a photographer from the previous generation who continued to work in celebrity portraiture, photographers such as Helmut Newton, David Bailey, Bert Stern, and Richard Avedon.

A movie star today will sit for the camera for the express purpose of selling his or her latest motion picture release. There is the rare sitting for a photographer's personal portfolio, such as the work of the late Robert Mapplethorpe, but the majority of the sittings are for the hard sell of a new movie, and many of the top stars today will only pose when they are guaranteed they will appear on the cover of the magazine. Many demand, and freely exercise, the right to choose which shots will be issued to the public.

Old Hollywood image departments have been replaced by personal managers, agents, and publicists, whose intended purpose is to monitor the way a star presents him- or herself to the public. Without the manipulation of a strong studio system, today's stars find themselves faced with creating their own personas. Thus, the work between photographer and star becomes a close and important collaboration.

Today's photographers, like the photographers of the golden years of Hollywood, are illusionists, but today's illusions are based on stylish interpretations of reality, rather than on enigma. Present-day portrait photographers continue to create dreams, but they are no longer impossible dreams. NEW HOLLYWOOD GLAMOUR photography is all about style, and each photographer uses his or her unique eye to create a singular portrait. When photojournalists such as Mary Ellen Mark and Sylvia Plachy turn their cameras to movie stars, something so personal is created that one must take pause. Many photographers have come from the worlds of fashion photography (Michael O'Brien, Steven Klein), music (Laura Levine), and the acting profession itself (Dennis Hopper). Each of these photographers, working closely with the film stars, has redefined glamour forever.

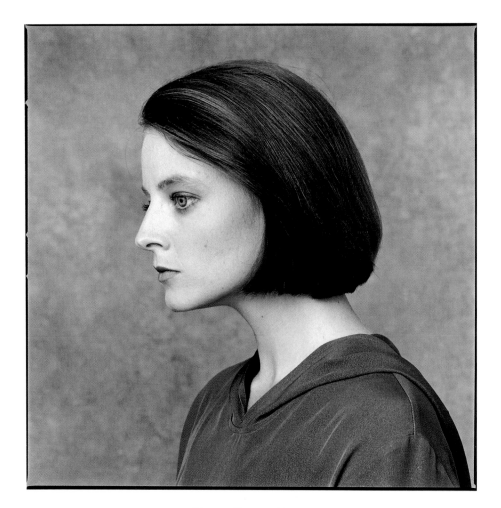

MARY ELLEN MARK
Jodie Foster *1990*

Hollywood glamour photography in the 1930s was almost exclusively about creating illusion, making magic. While the shape and scope of stardom has radically changed since then, the insatiable appetite for celebrity images remains, and legions of photographers continue to feed the public's desires. This NEW HOLLYWOOD GLAMOUR photography is not afraid to pay homage to the portraits of yesteryear, but these new artists have set the past on its ear and have created something that defies description.

The photography of today is all about truth—direct contact between the star and the public. Thus, this new photography is quite personal. Its foundations are based on the man or woman next door rather than on the porcelain doll.

Will the mystique of the stars and photographers of today endure like that of the stars and photographers of the past? Only their films and portraits will tell. Ultimately, all glamour photography depends on the expression of a face; thank God they still have faces.

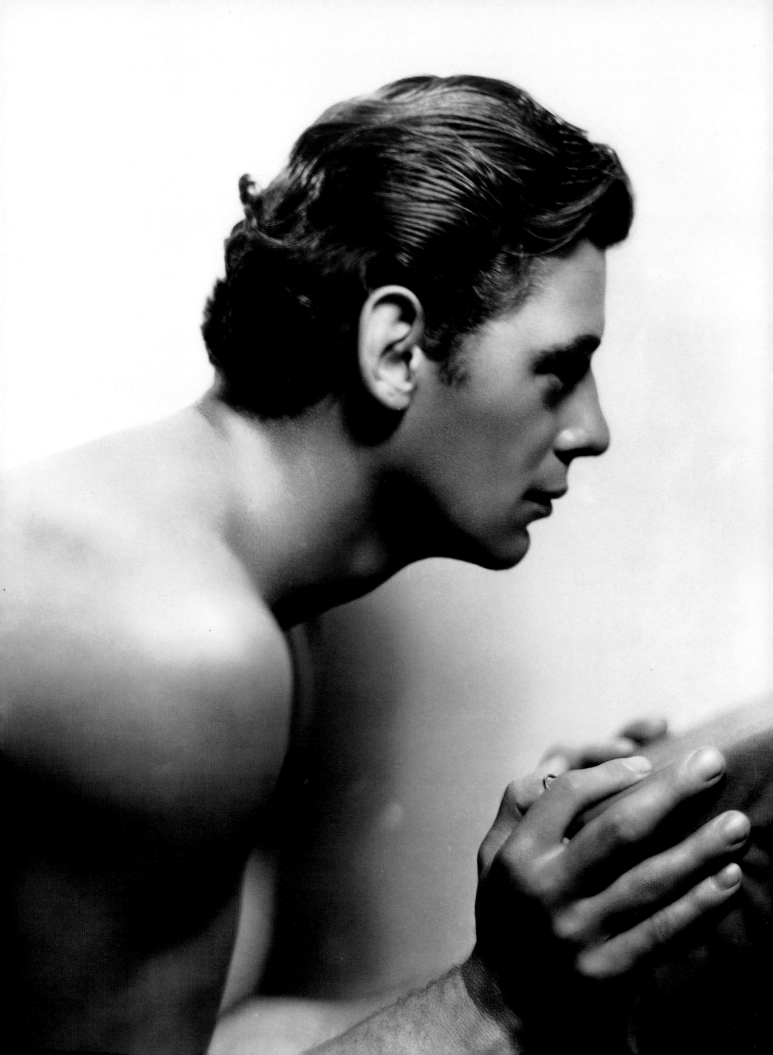

HOT SHOTS

At twenty-eight, Johnny Weissmuller had sex appeal; he simply posed for a studio portrait and the beholder felt a thunderous reverberation. Jean Harlow and Carole Lombard had the look, as did Gary Cooper and Robert Taylor. Each had a smoldering, sensual magic that quickened the heart and took the breath away.

Beefcake and cheesecake have been replaced by the universal "hot." Today, Richard Gere and Mel Gibson are hot, as are Uma Thurman and Isabella Rossellini. Their body language speaks of fire. Sex appeal is alive and well —only the bodies have changed.

ROBERT MAPPLETHORPE
Richard Gere *1982*

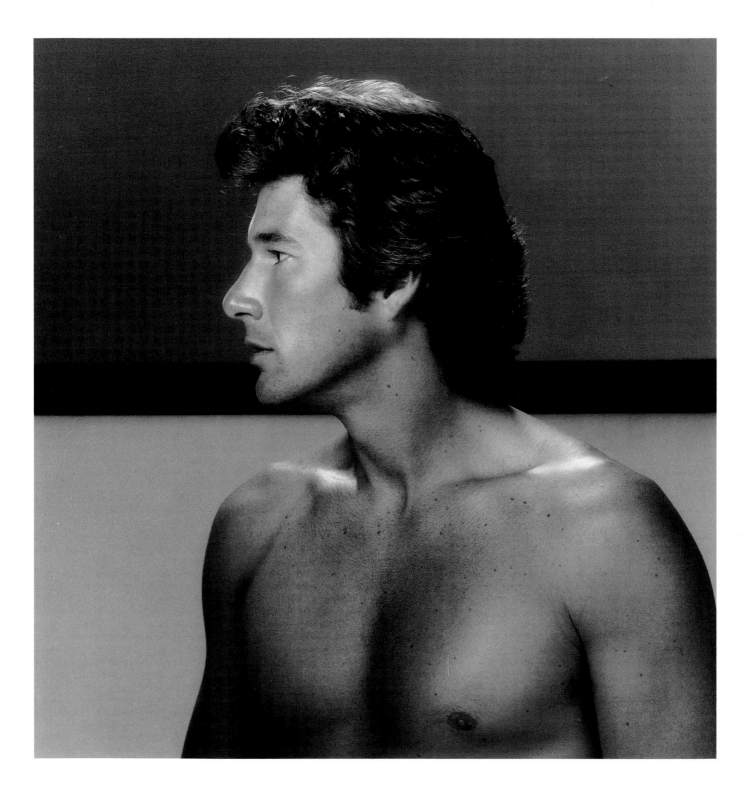

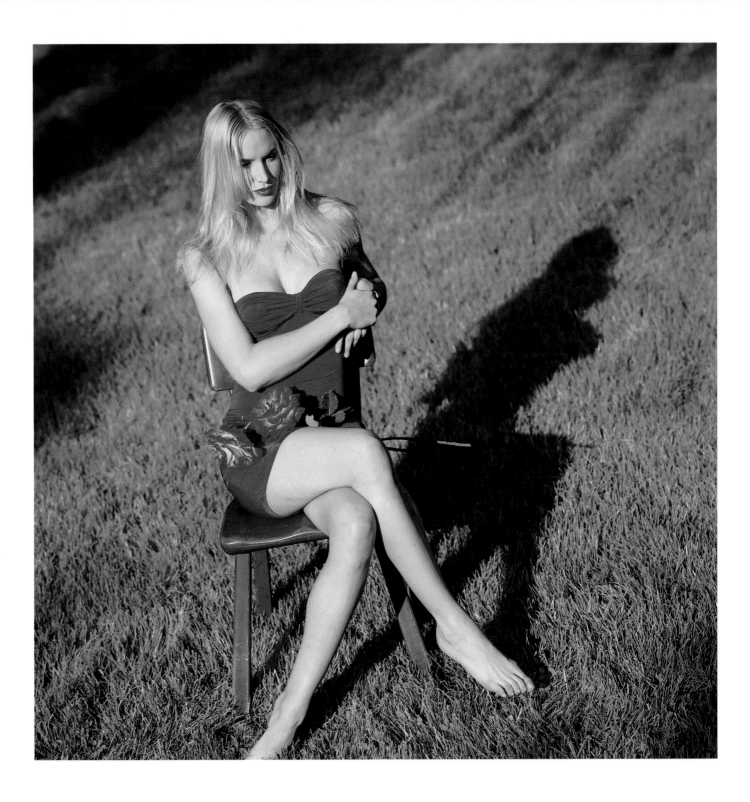

JEFFERY NEWBURY
Kelly Lynch *1990*

22

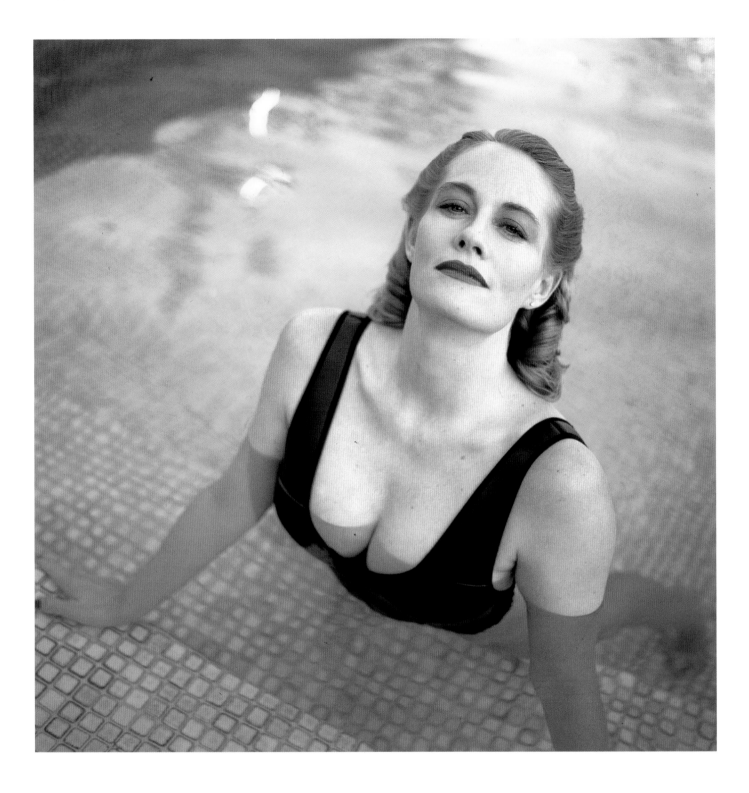

HELMUT NEWTON
Cybill Shepherd *1988*

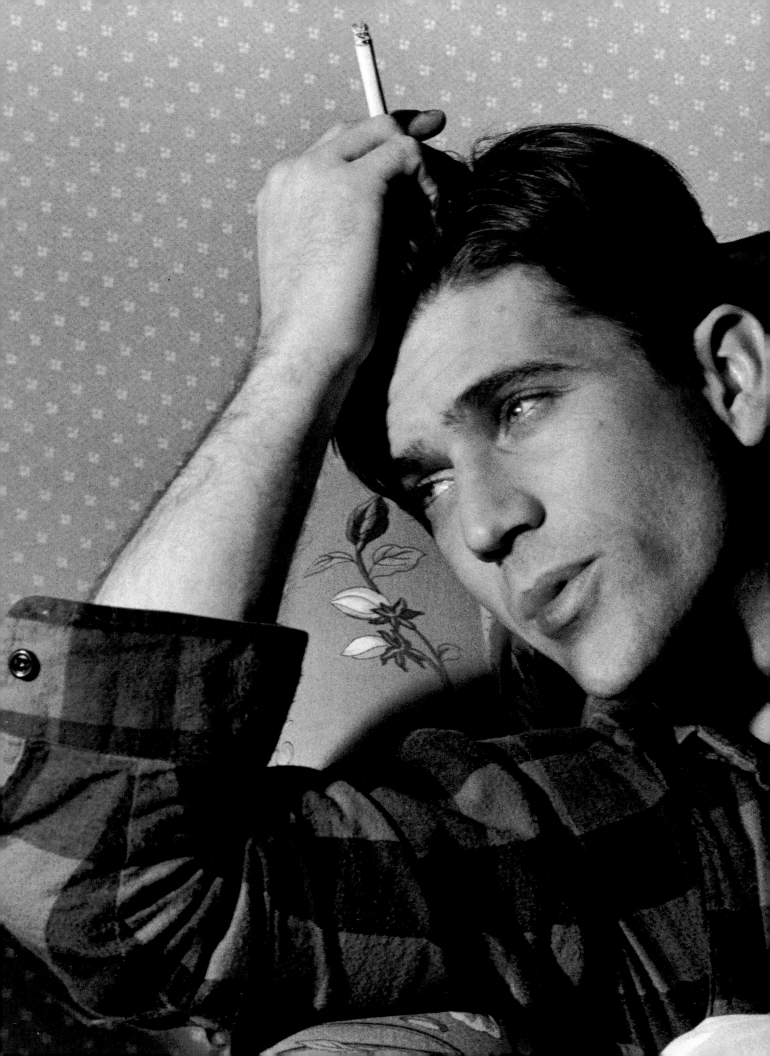

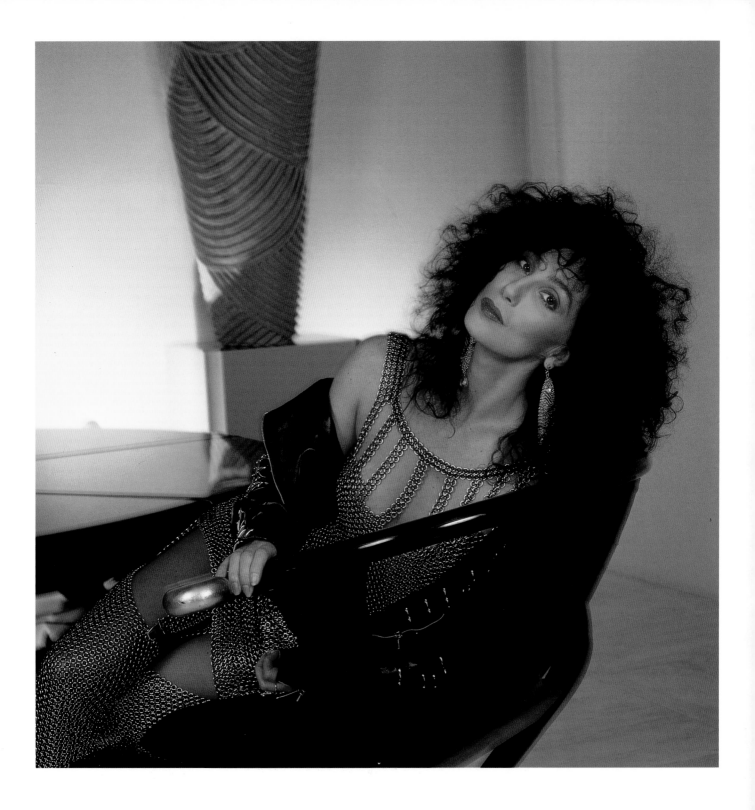

ANTHONY BARBOZA
Cher *1987*

OPPOSITE: KENN DUNCAN
Maxwell Caulfield *1981*

PRECEDING PAGES: RUDI MOLACEK
Mel Gibson *1984*

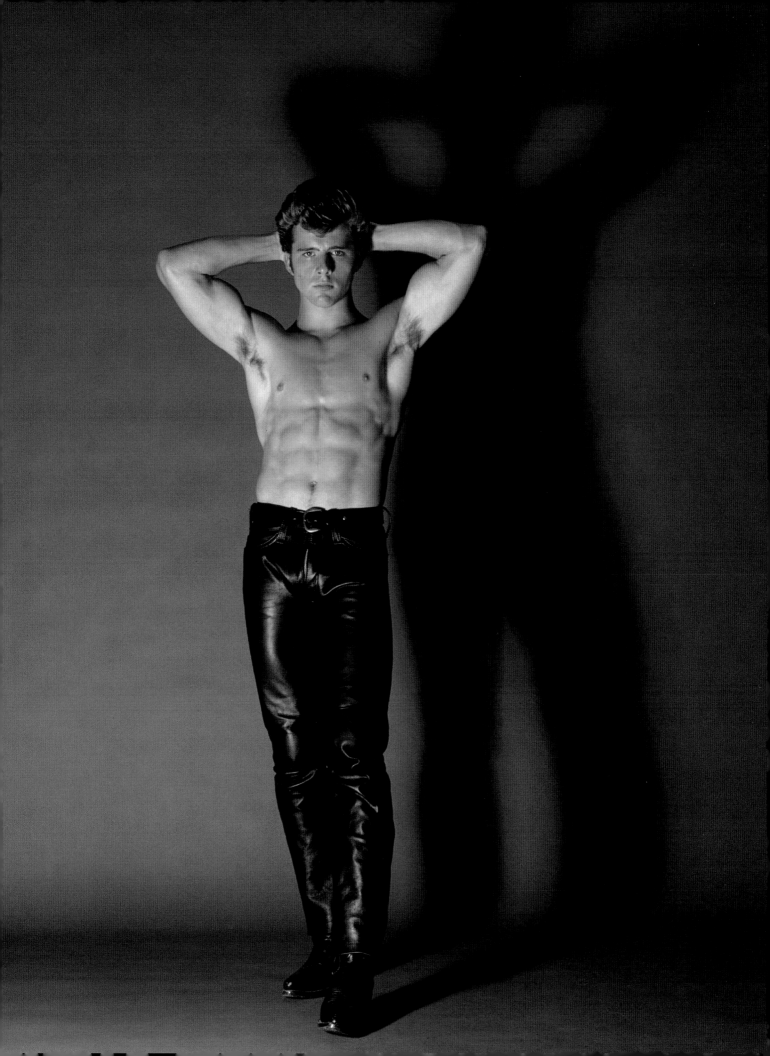

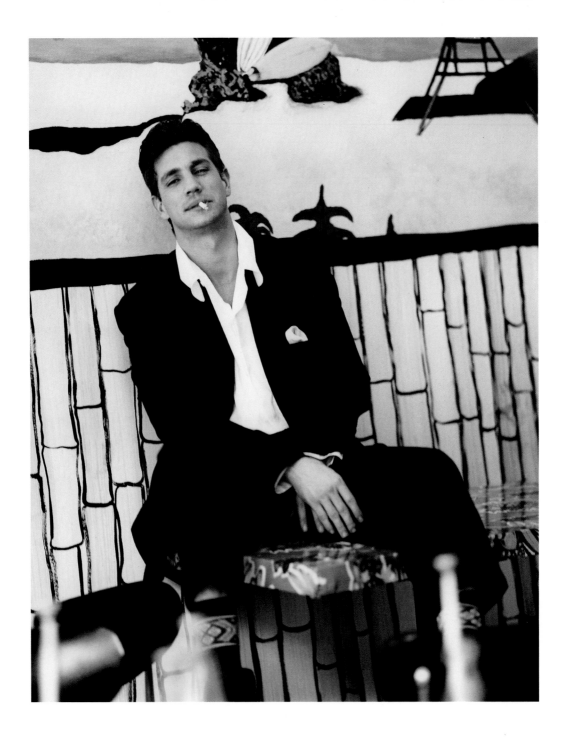

MICHAEL O'BRIEN
Eric Roberts *1987*

OPPOSITE: MARK CONTRATTO
River Phoenix *1991*

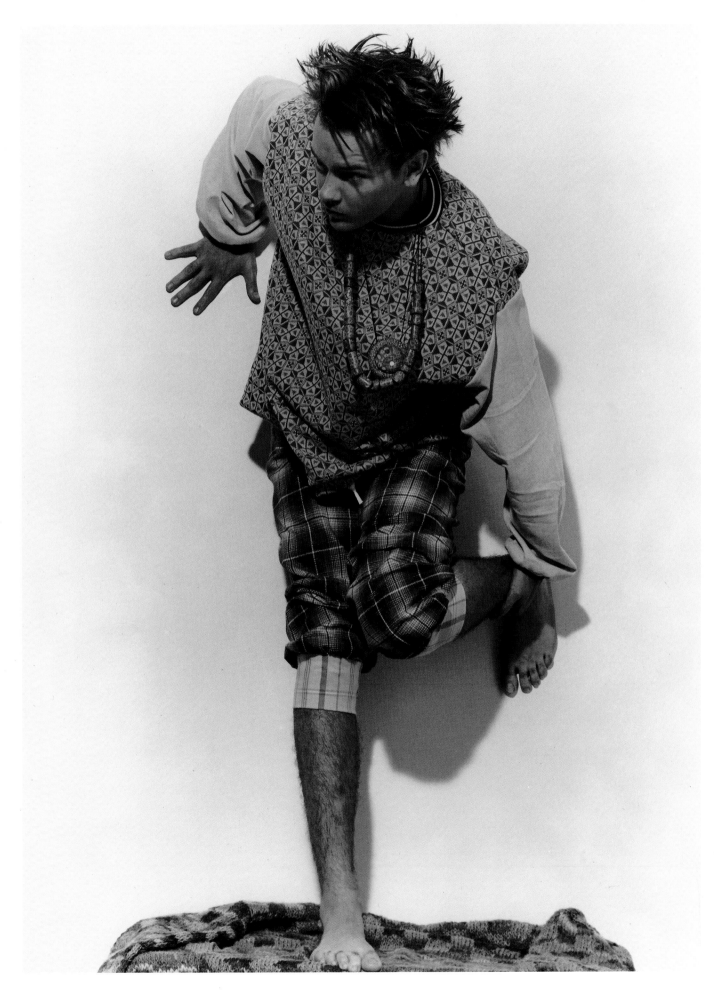

JOSEF ASTOR
Uma Thurman *1989*

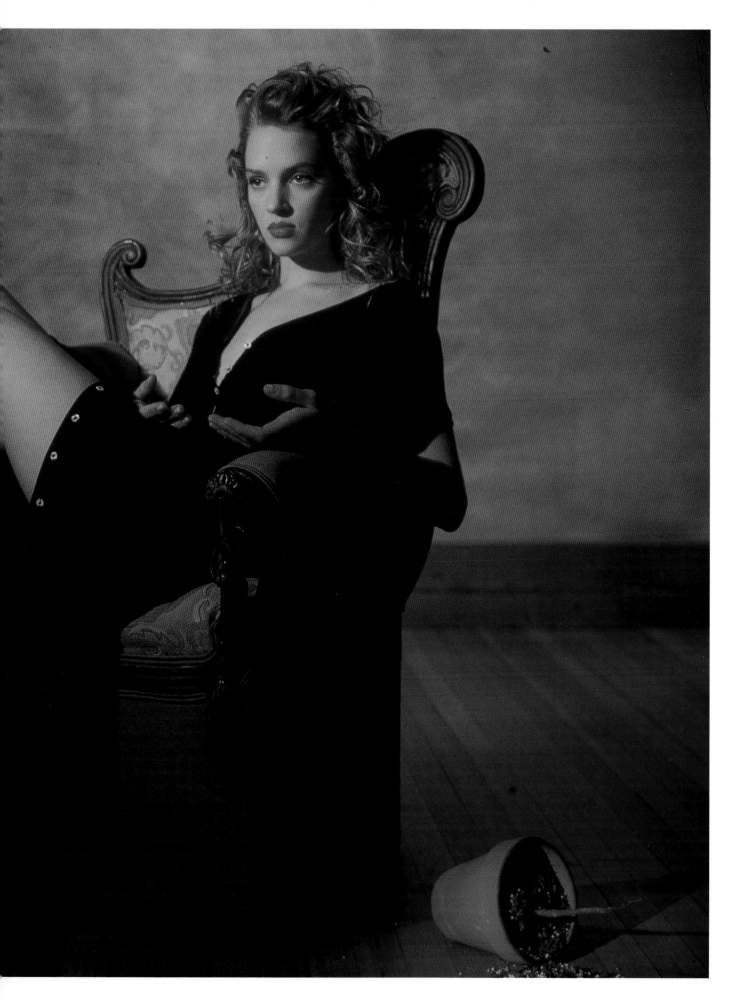

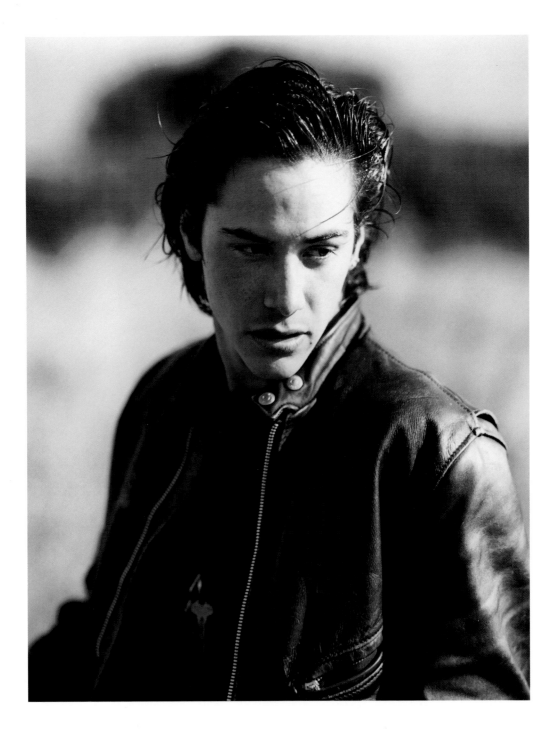

ABOVE: **MICHAEL O'BRIEN**
Keanu Reeves *1989*

OPPOSITE: **JEFFREY THURNHER**
Juliette Lewis *1991*

PAGE 34: **LARA ROSSIGNOL**
Gary Oldman *1990*

PAGE 35: **ALBERT SANCHEZ**
Winona Ryder *1990*

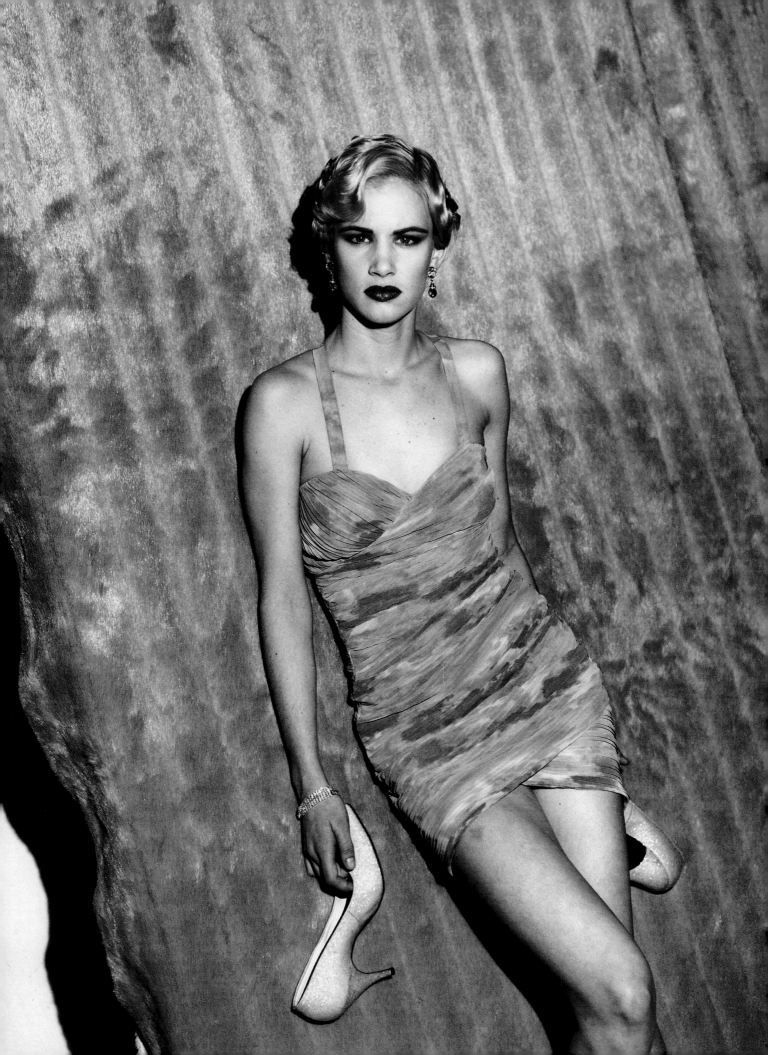

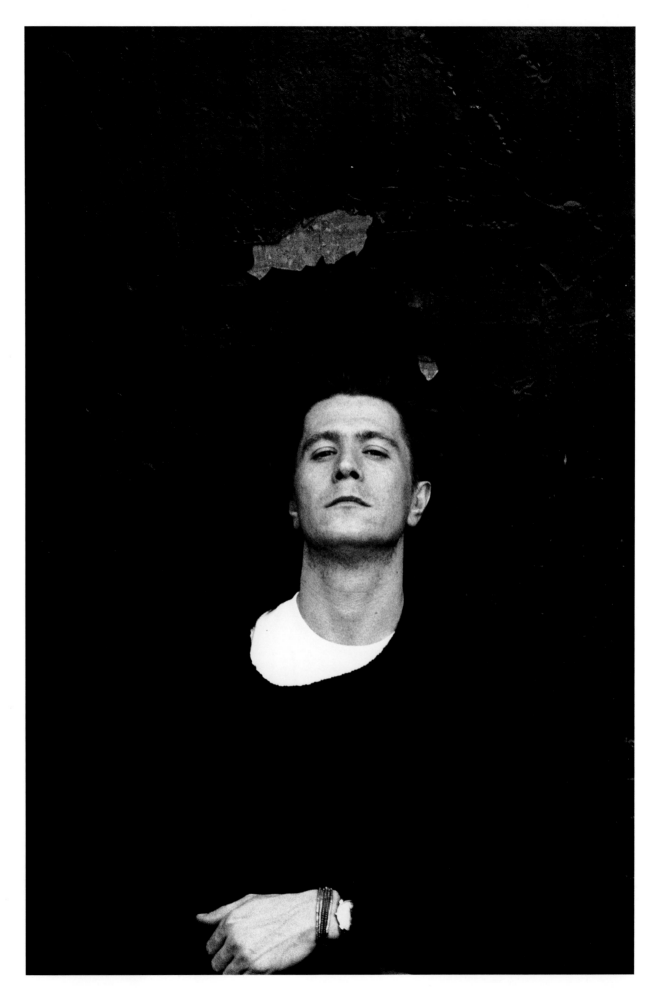

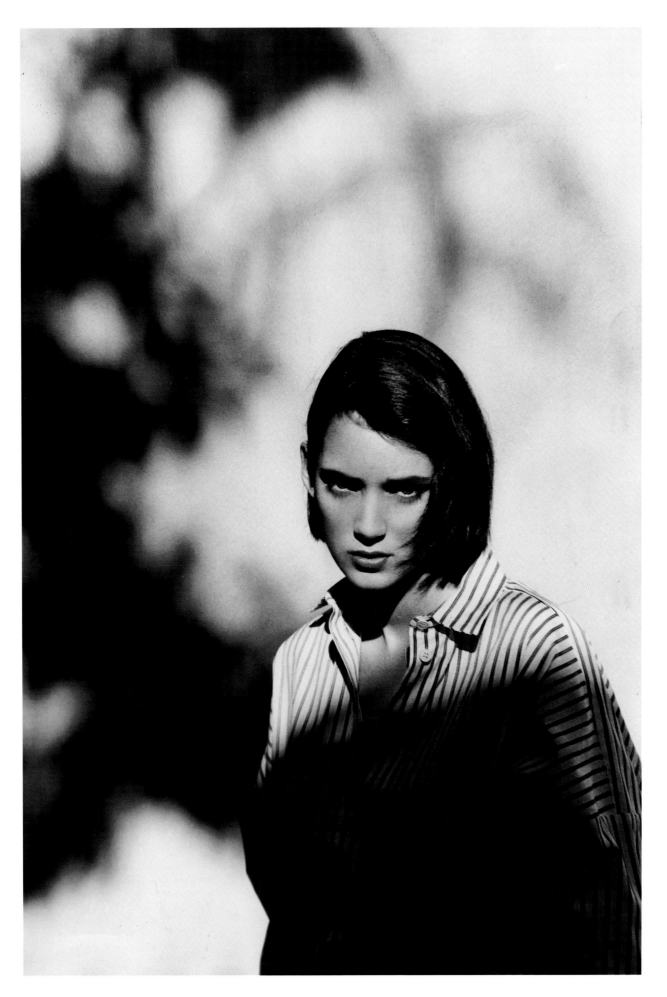

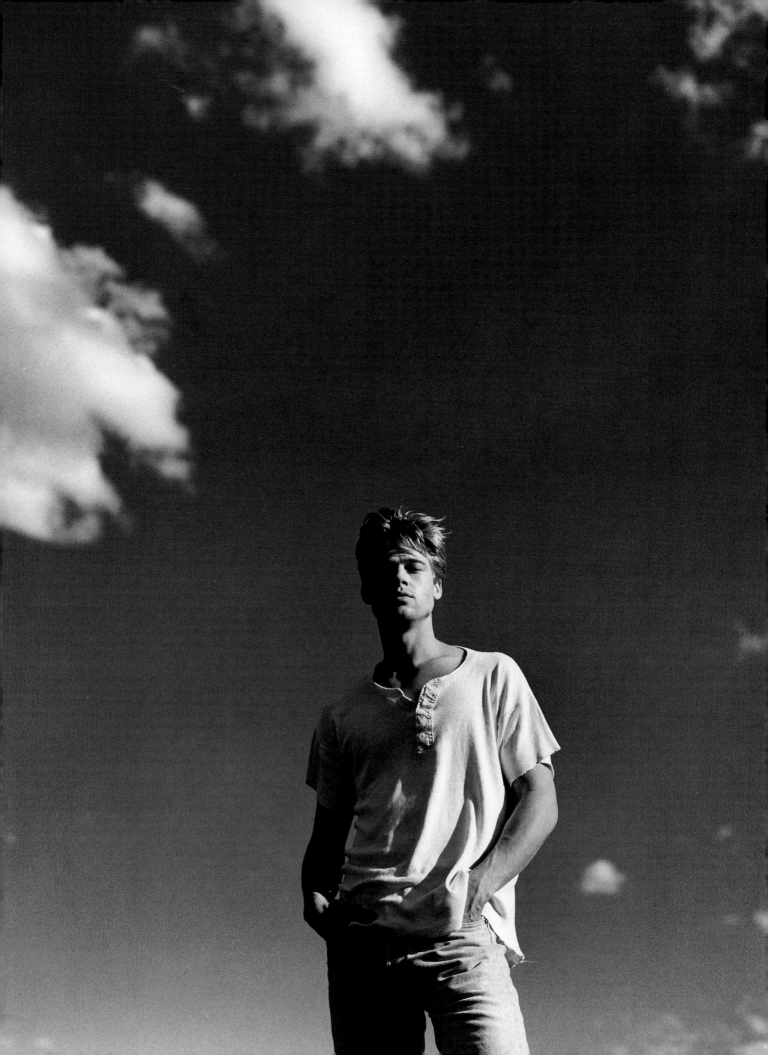

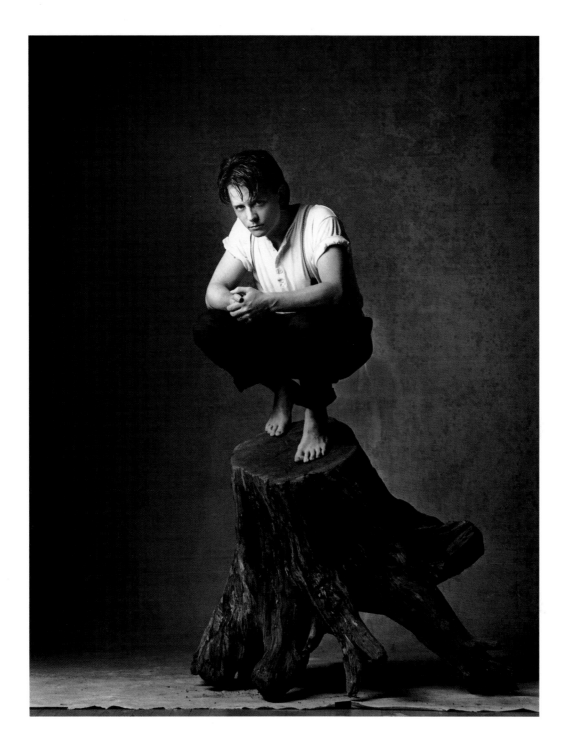

BLAKE LITTLE
Michael J. Fox *1991*

OPPOSITE: **GEORGE HOLZ**
Brad Pitt *1991*

JEFFREY THURNHER
Jennifer Jason Leigh *1990*

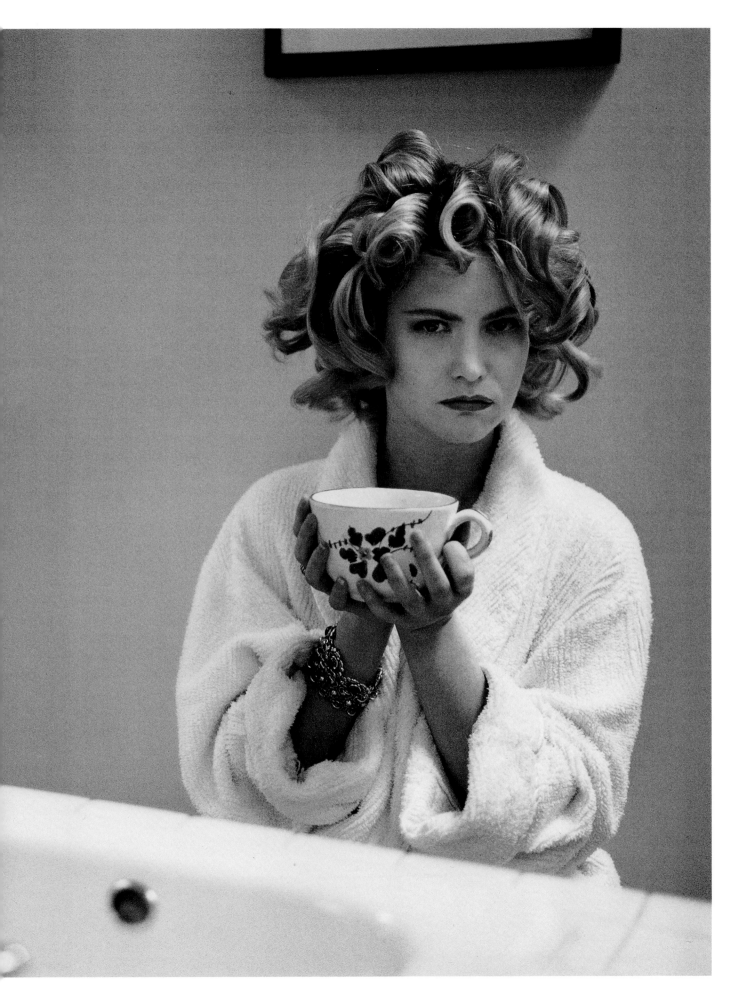

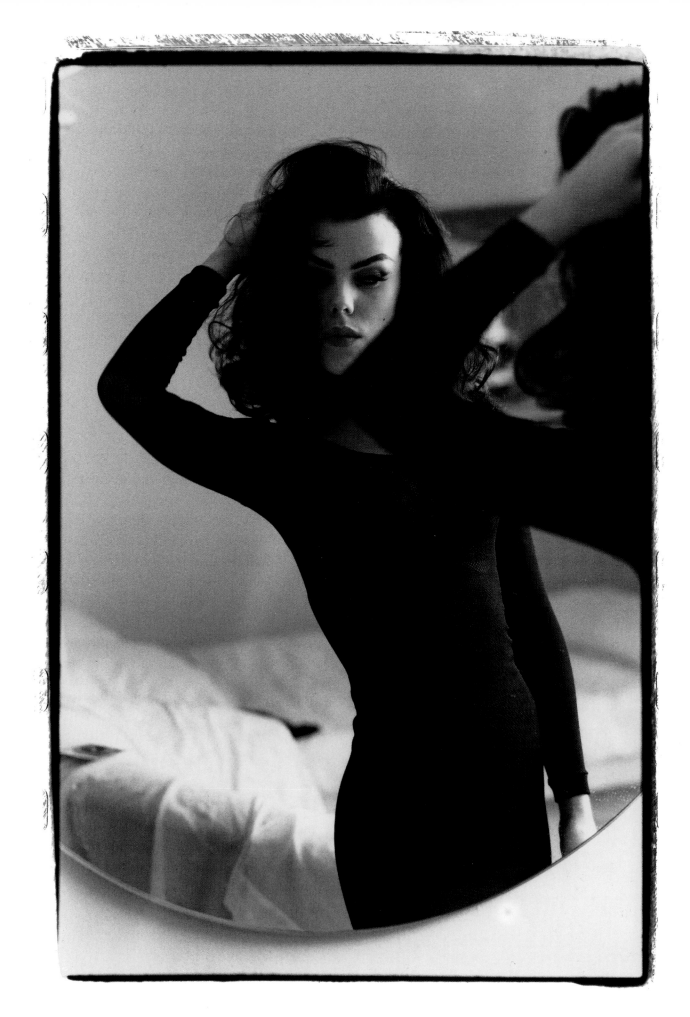

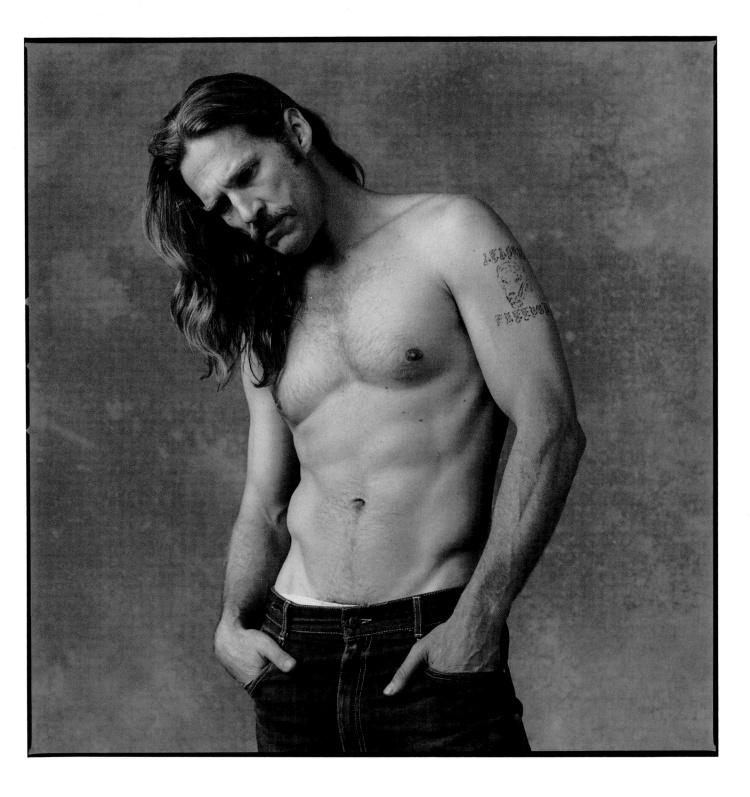

MARY ELLEN MARK
Jeff Bridges *1991*

OPPOSITE: LAURA LEVINE
Debi Mazar *1991*

41

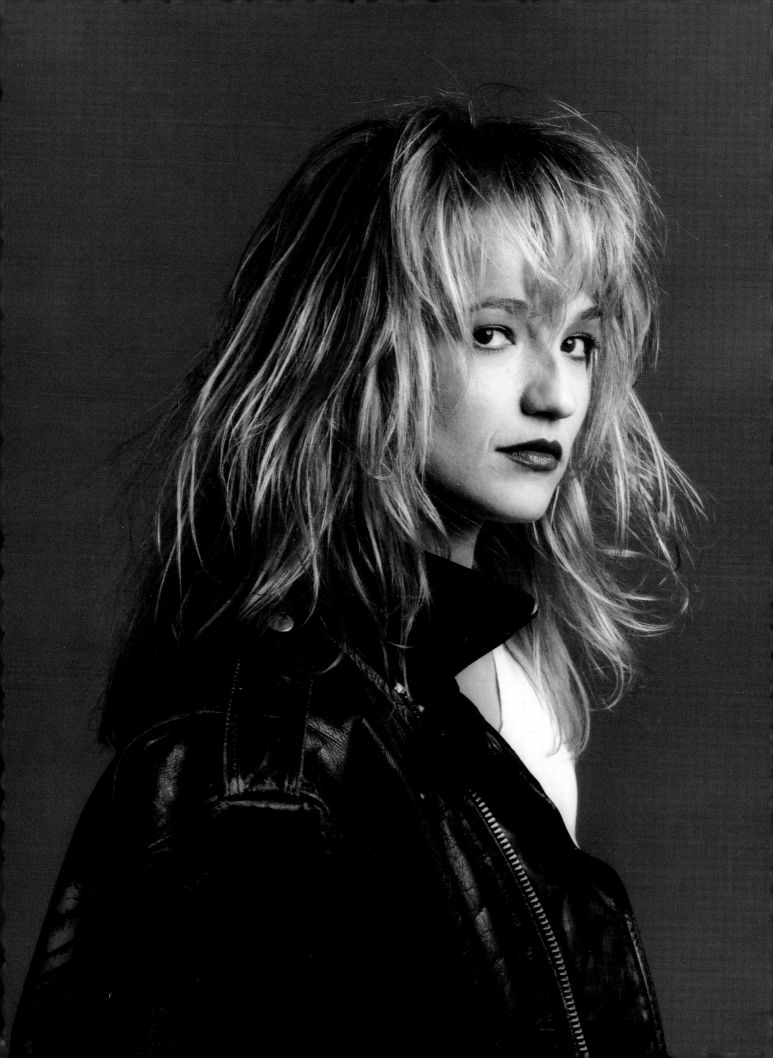

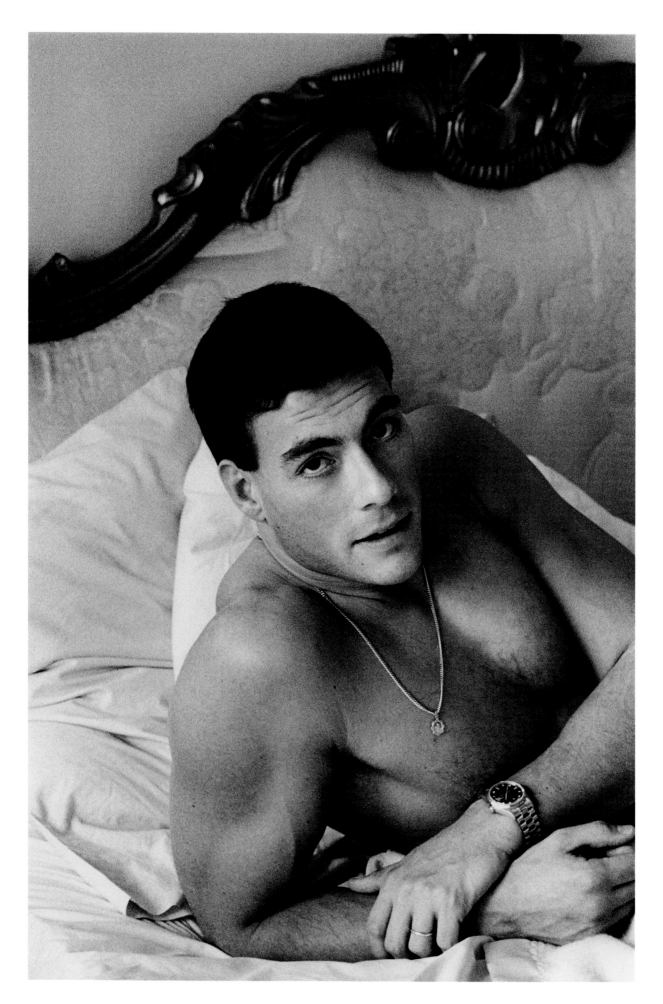

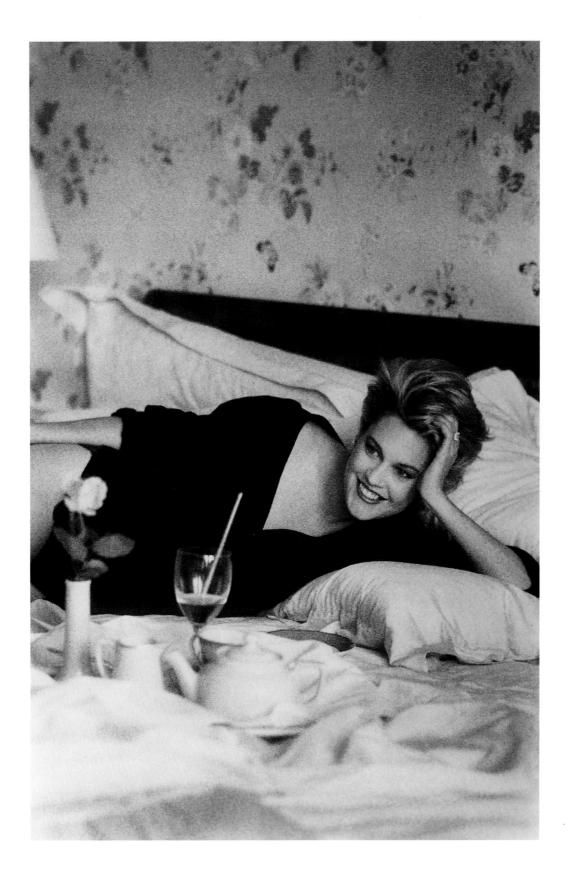

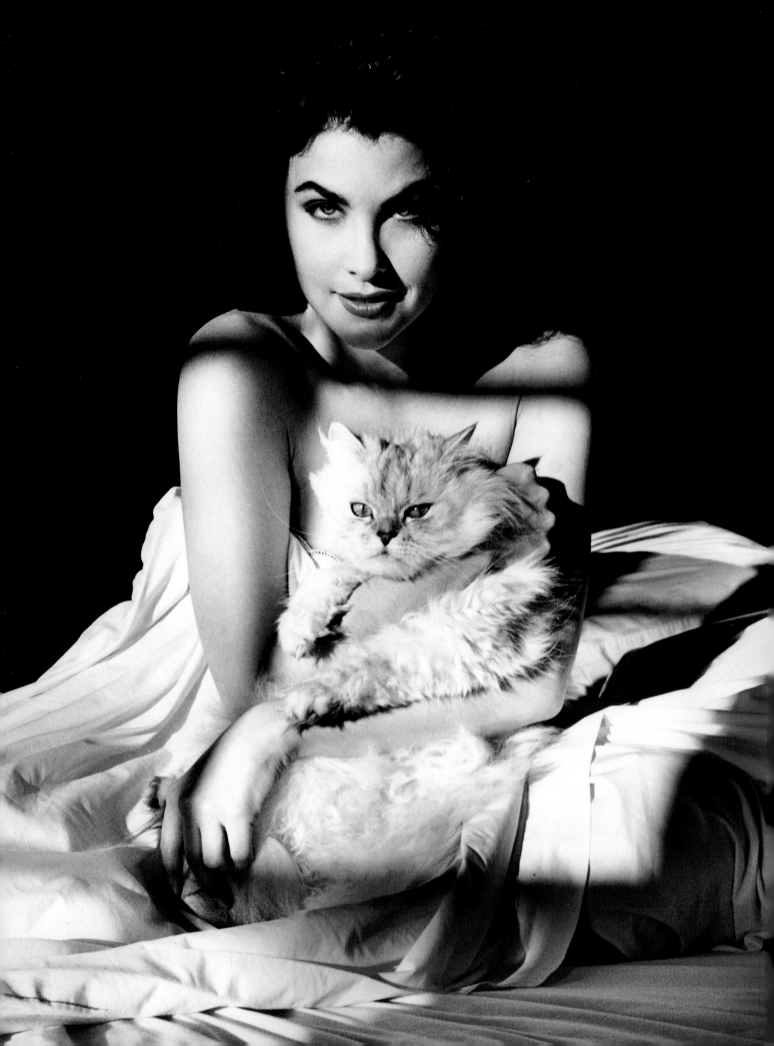

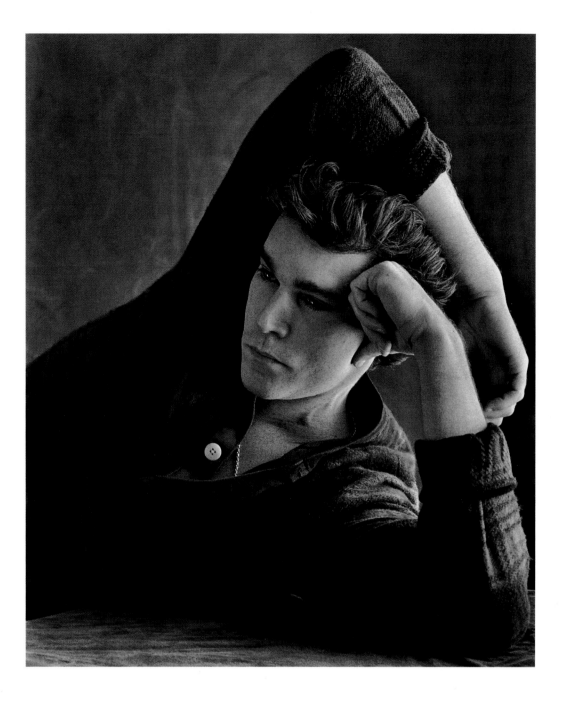

MARION ETTLINGER
Ray Liotta *1989*

OPPOSITE: **JESSE FROHMAN**
Sherilyn Fenn *1991*

47

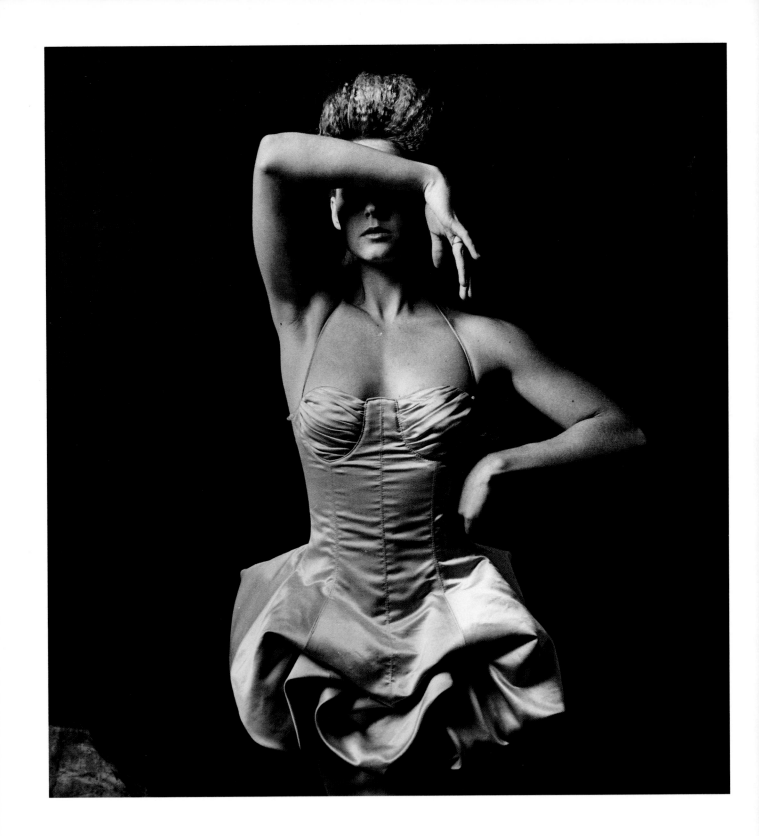

MARCUS LEATHERDALE
Jodie Foster *1988*

OPPOSITE: BOB FRAME
Isabella Rossellini *1991*

48

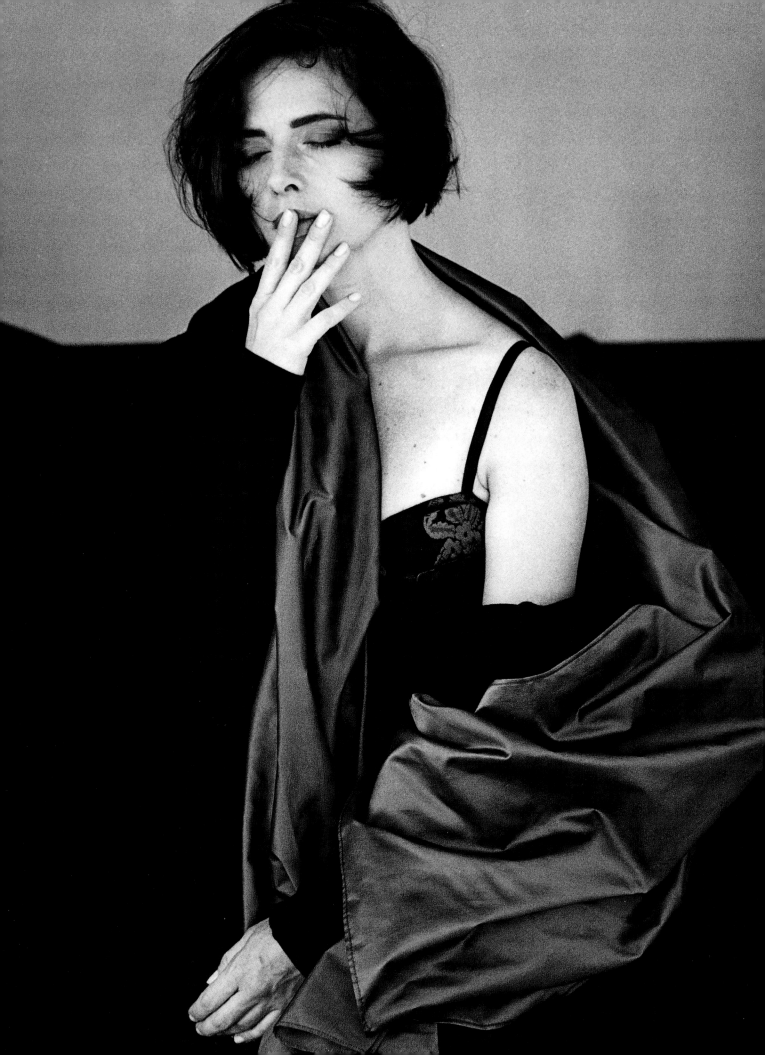

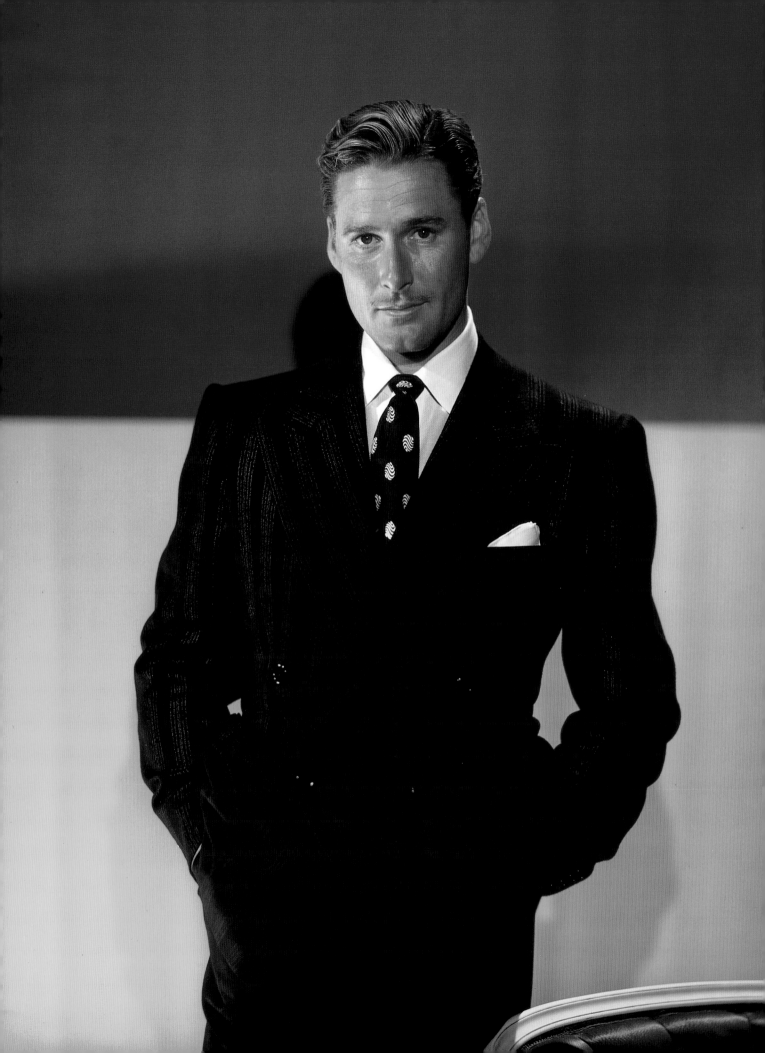

STRIKE A POSE

To pose properly is to strike an attitude, to create a heroic façade for the purpose of being viewed. All of the great Hollywood stars were great poseurs: Garbo, Davis, and Hepburn, for example. Among men, Erroll Flynn's gift for posturing translated beautifully onto film. Their portraits are a permanent record of their stardom.

Today, portraits reveal more about the stars. The pose can tell all—the dark side, the far side, the private side—the sides seldom seen on the silver screen. Spike Lee takes an unusually sophisticated stance, Michael J. Fox appears bewitchingly aggressive, and Ann Magnuson exudes mystery. This is the stuff that dreams are made of.

ANTHONY BARBOZA
Spike Lee *1991*

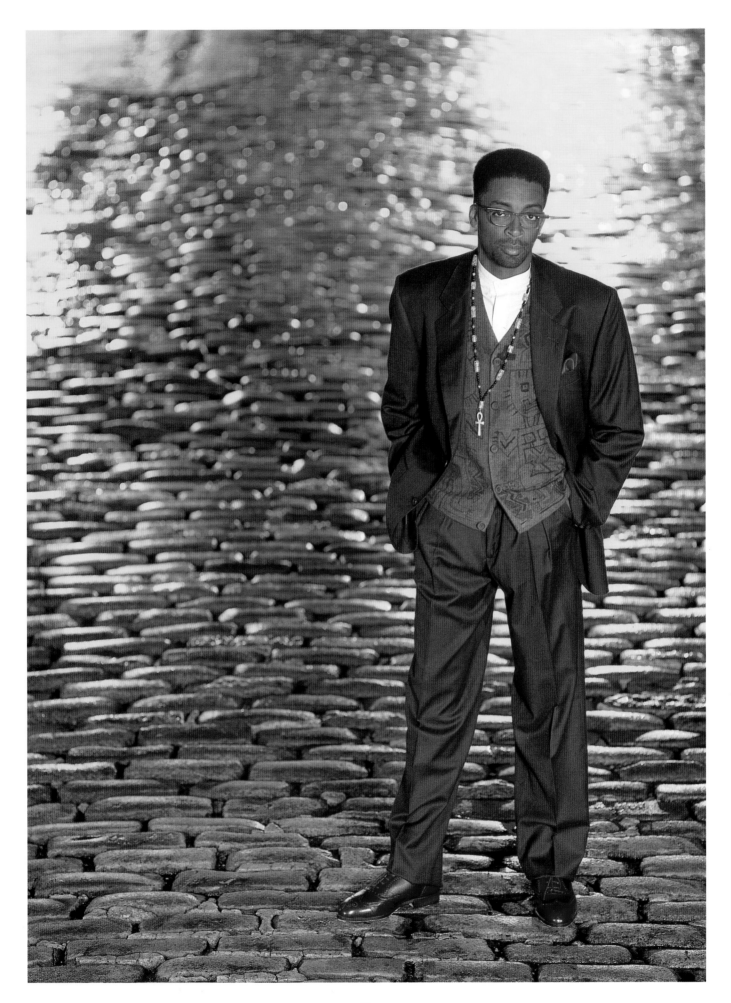

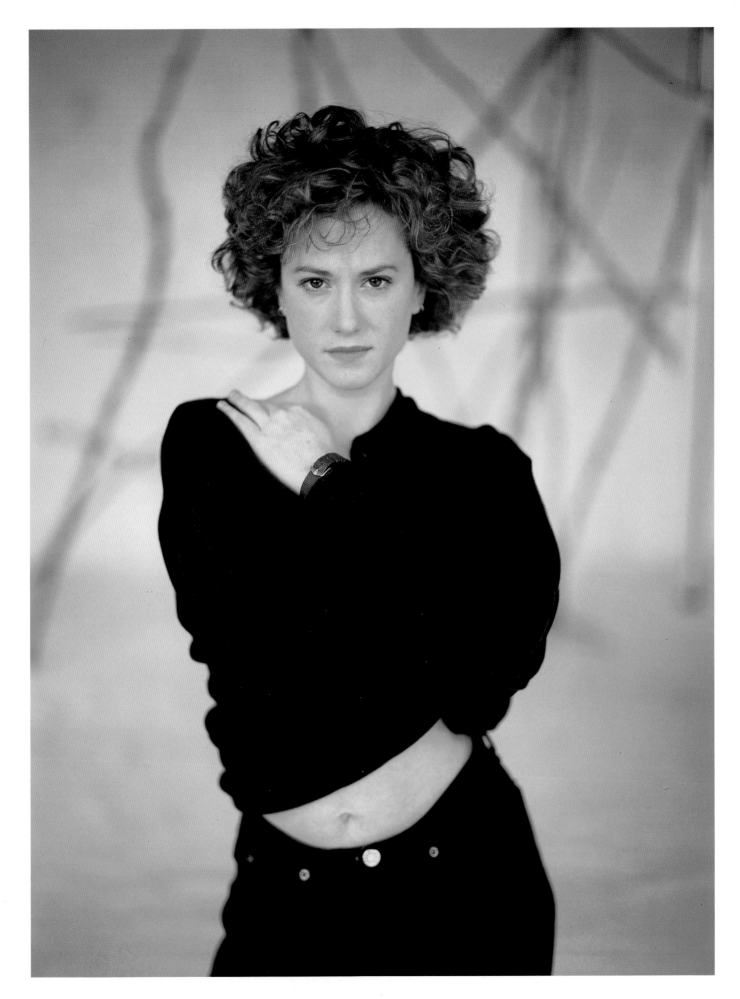

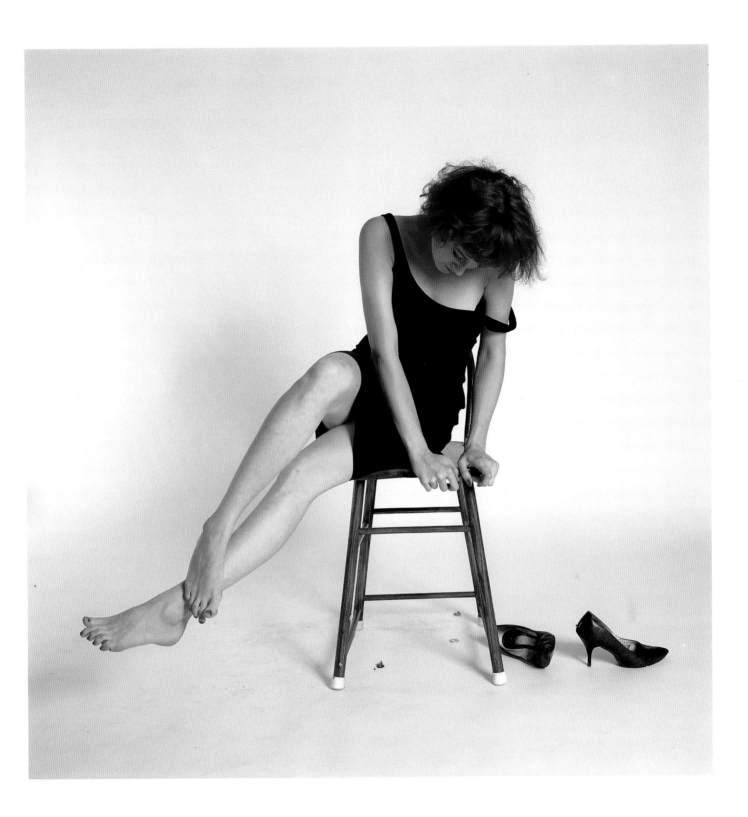

LAURA LEVINE
Ann Magnuson *1985*

OPPOSITE: GEORGE HOLZ
Holly Hunter *1987*

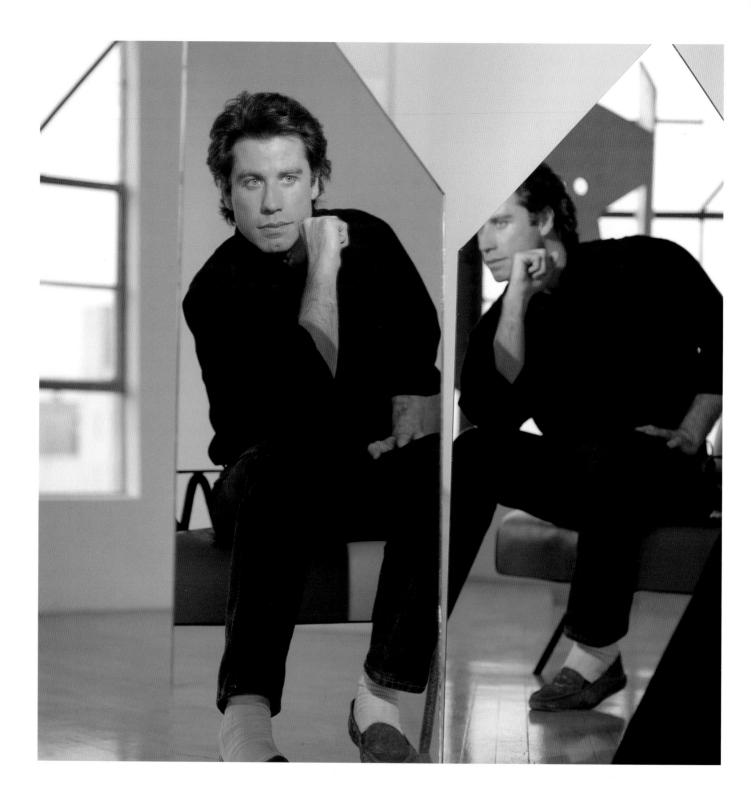

THEO WESTENBERGER
John Travolta *1989*

58

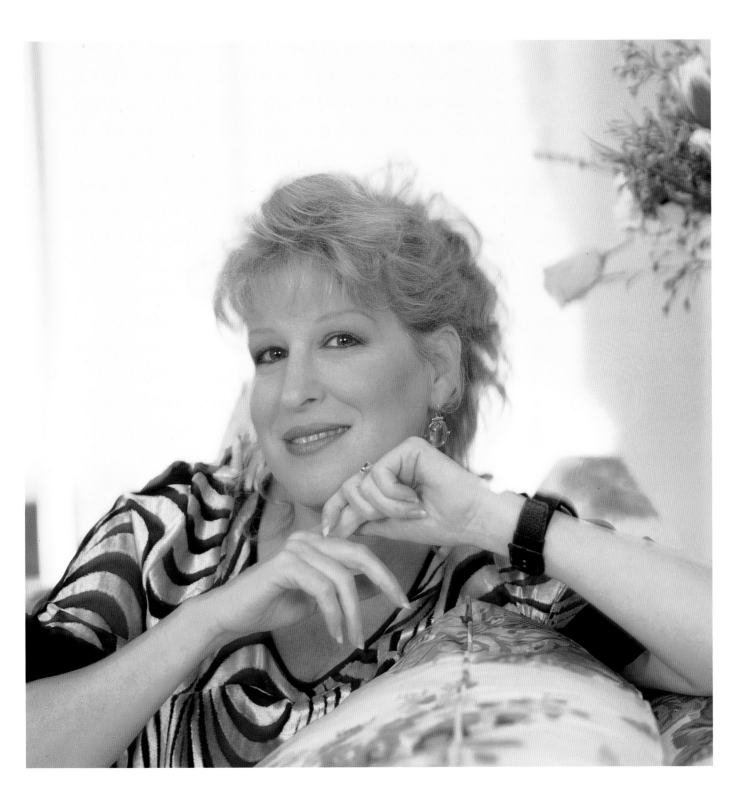

TIMOTHY GREENFIELD-SANDERS
John Turturro *1991*

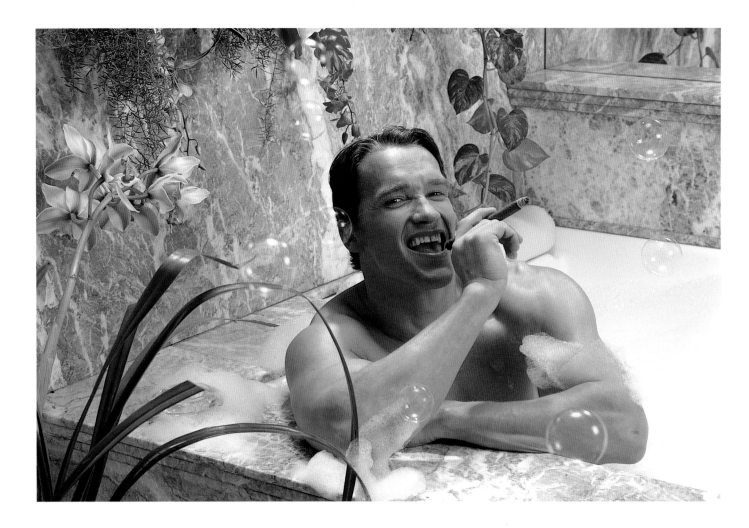

THEO WESTENBERGER
Arnold Schwarzenegger *1988*

OPPOSITE: RICHIE WILLIAMSON & DEAN JANOFF
Eric Bogosian *1987*

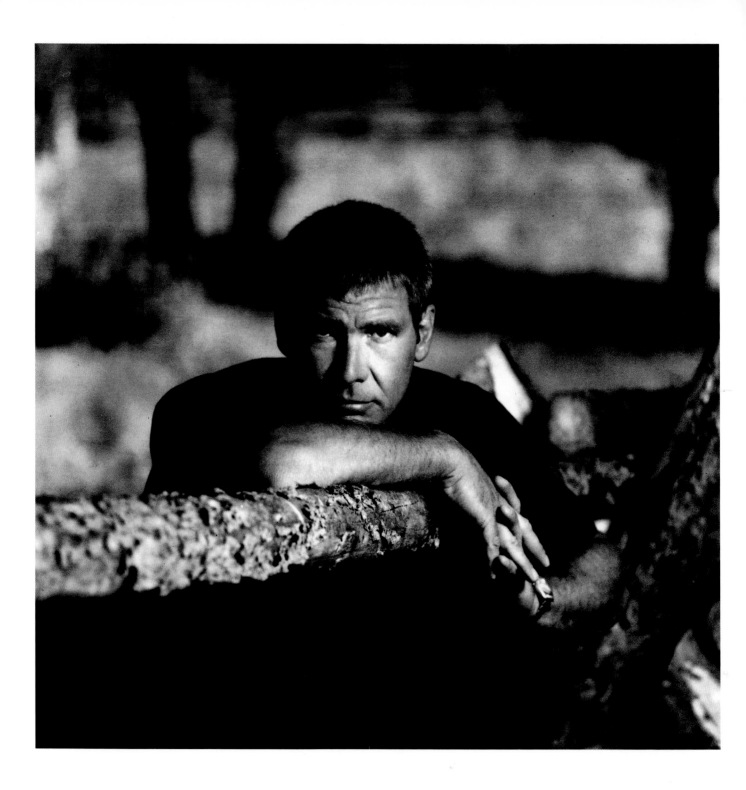

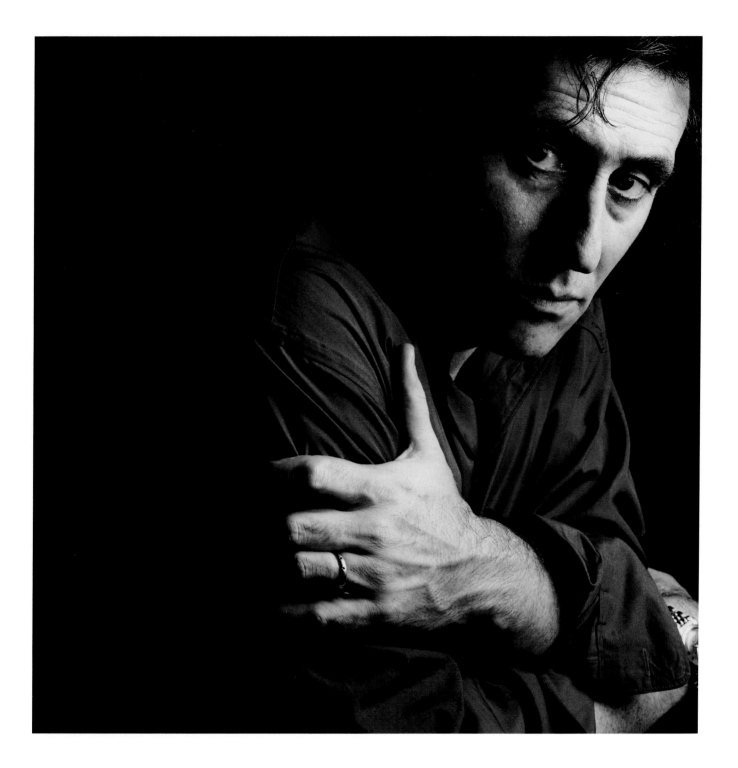

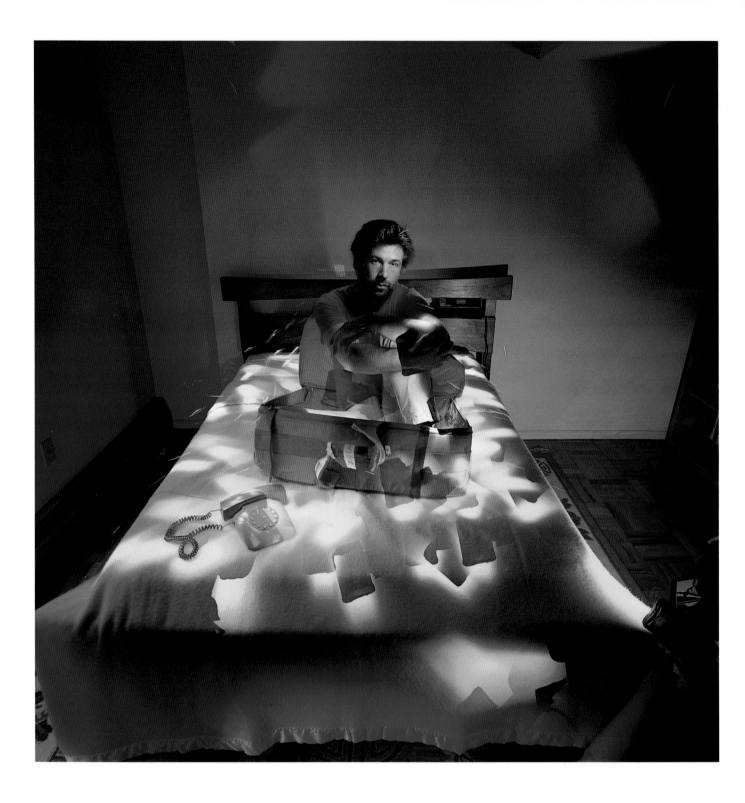

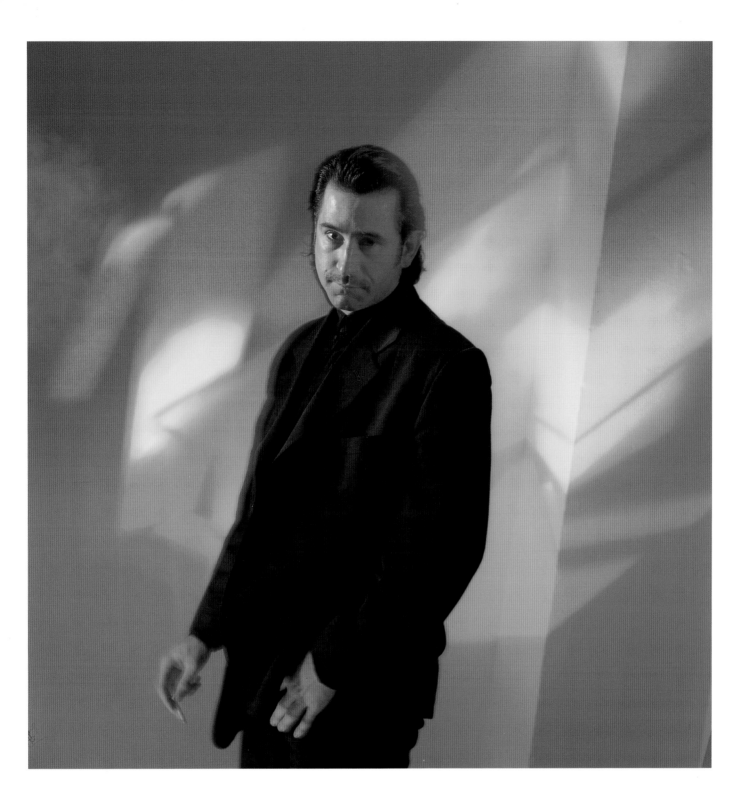

FRANK LINDNER
Anthony LaPaglia *1991*

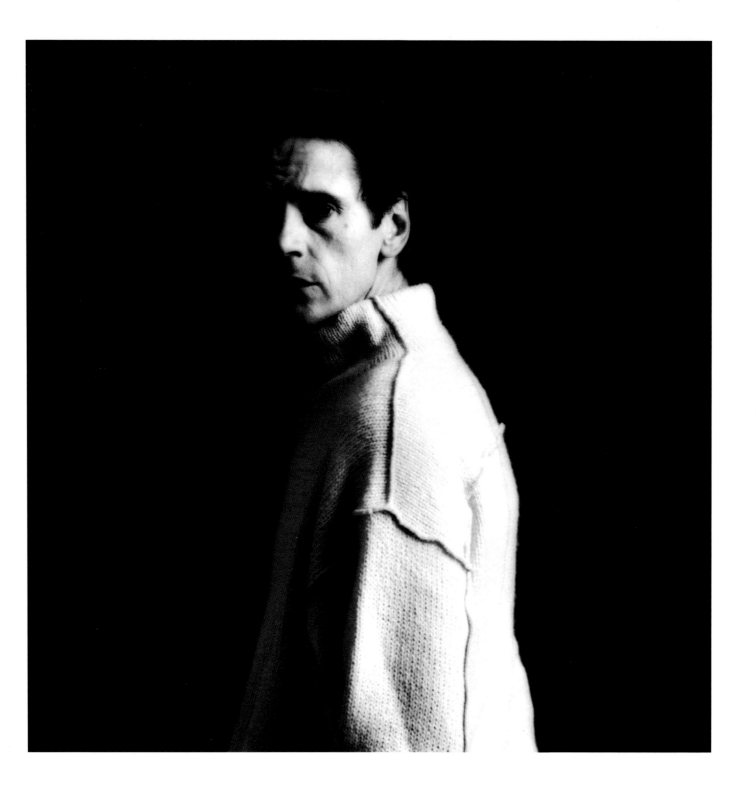

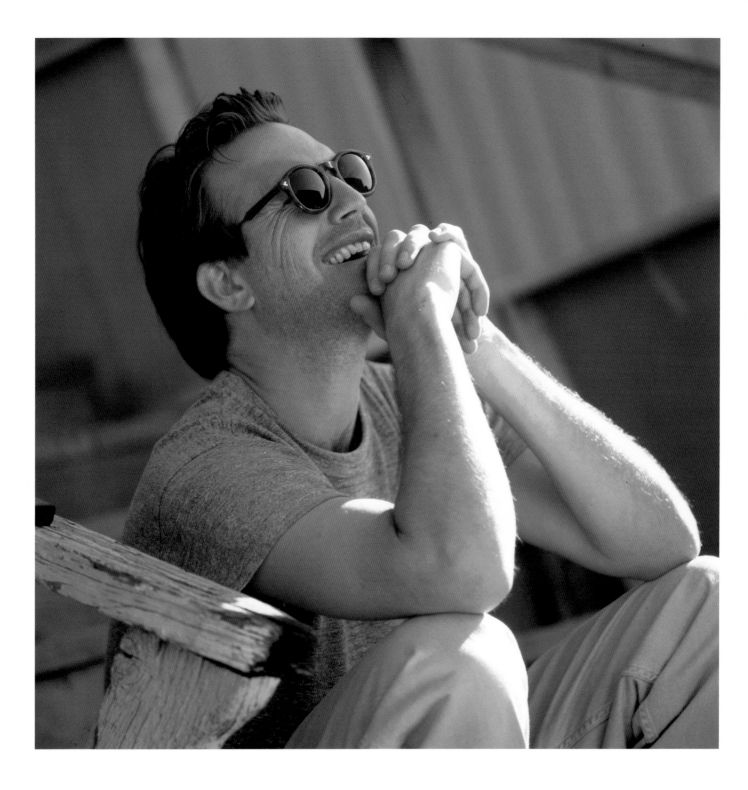

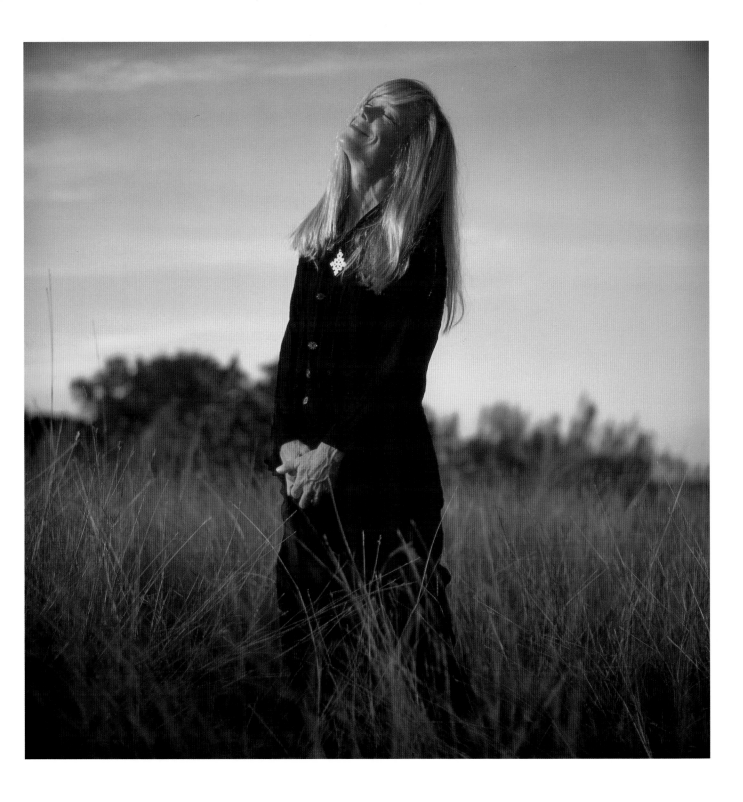

FRANK W. OCKENFELS₃
Sissy Spacek *1981*

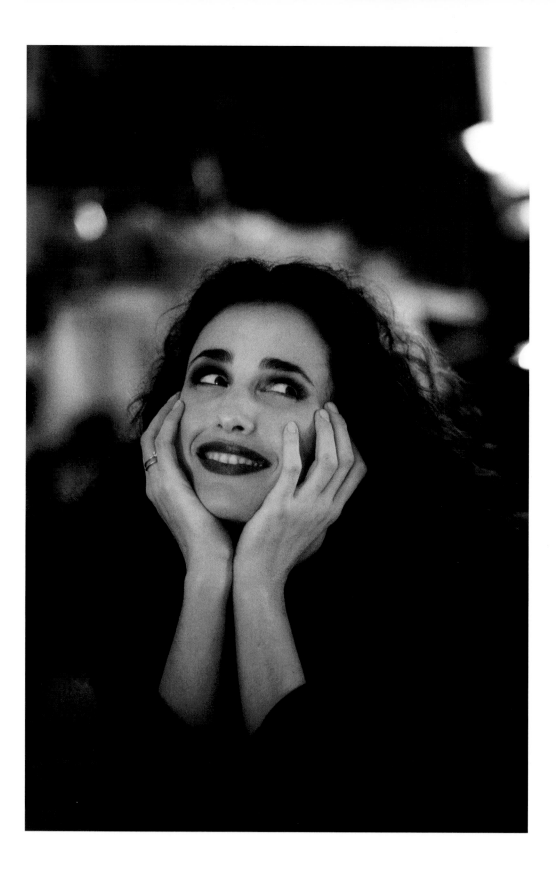

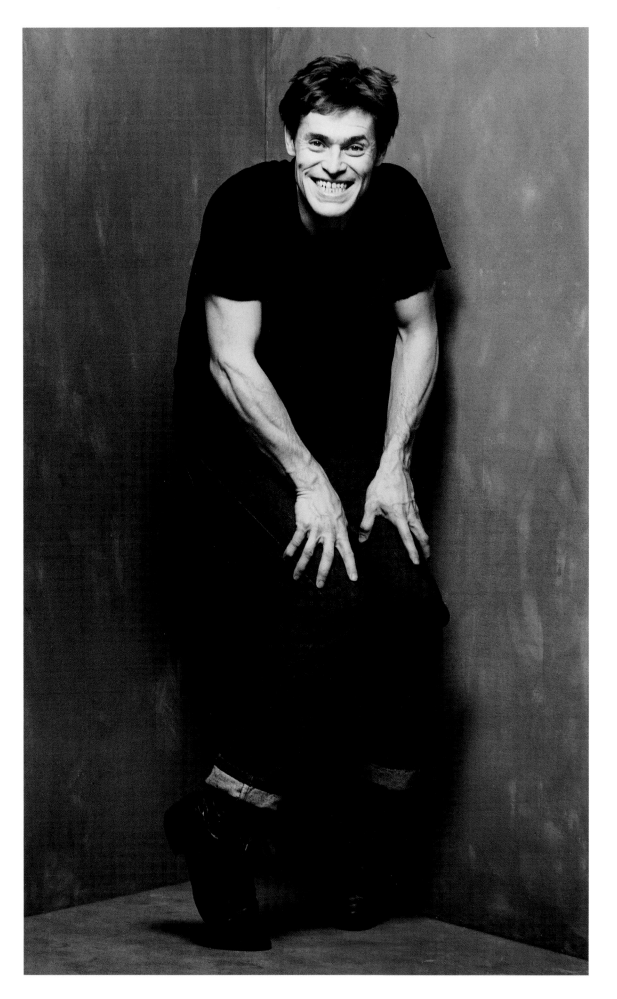

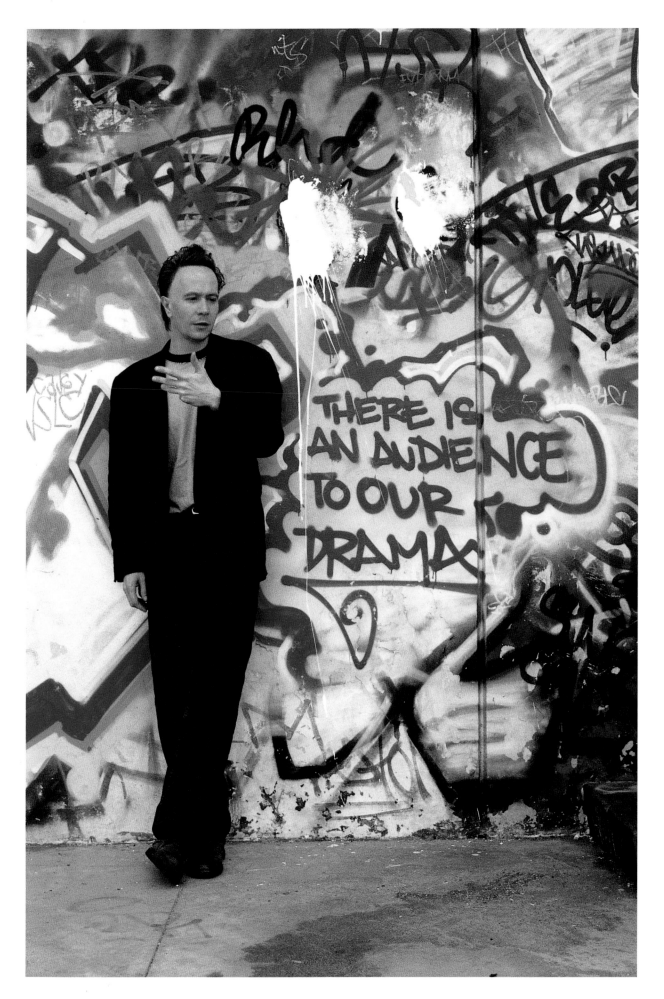

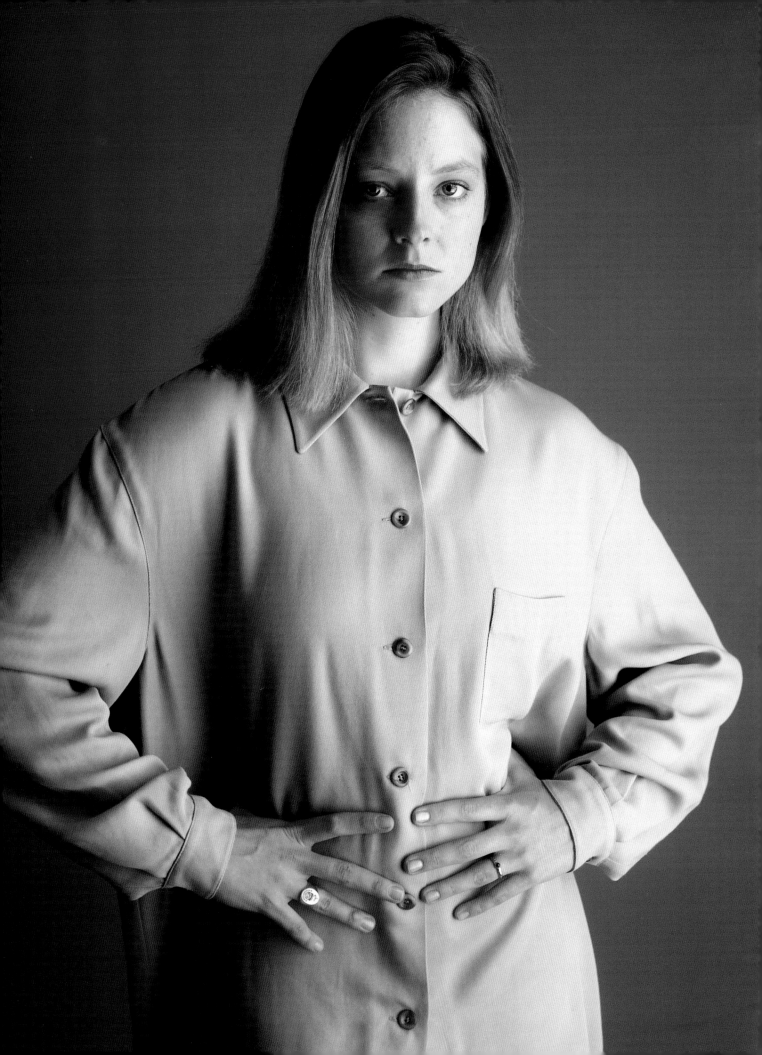

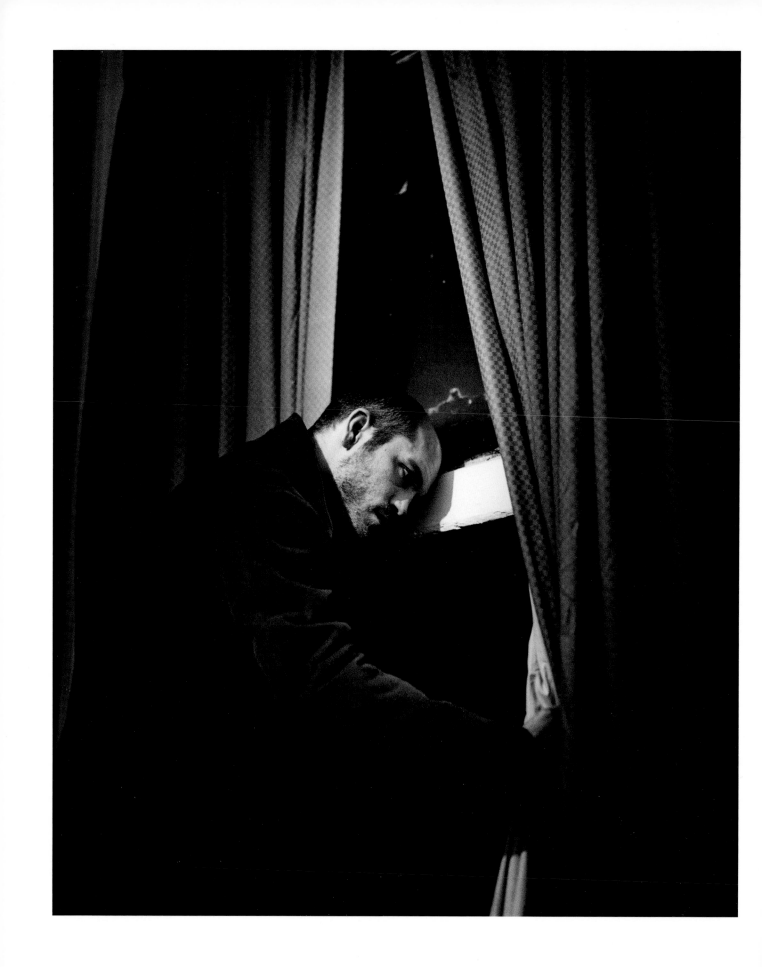

STEVEN KLEIN
John Malkovich *1991*

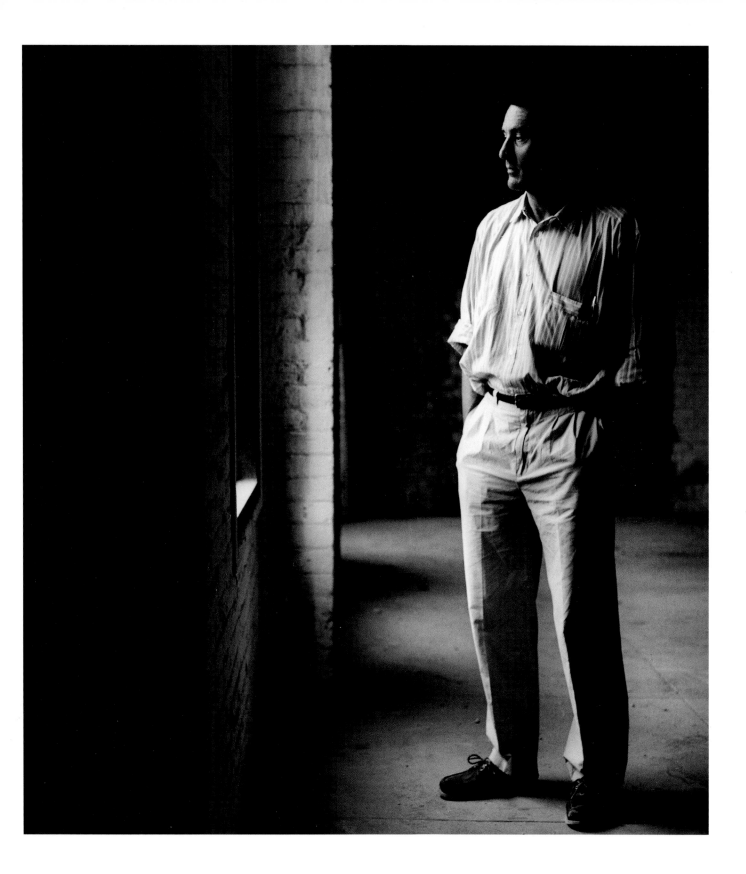

JEFFREY HENSON SCALES
Robert DeNiro *1989*

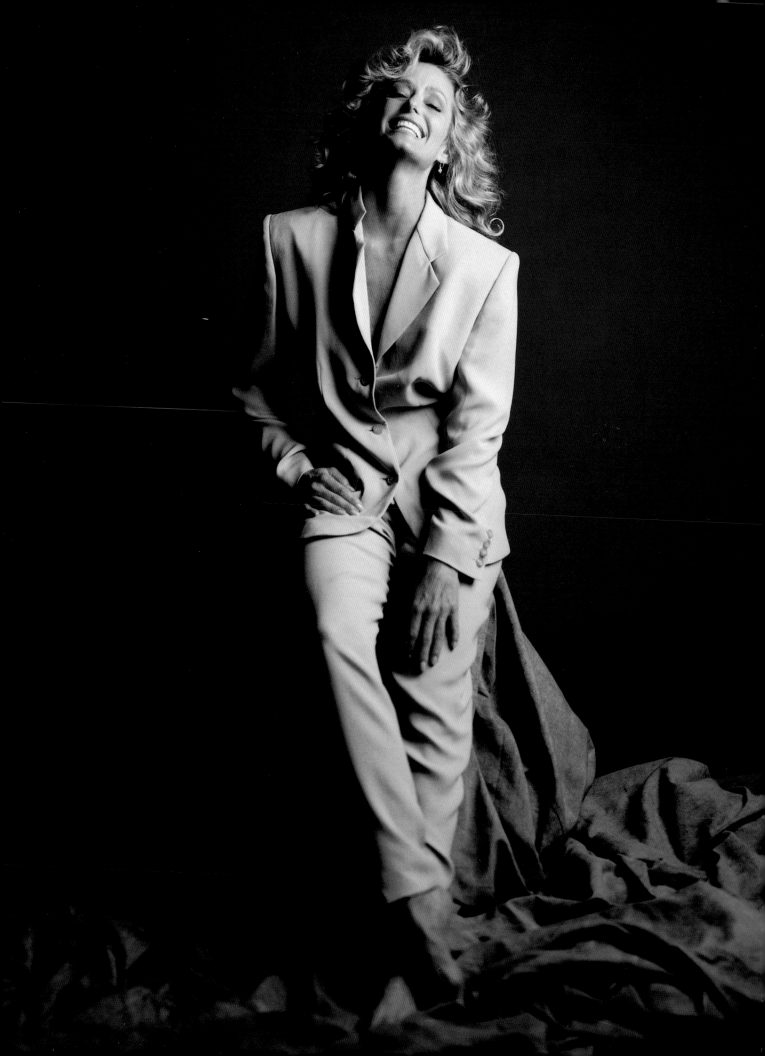

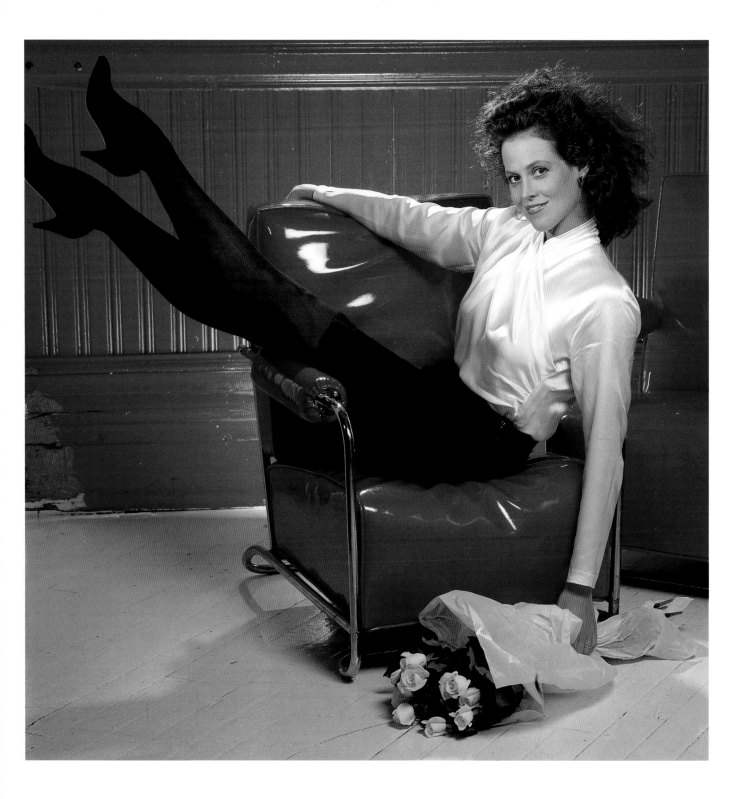

ABOVE: **THEO WESTENBERGER**
Sigourney Weaver *1988*

OPPOSITE: **TIMOTHY GREENFIELD-SANDERS**
Farrah Fawcett *1989*

PAGE 80: **STEVEN KLEIN**
Willem Dafoe & John Lurie *1990*

PAGE 81: **MARION ETTLINGER**
Harry Connick, Jr. *1989*

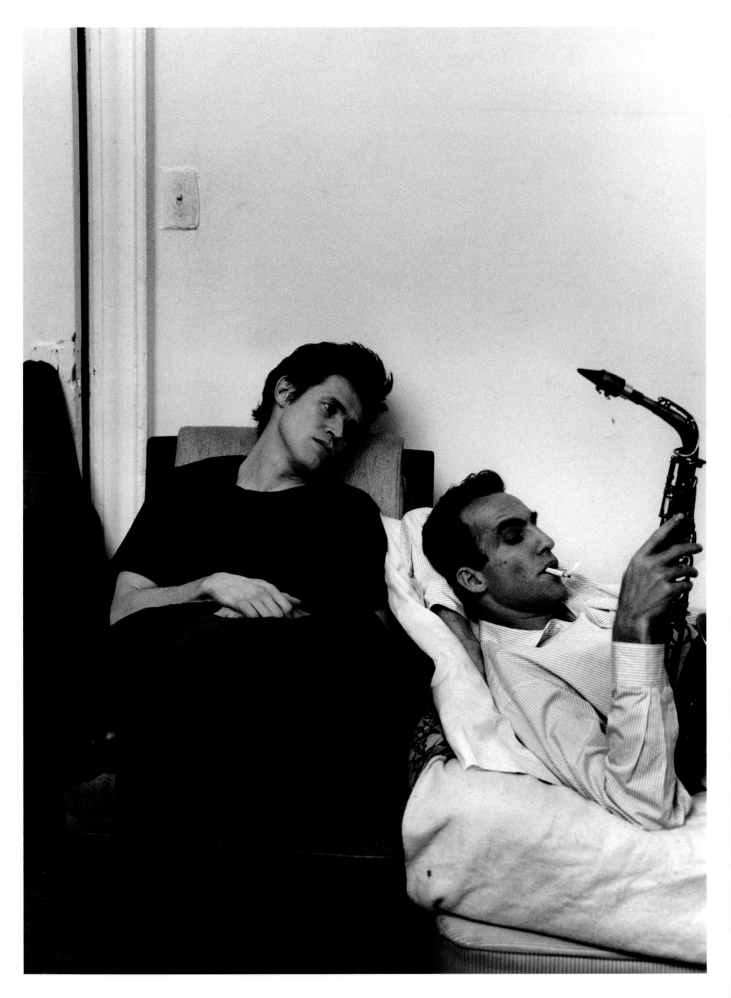

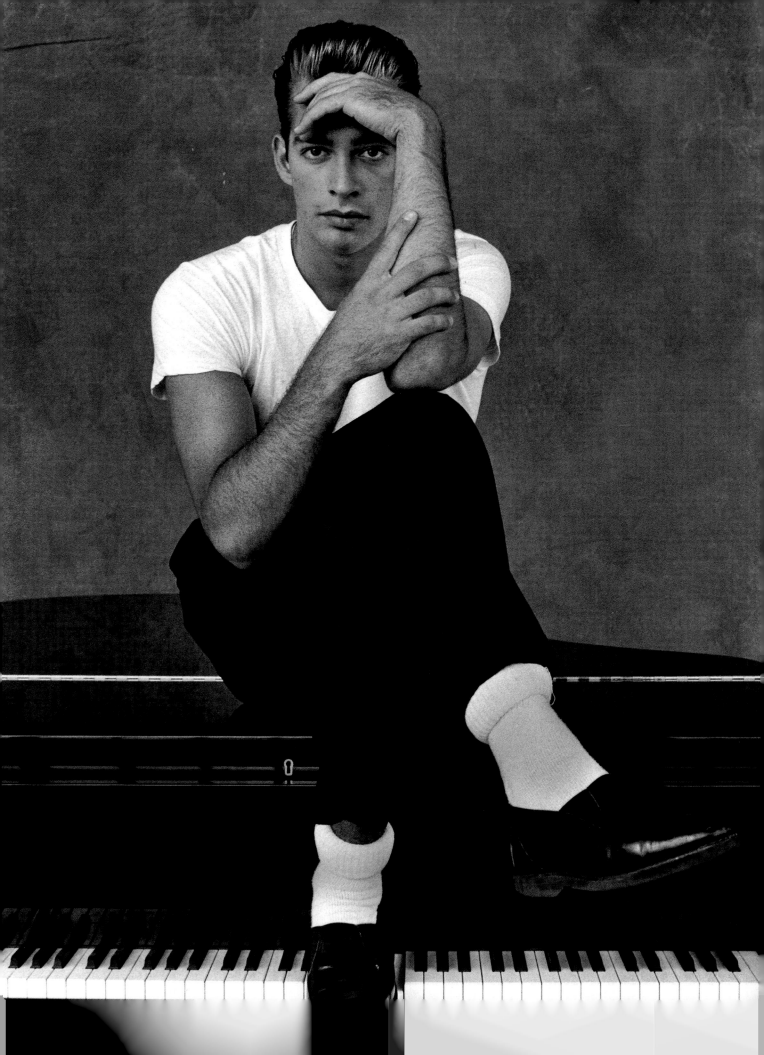

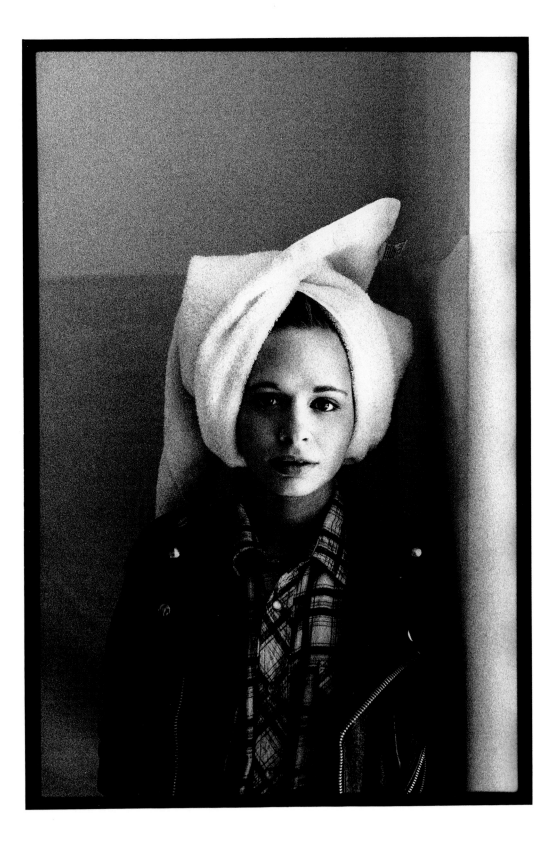

CHRIS BUCK
Adrienne Shelly *1990*

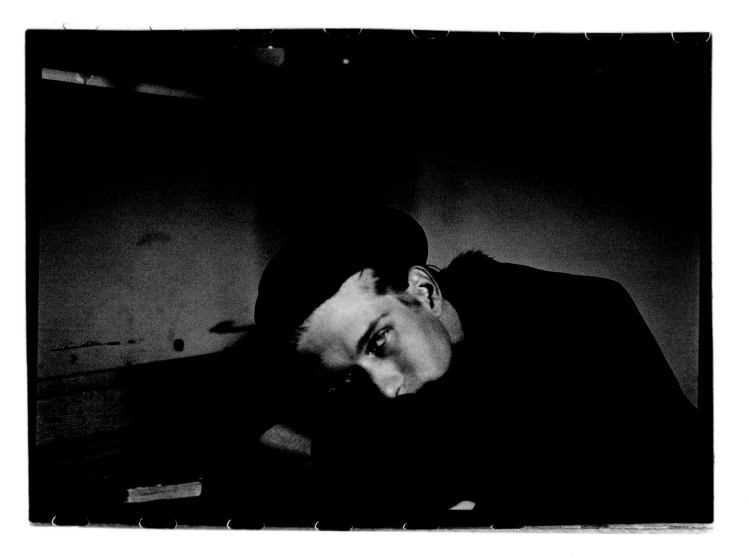

LARA ROSSIGNOL
Stephen Baldwin *1989*

FOLLOWING PAGES: LARA ROSSIGNOL
Nicolas Cage *1984*

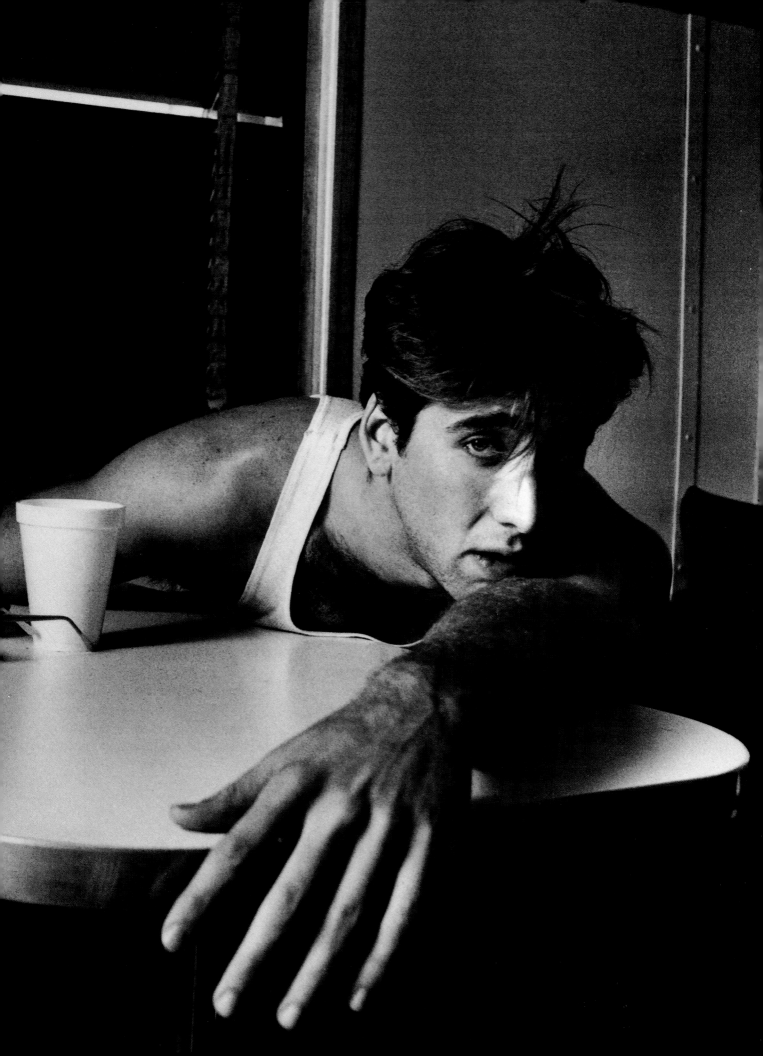

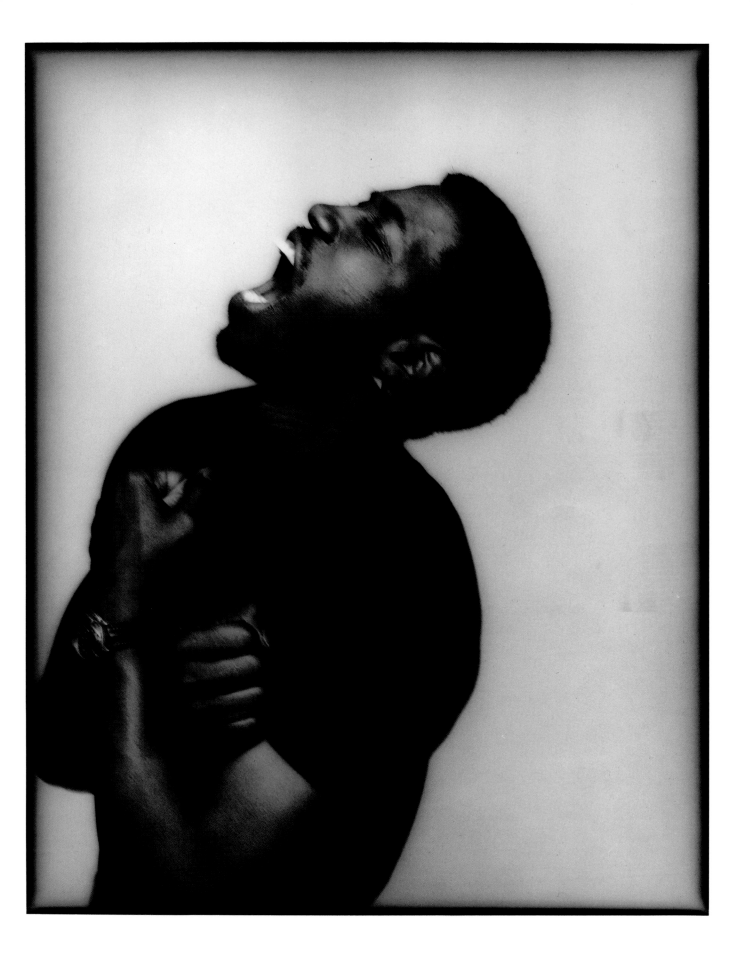

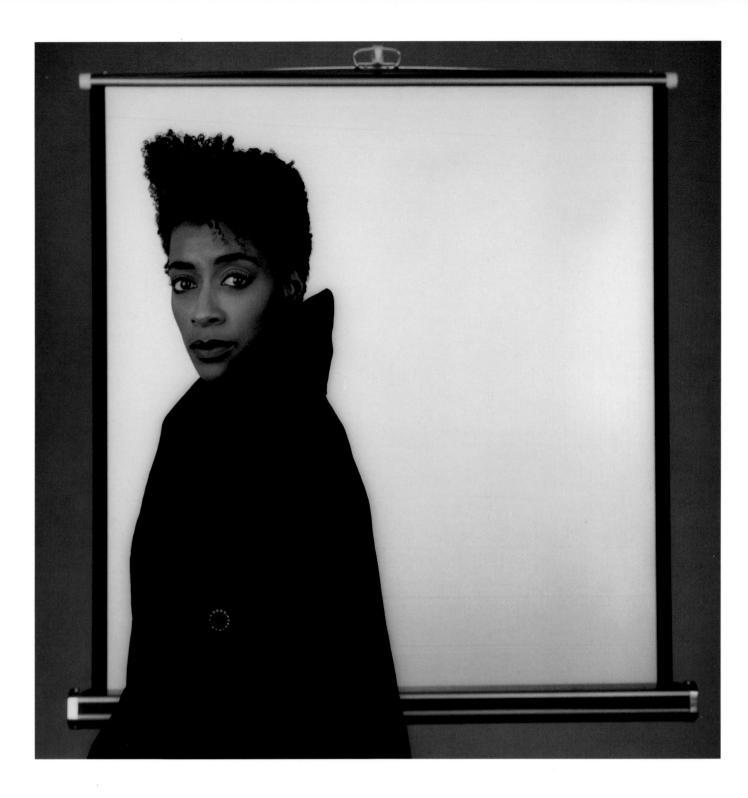

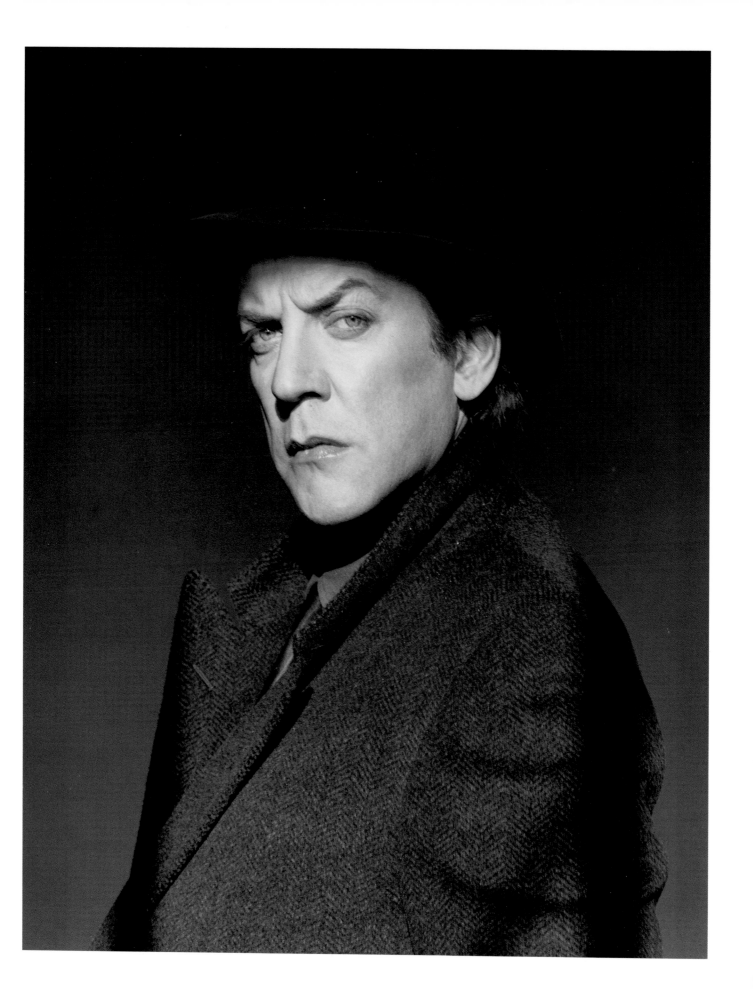

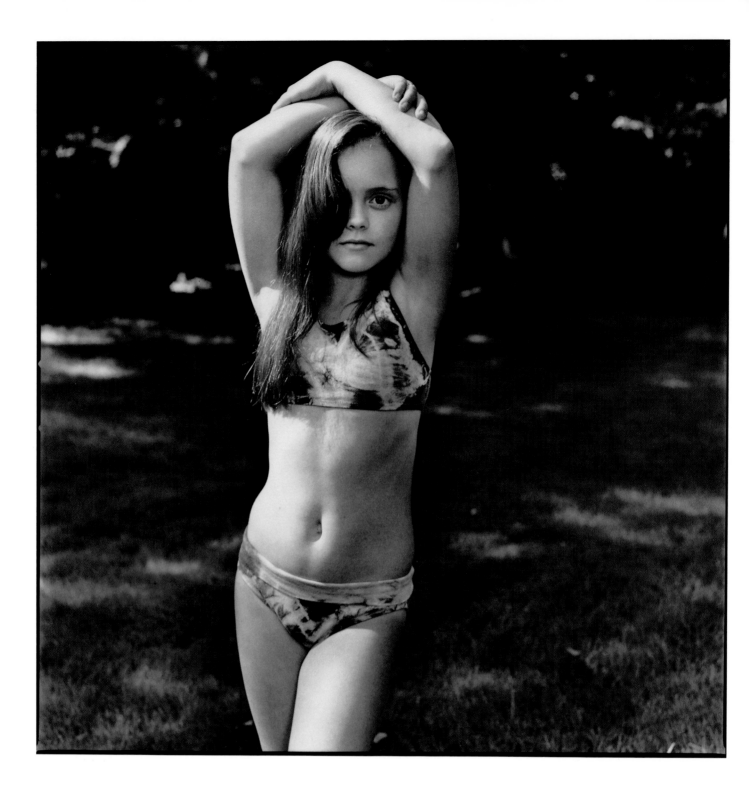

MARY ELLEN MARK
Christina Ricci *1991*

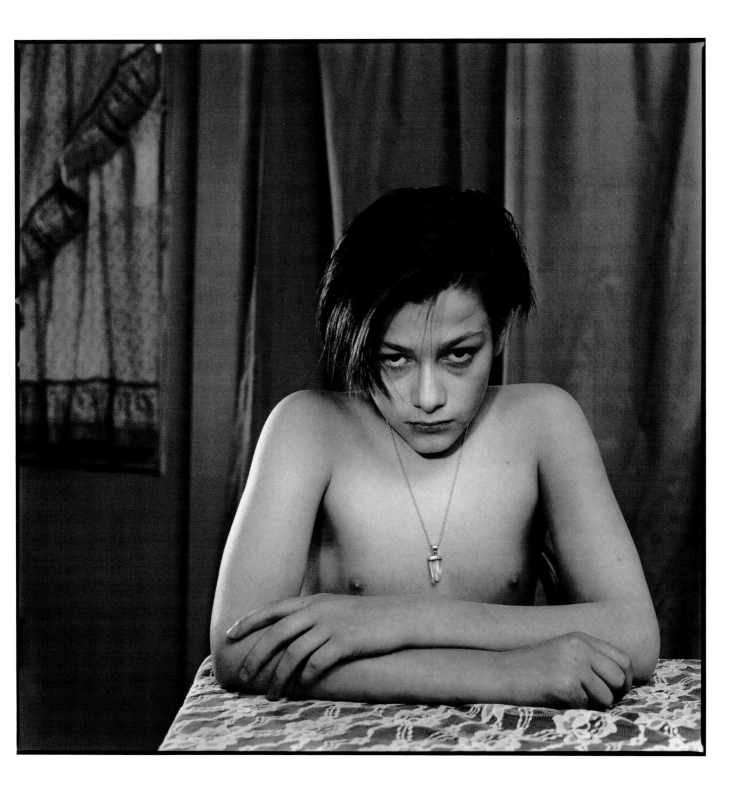

MARY ELLEN MARK
Edward Furlong *1991*

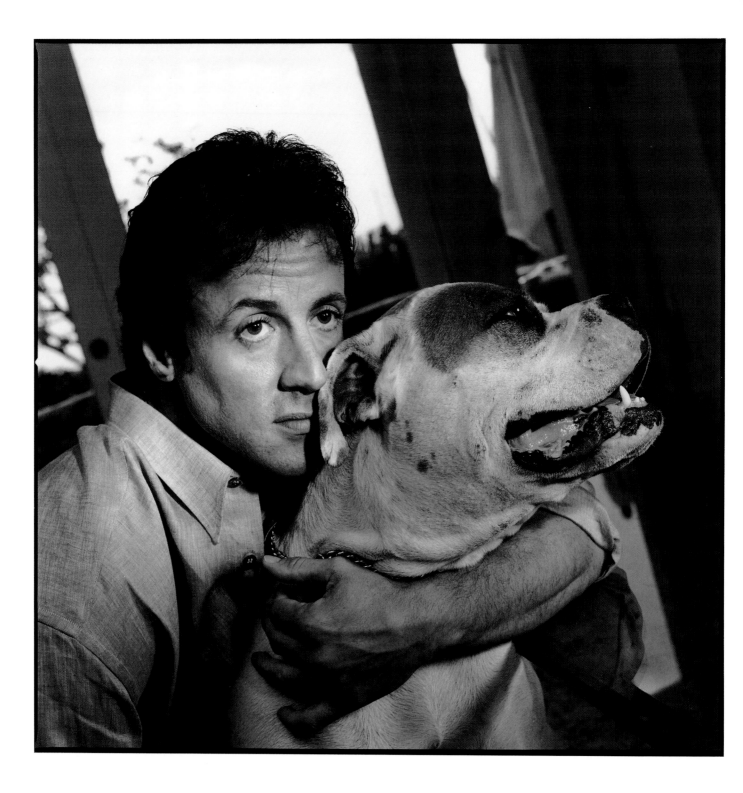

MARY ELLEN MARK
Sylvester Stallone *1991*

OPPOSITE: MARK HANAUER
Carol Kane *1989*

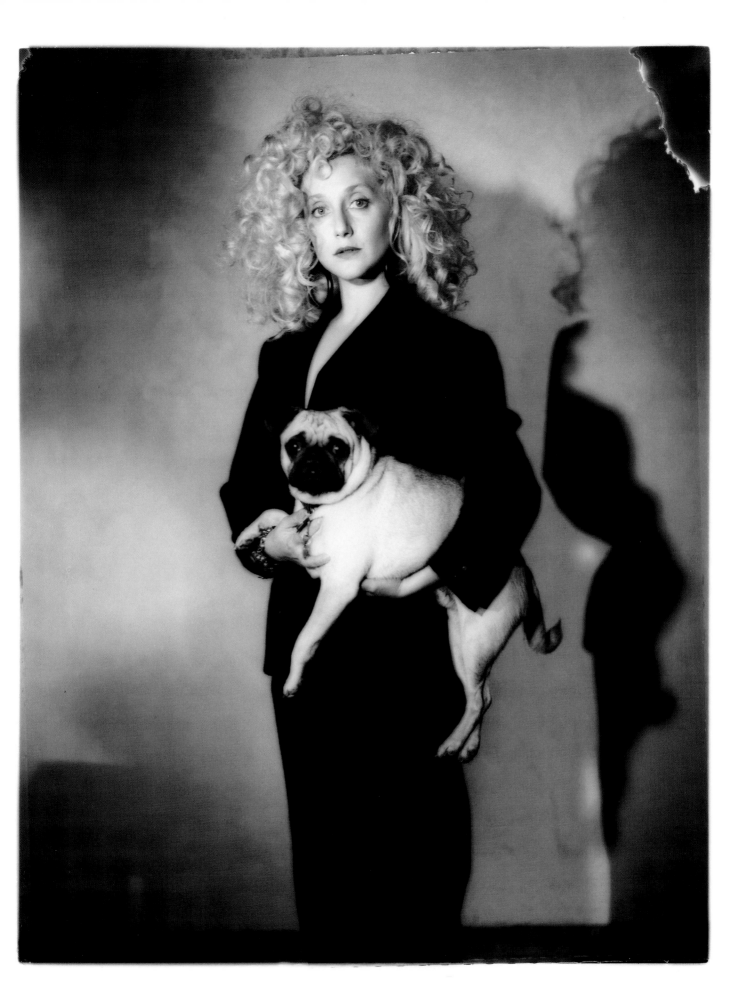

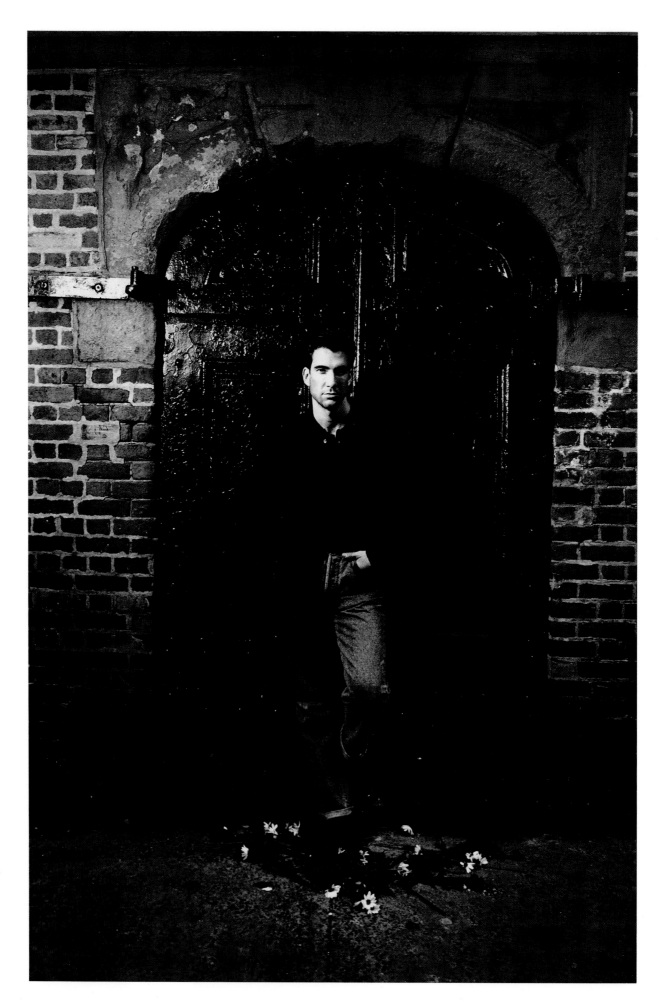

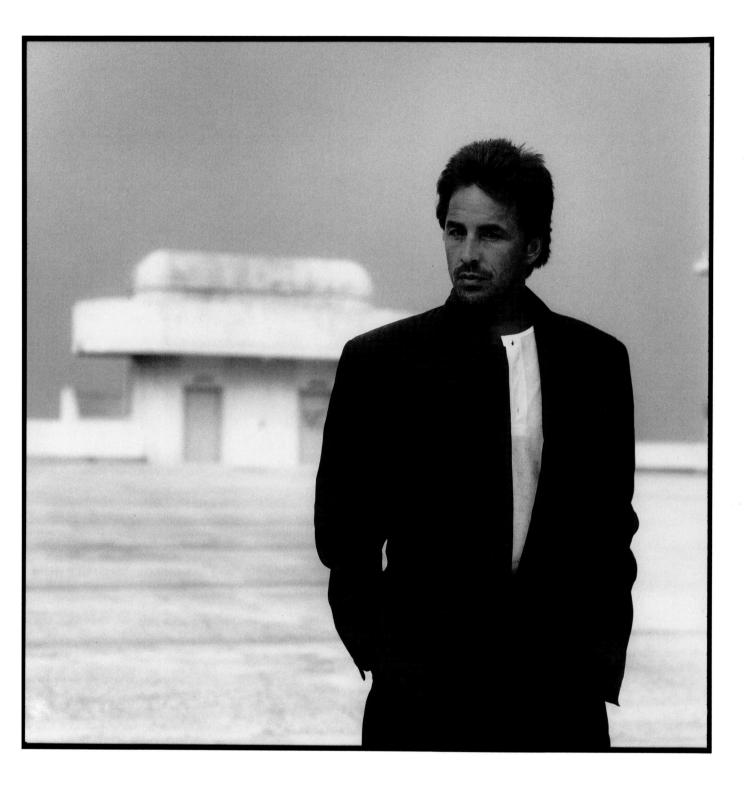

ABOVE: **MARY ELLEN MARK**
Don Johnson *1986*

OPPOSITE: **FRANK LINDNER**
Dylan McDermott *1990*

PAGE 96: **SUSAN JOHANN**
Barbara Sukowa *1992*

PAGE 97: **MARK HANAUER**
Danny Glover *1991*

95

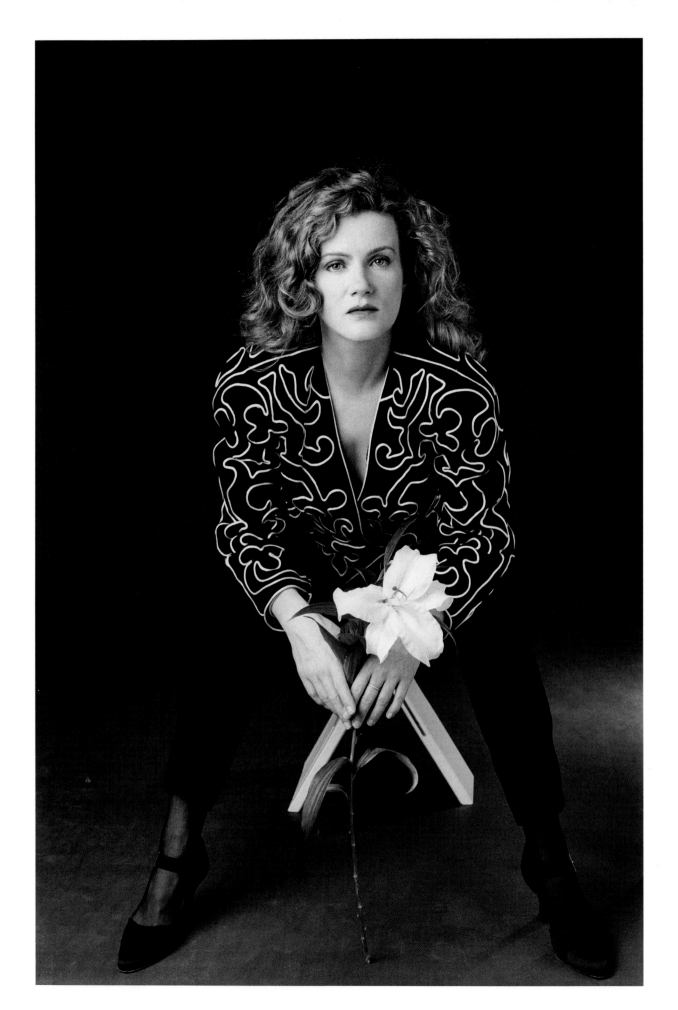

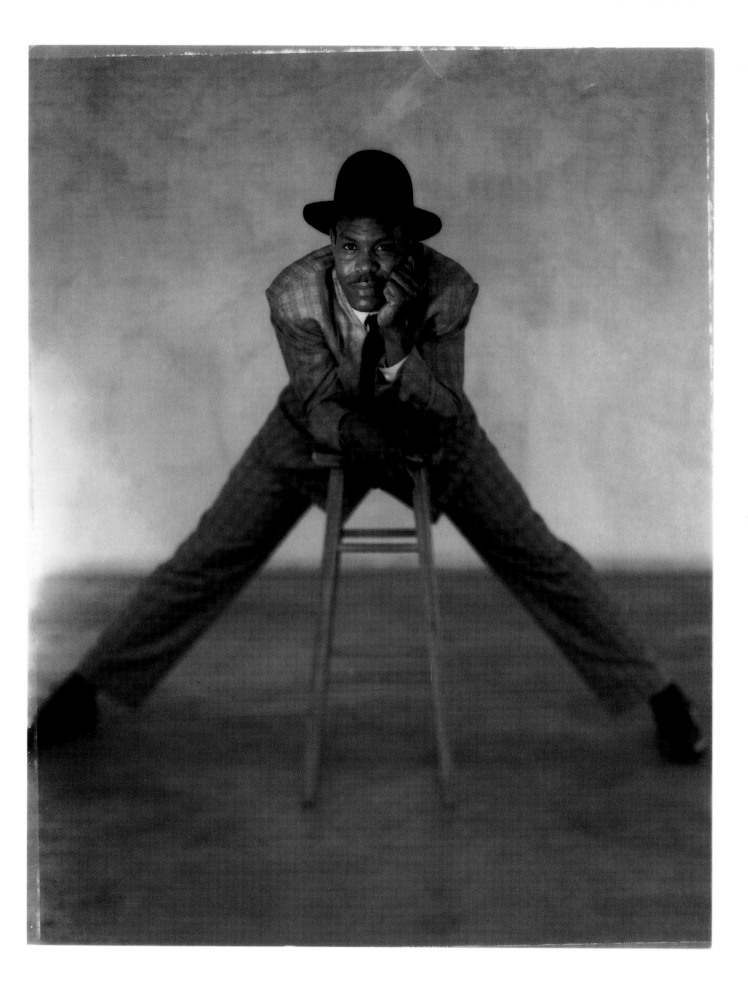

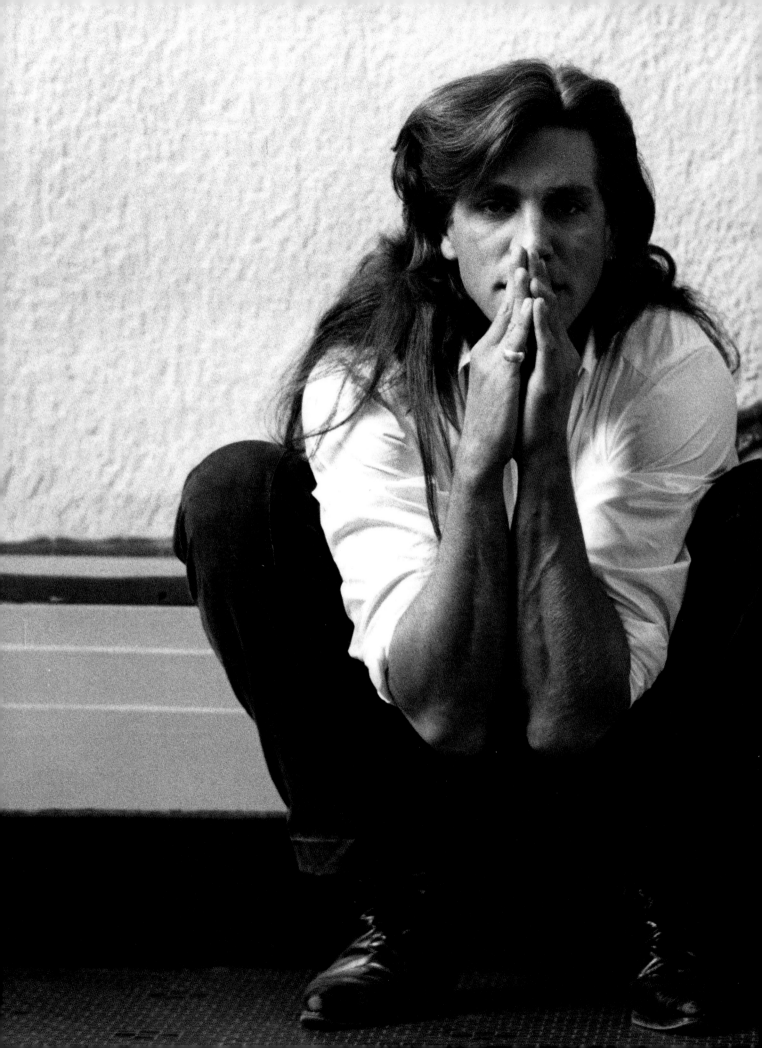

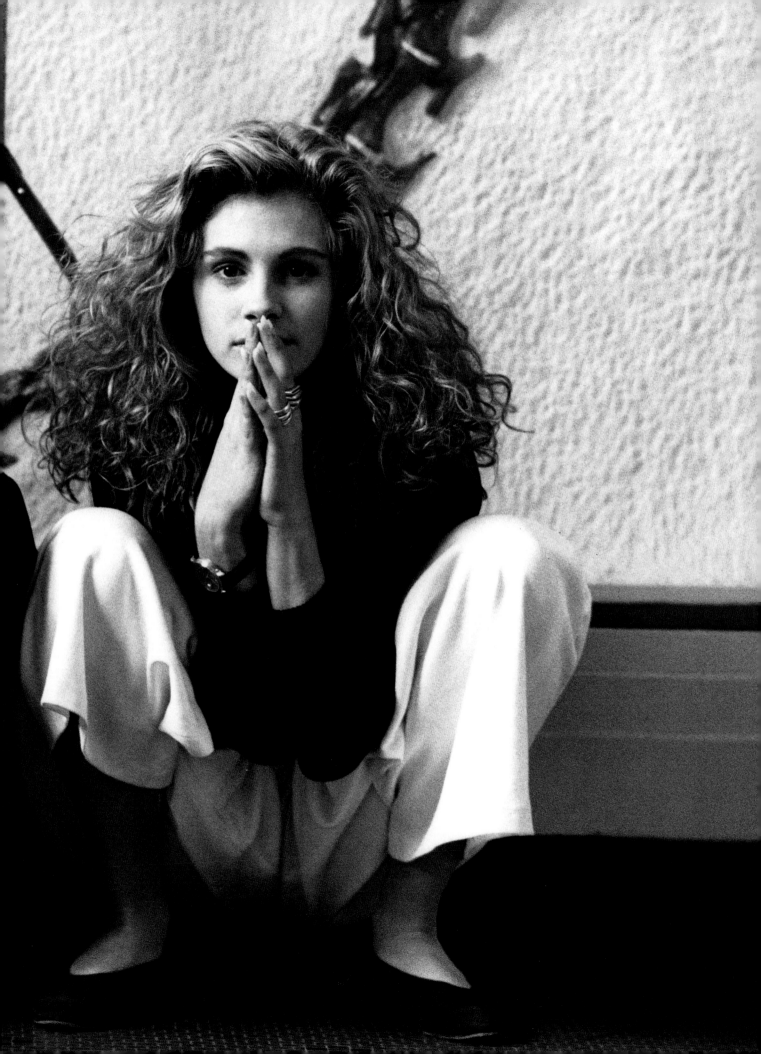

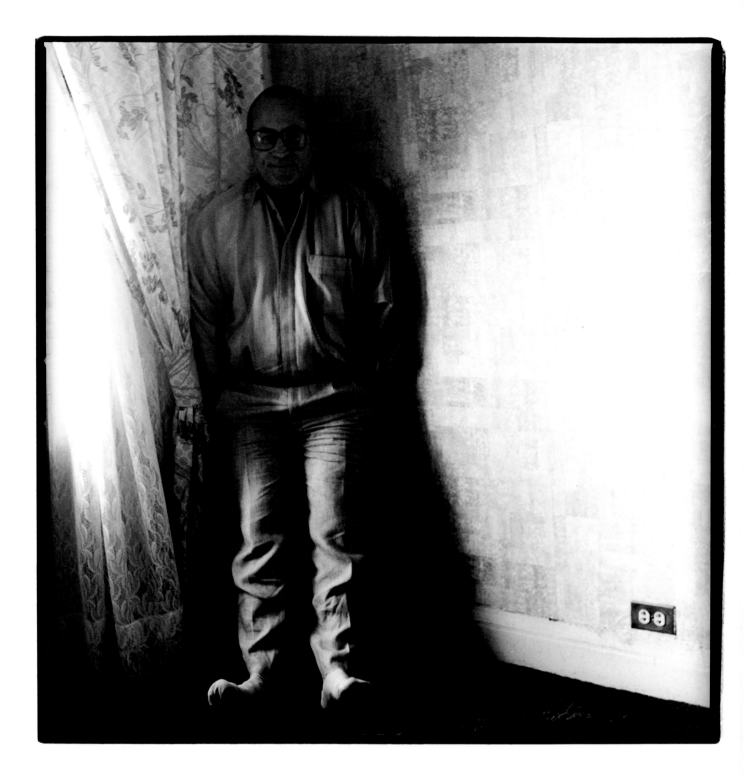

SYLVIA PLACHY
Bob Hoskins *1986*

OPPOSITE: JEFFREY THURNHER
Luke Perry *1991*

PRECEDING PAGES: BOB FRAME
Eric & Julia Roberts *1988*

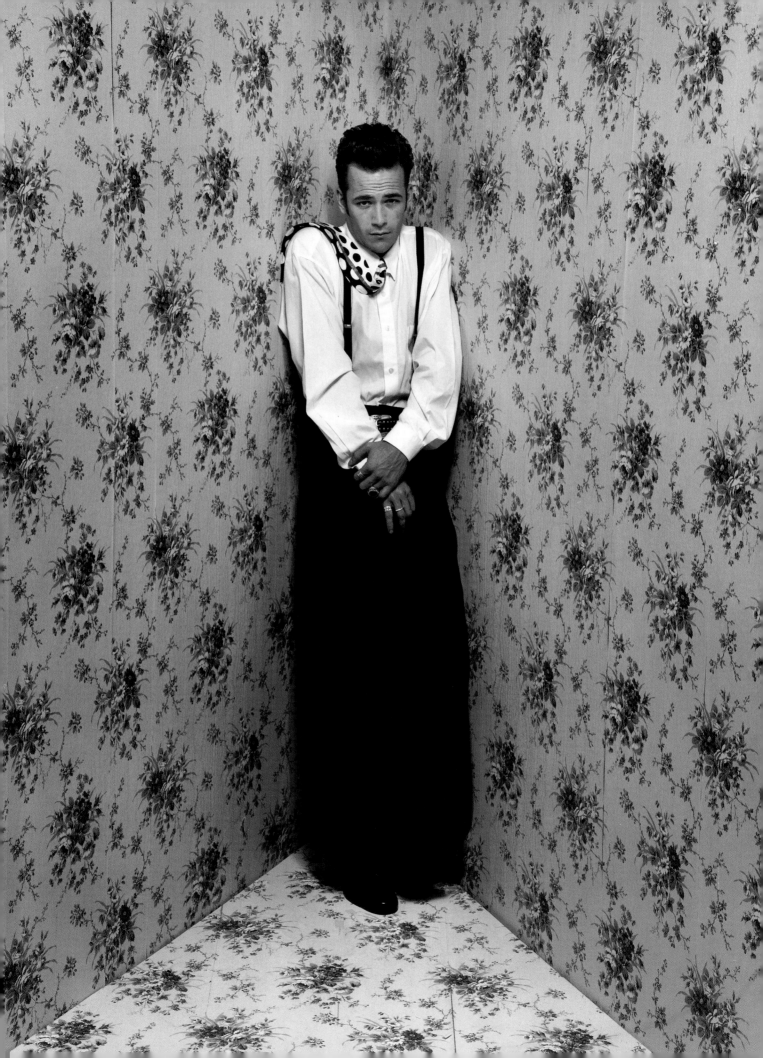

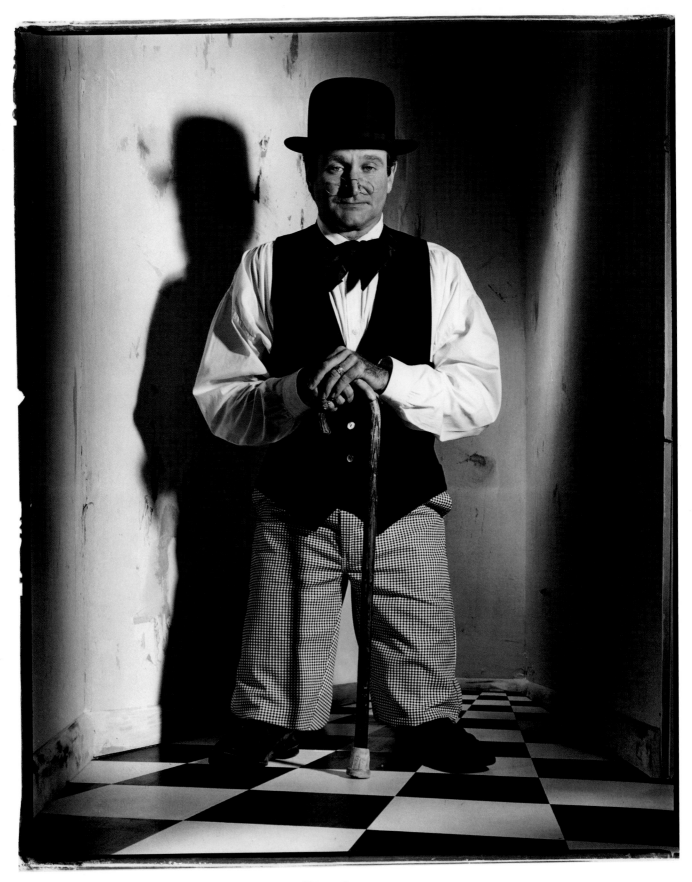

MARK SELIGER
Robin Williams *1991*

OPPOSITE: **MARCUS LEATHERDALE**
Kiefer Sutherland *1988*

102

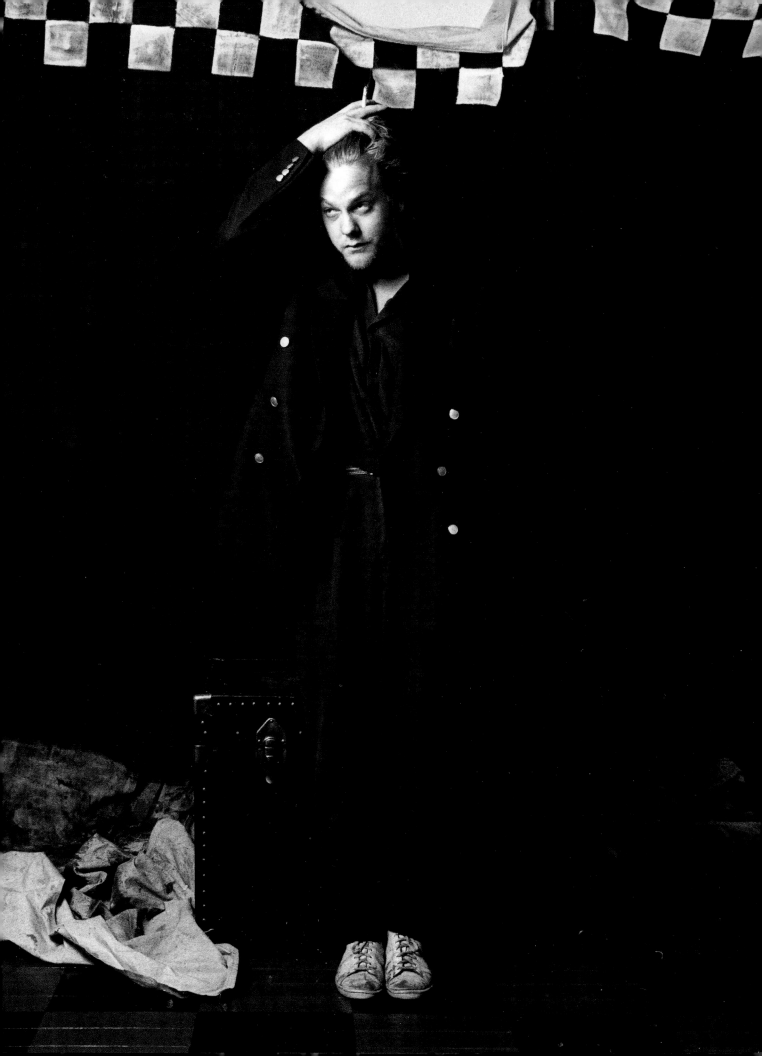

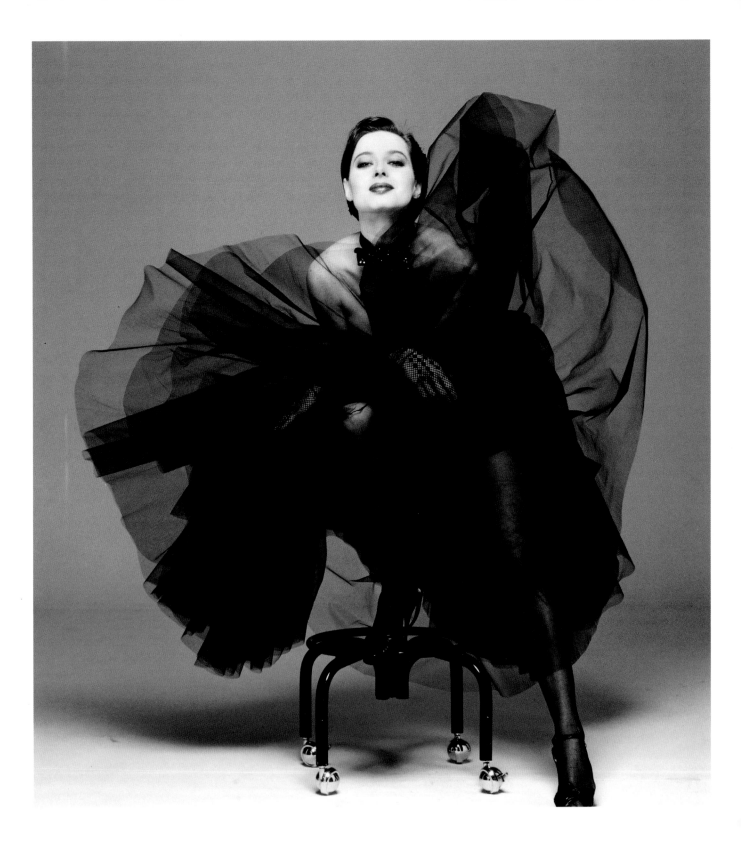

BILL KING
Isabella Rossellini *1983*

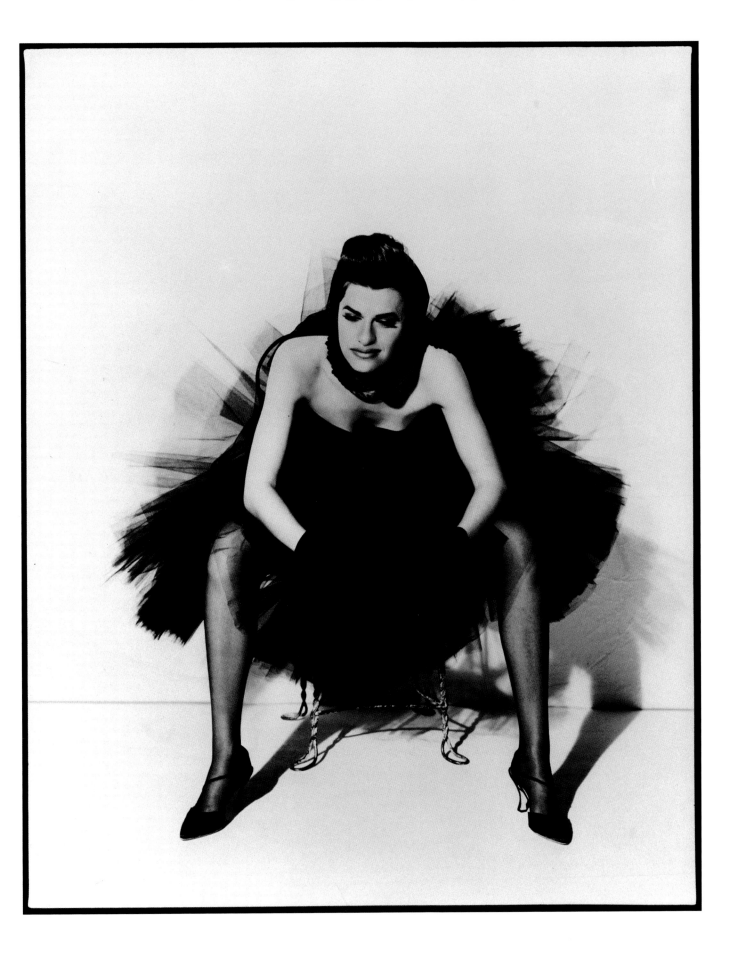

STEVEN KLEIN
Sandra Bernhard *1991*

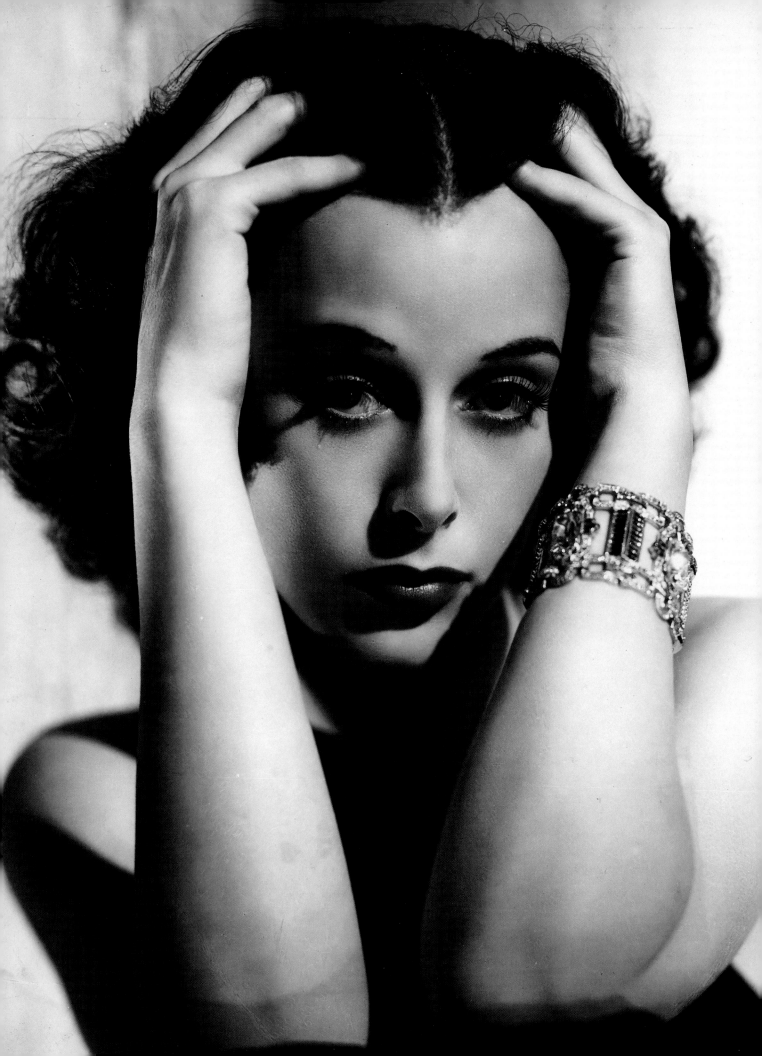

ACTING HEADS

ROBERT COBURN
Hedy Lamarr *1939*

In portrait photography, the eyes should be unforgettable, the mouth, divine. Hedy Lamarr's intense eyes and Gary Cooper's—as blue as a clear day in heaven—could burn celluloid. Barbara Stanwyck had sensitive eyes, but she also had those lips: beautiful, firm, determined—sublime.

Today, Glenn Close carries the strength of Venus on her face, all because of the shimmer of her eyes and the contour of her mouth. Patrick Swayze, for all of his beefcake bravado, has beautiful, sensuous eyes. Wise is the star who can use his or her face to hide, yet reveal.

GEORGE HOLZ
Glenn Close *1989*

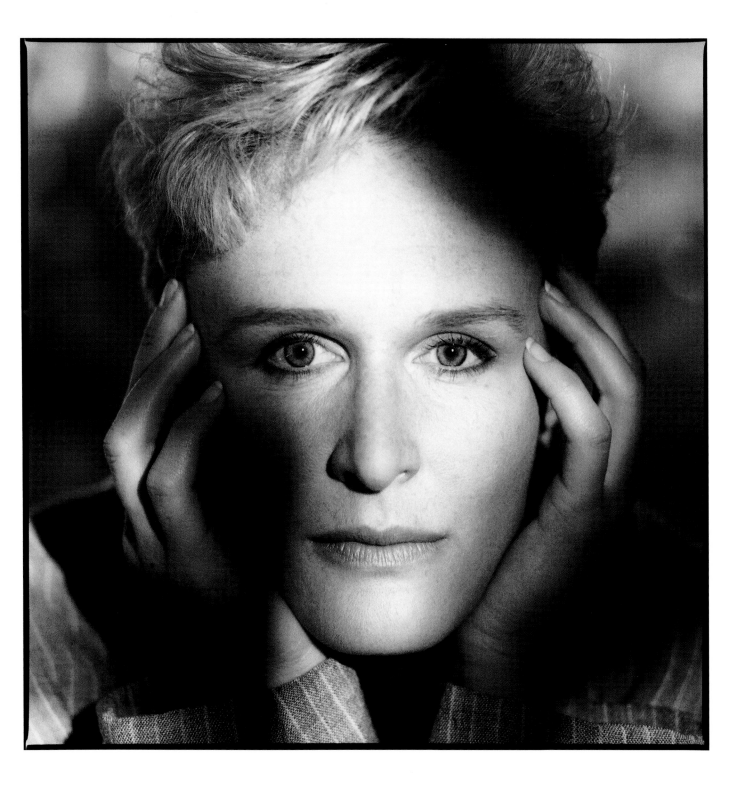

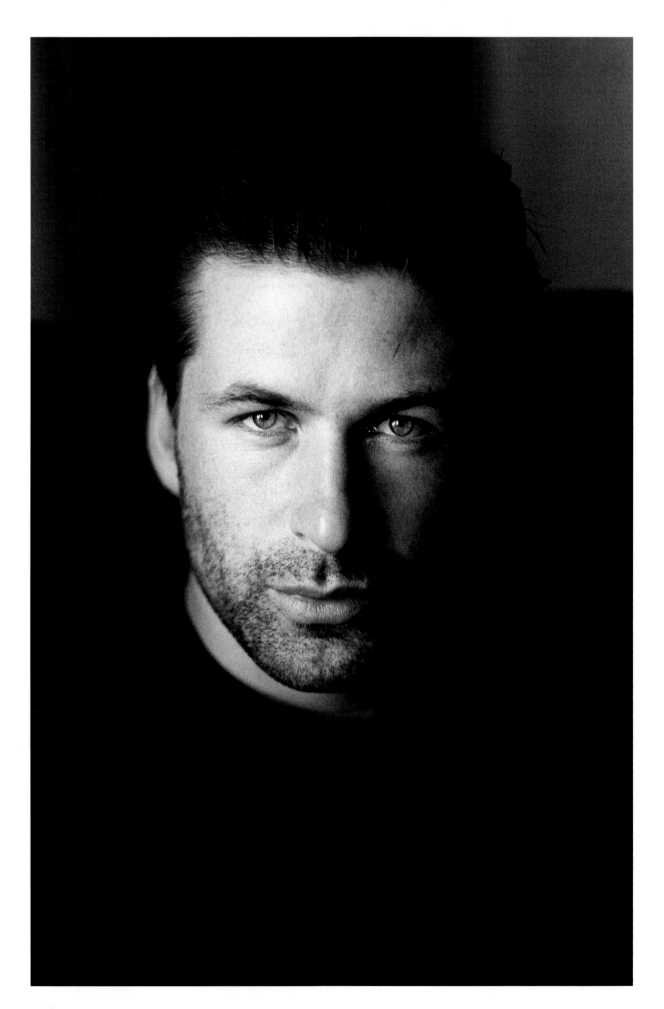

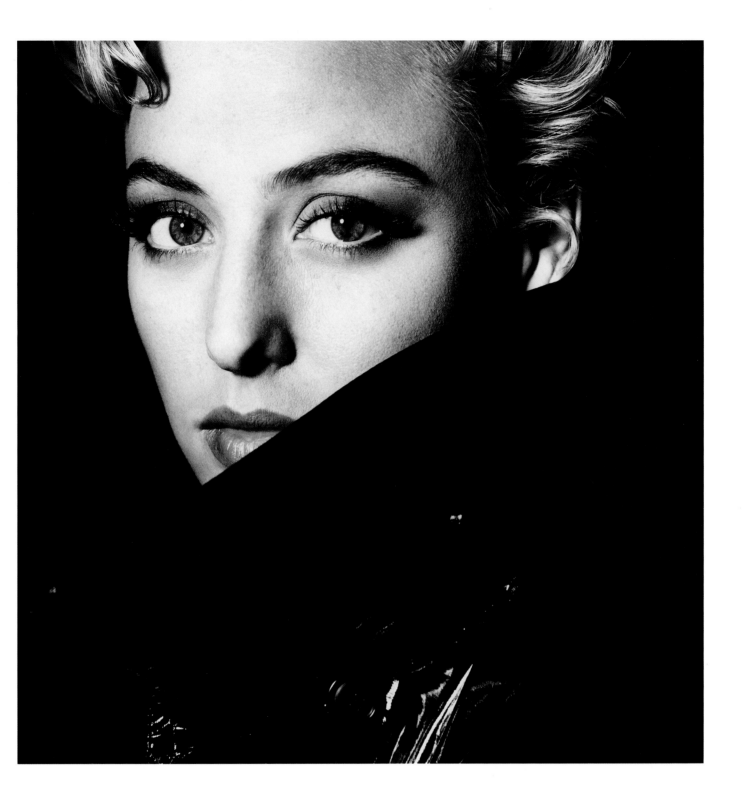

PATRIK ANDERSSON
Virginia Madsen *1991*

OPPOSITE: **ANDREW BRUCKER**
Alec Baldwin *1990*

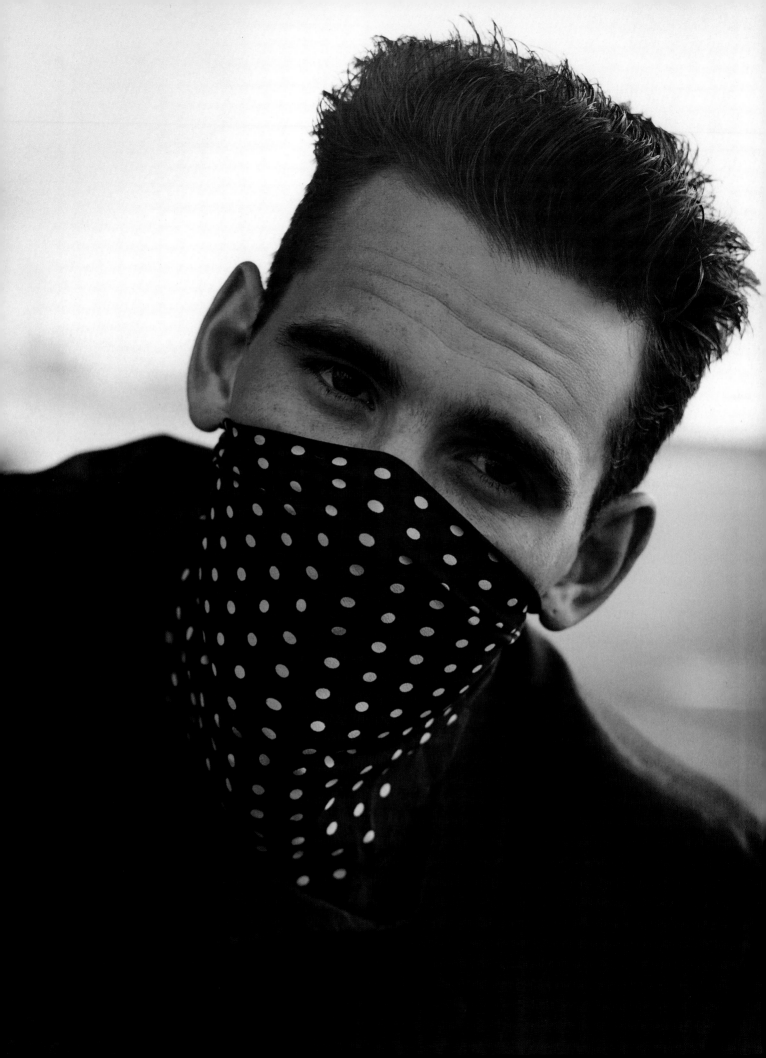

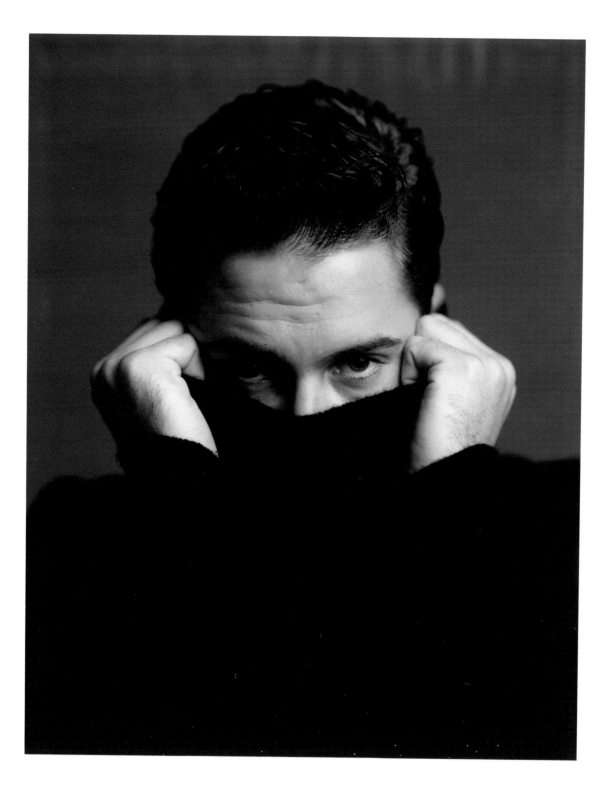

TIMOTHY GREENFIELD-SANDERS
Rob Lowe *1989*

OPPOSITE: BOB FRAME
Matt Dillon *1989*

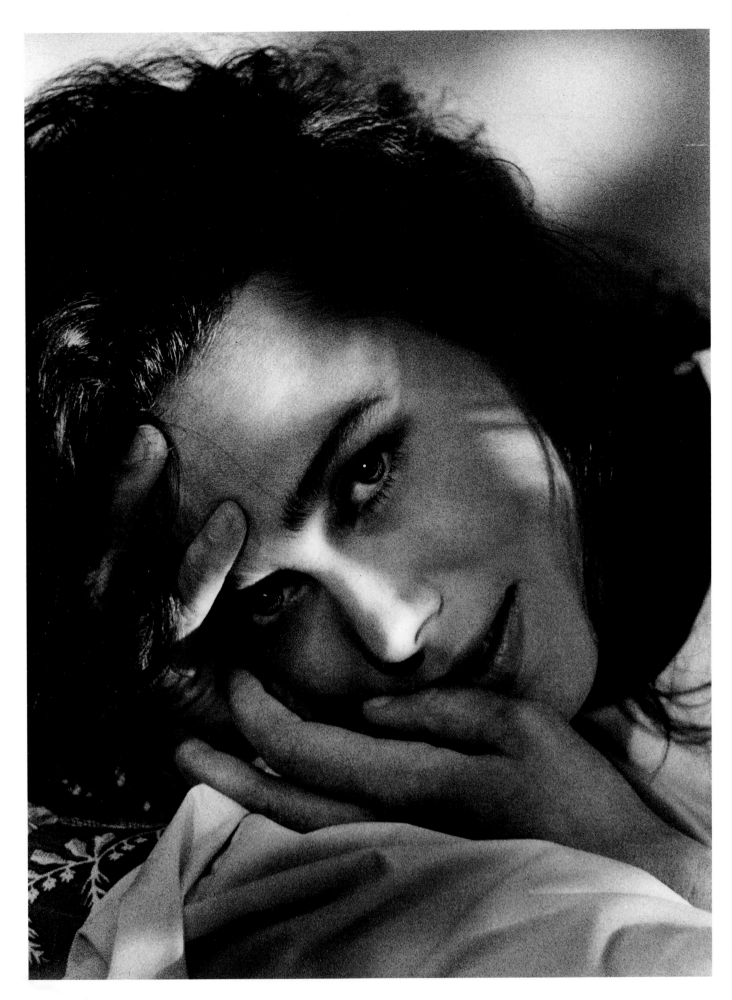

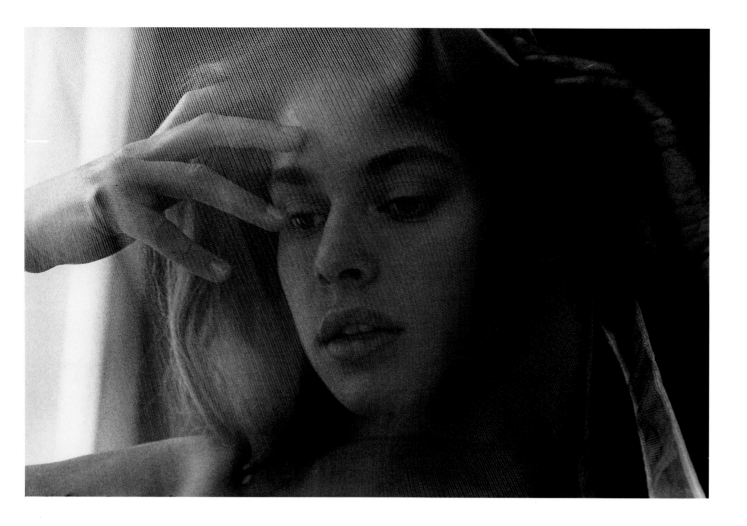

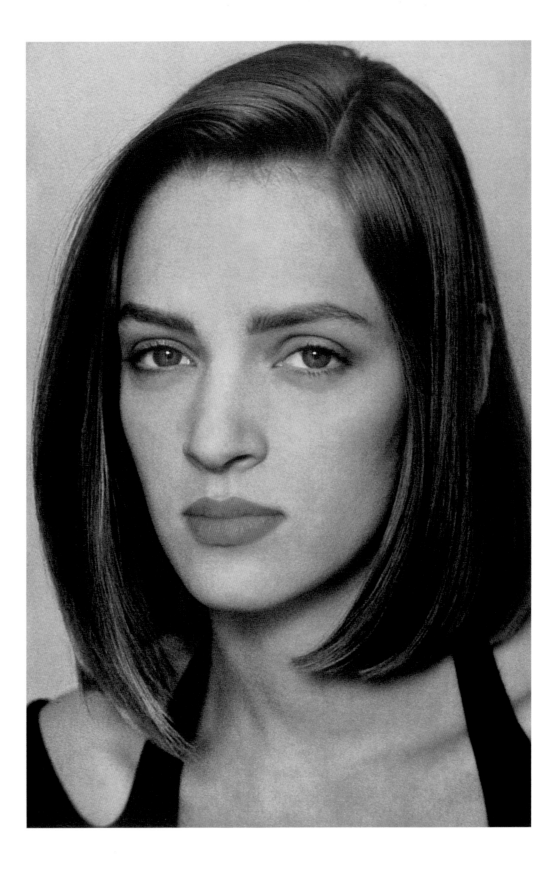

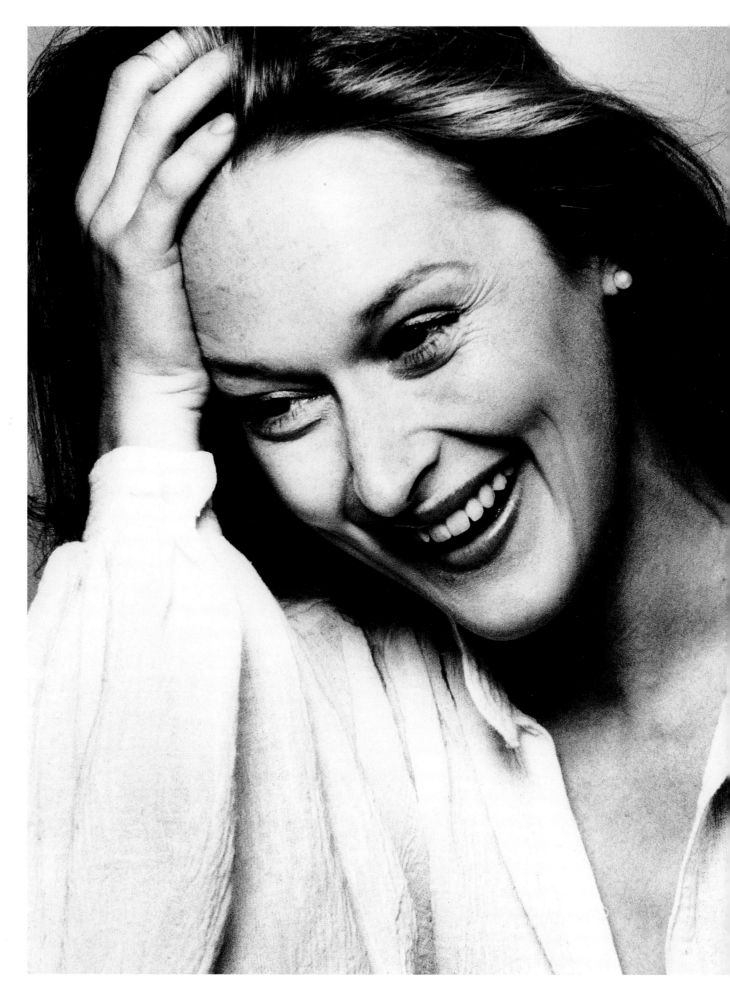

119

ANTONIN KRATOCHVIL
Nick Nolte *1991*

120

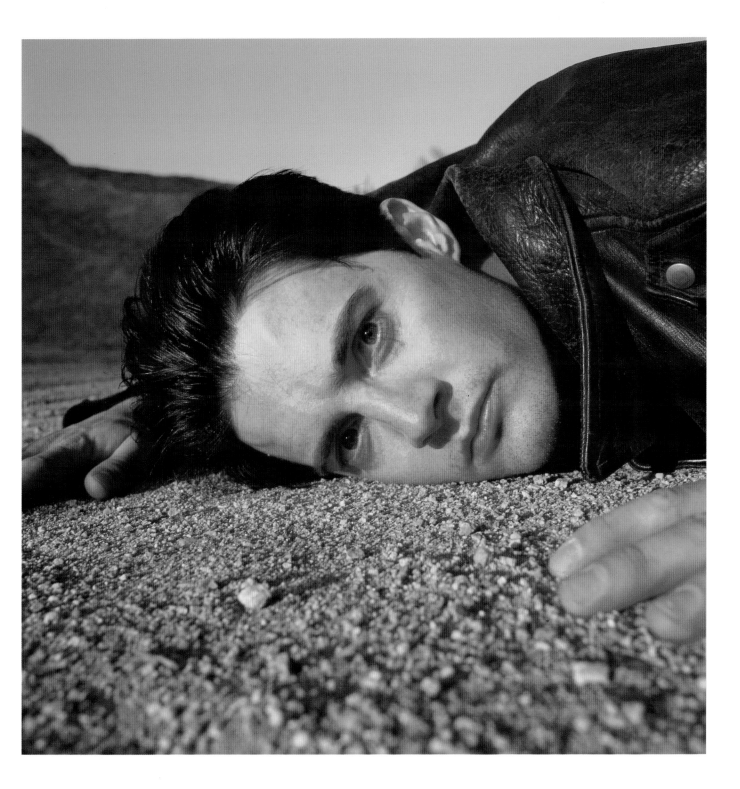

FRANK W. OCKENFELS 3
Kyle MacLachlan *1989*

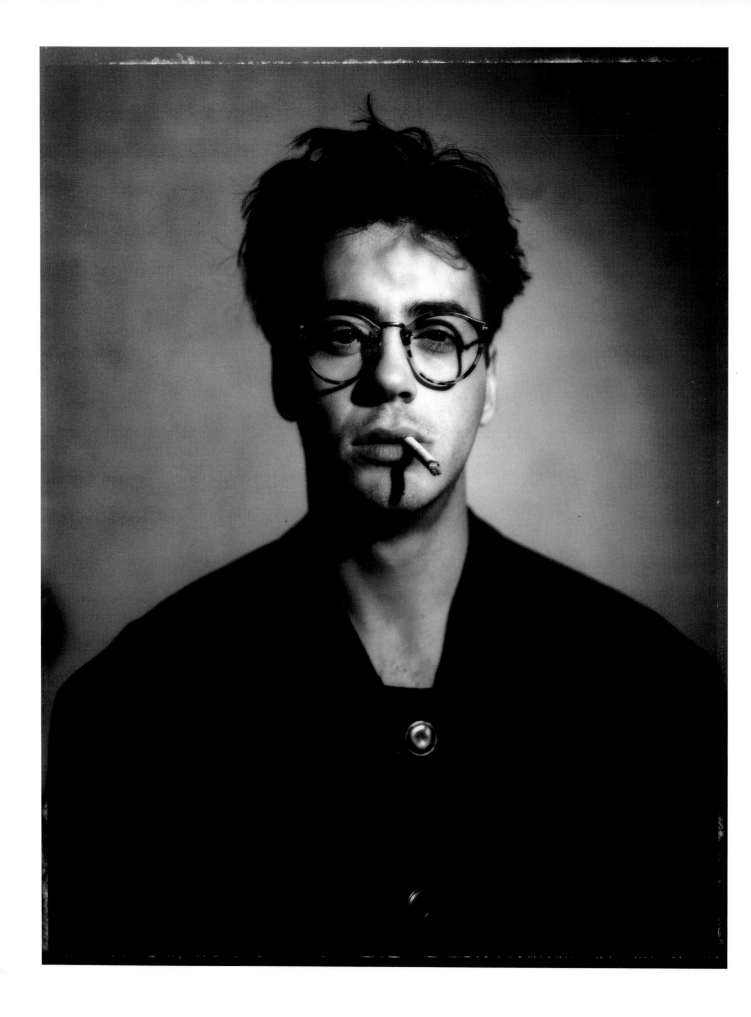

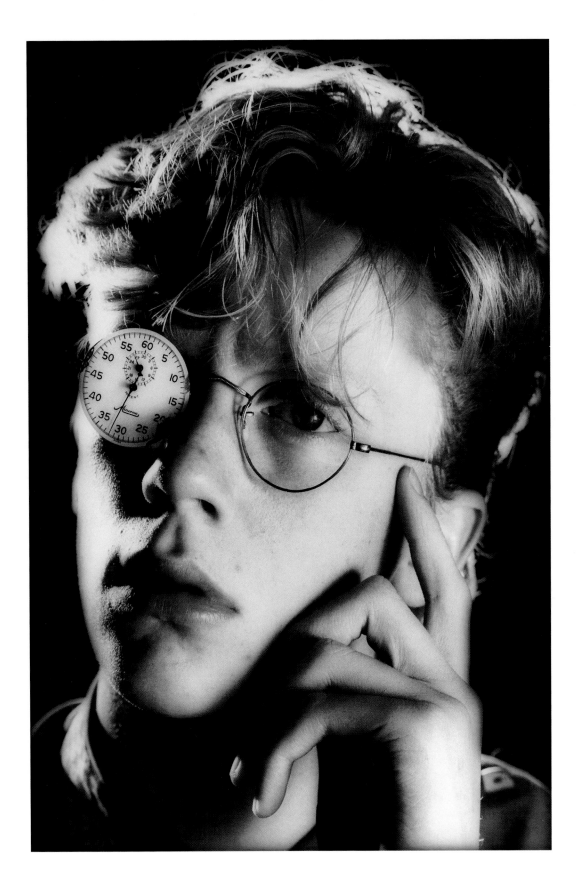

ROCKY SCHENCK
Anthony Michael Hall *1990*

OPPOSITE: MARK HANAUER
Robert Downey, Jr. *1988*

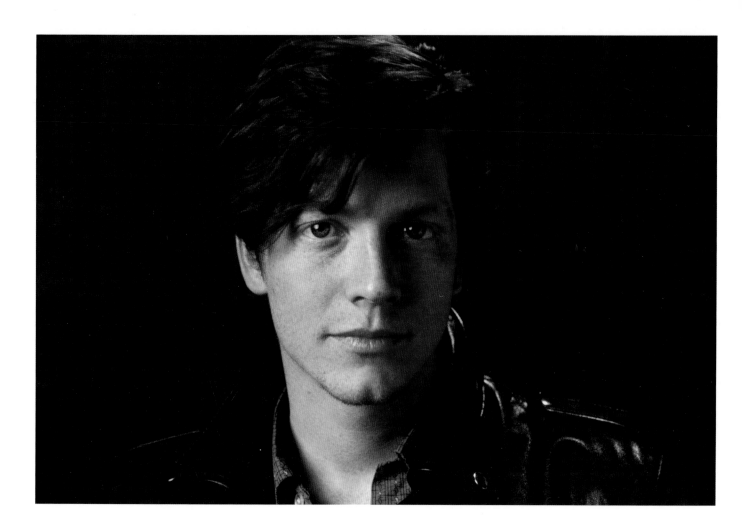

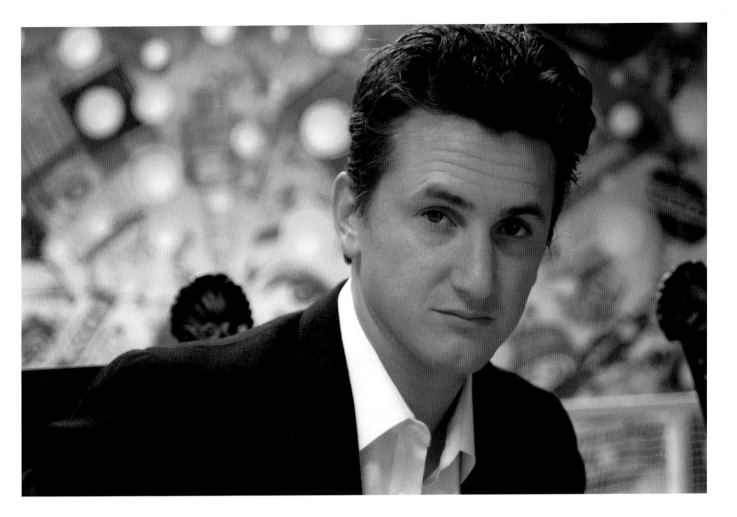

DENNIS HOPPER
Sean Penn *1991*

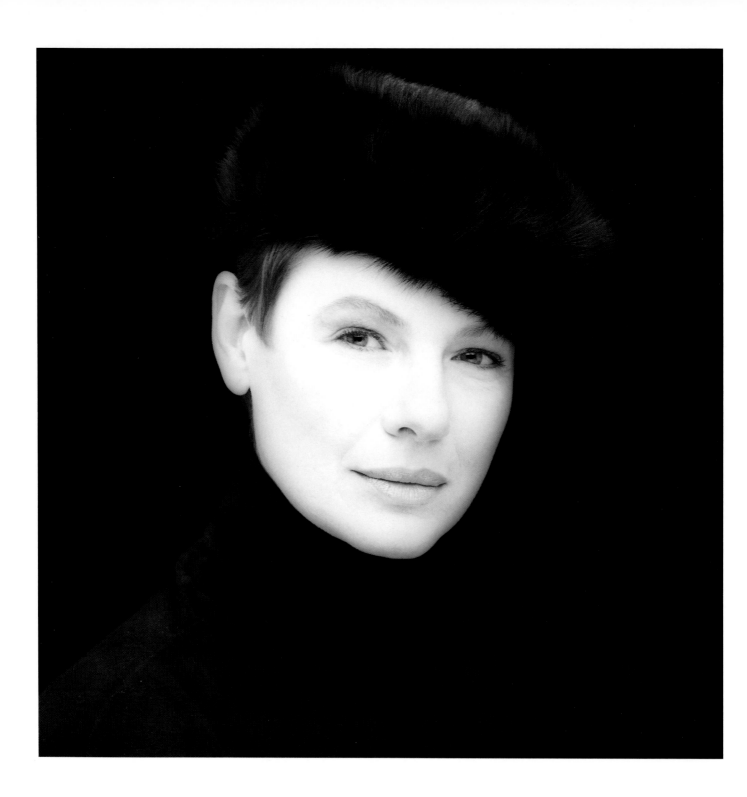

ROBERT MAPPLETHORPE
Dianne Wiest *1988*

OPPOSITE: ALBERT SANCHEZ
Joanne Whaley-Kilmer *1989*

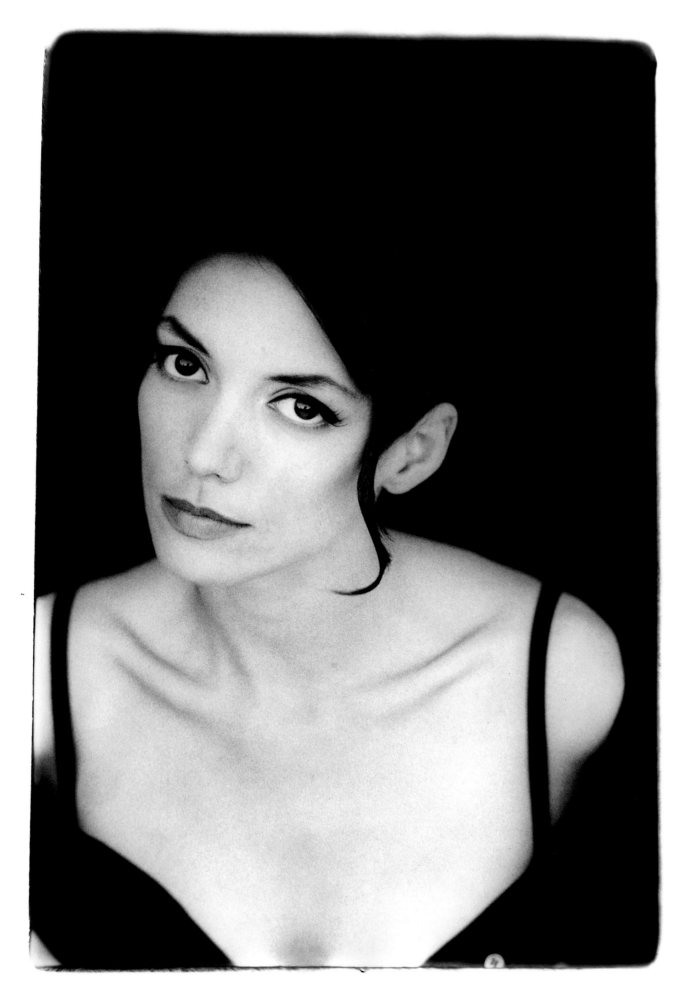

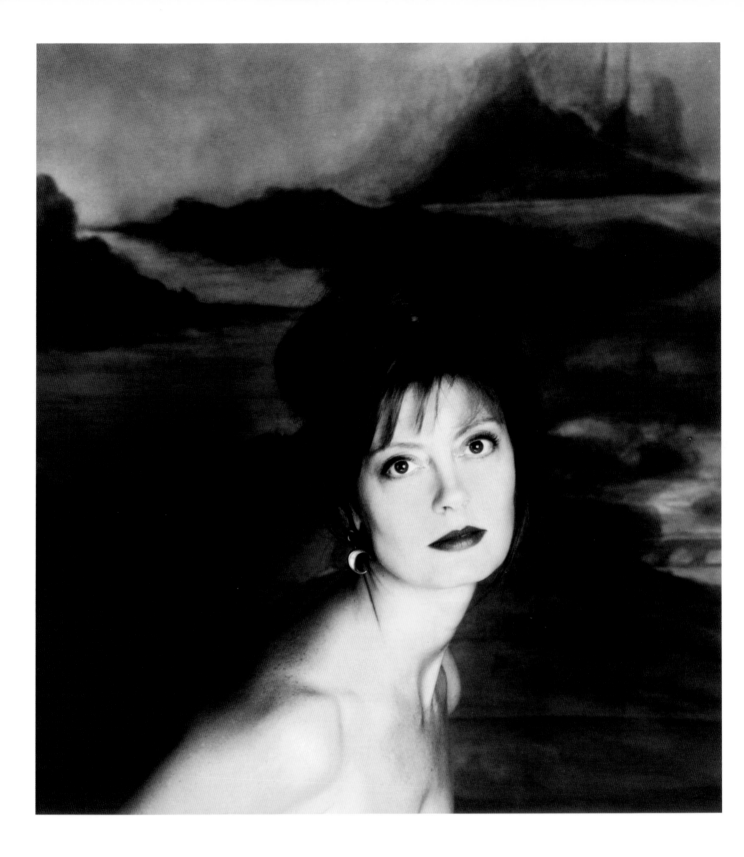

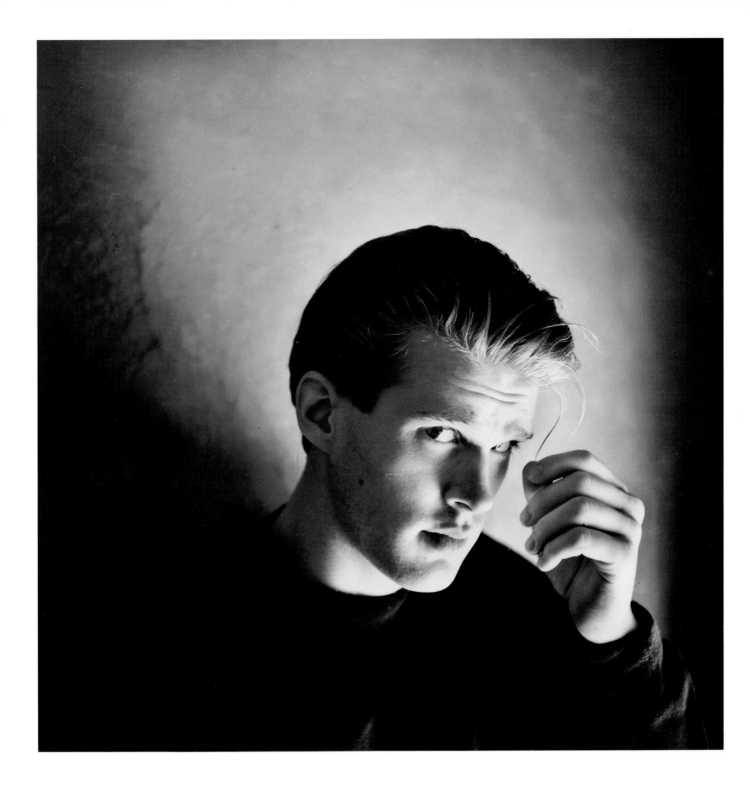

JOSEF ASTOR
Cary Elwes *1987*

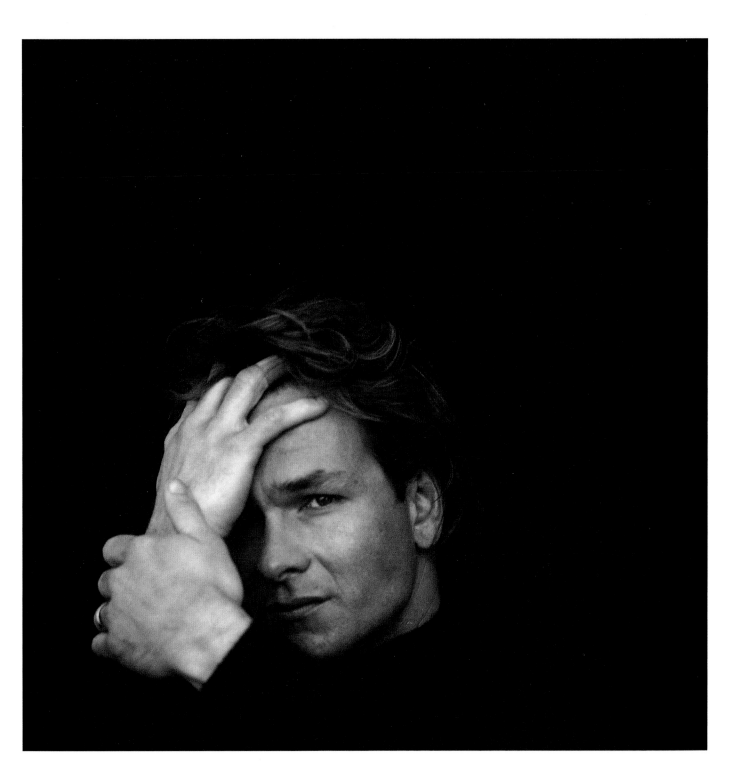

LARA ROSSIGNOL
Patrick Swayze *1990*

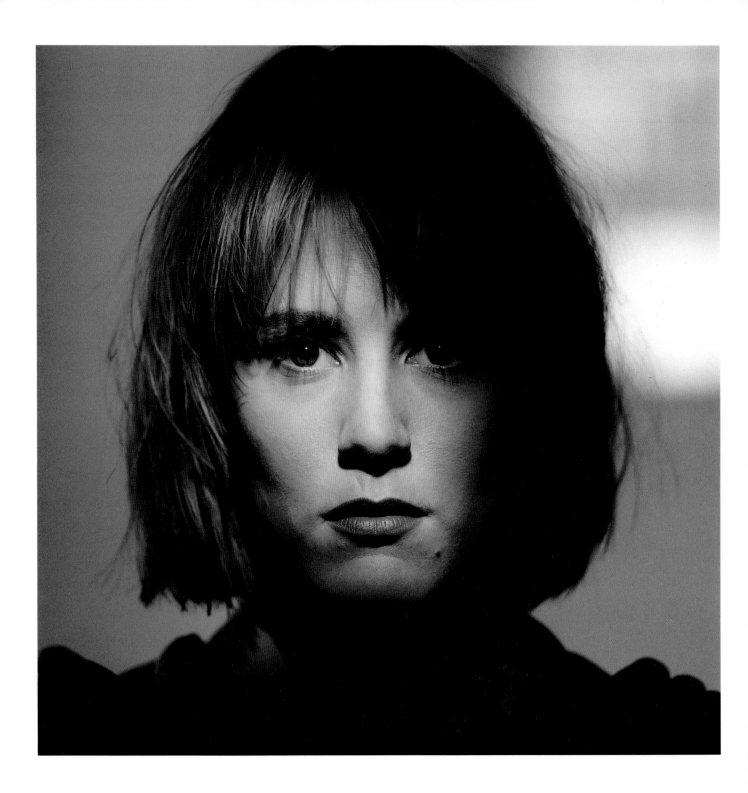

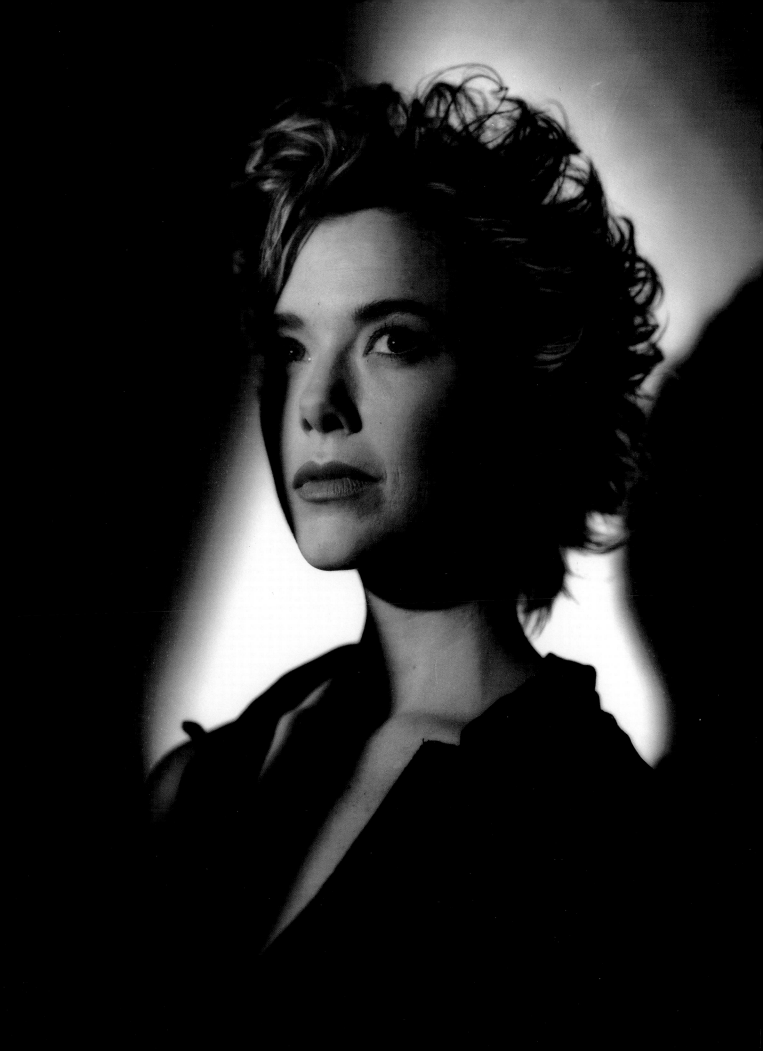

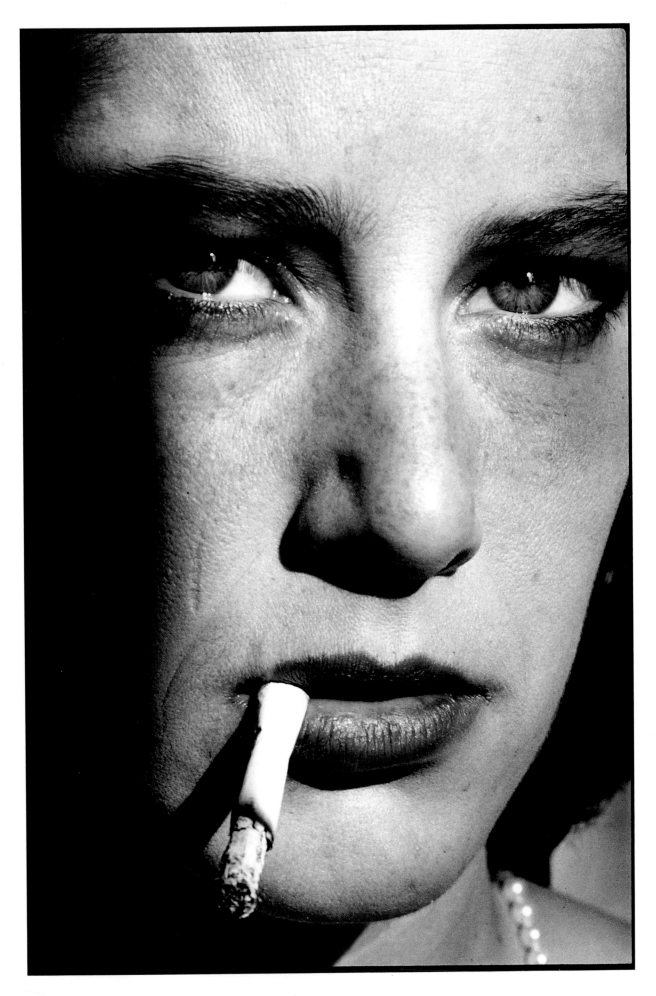

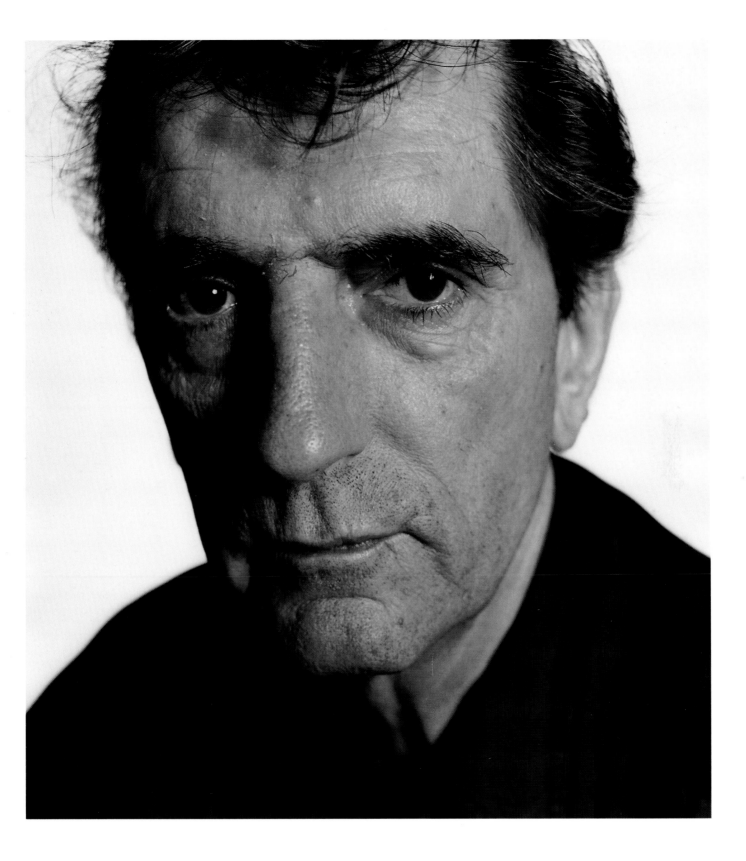

GREGORY HEISLER
Ed Harris *1990*

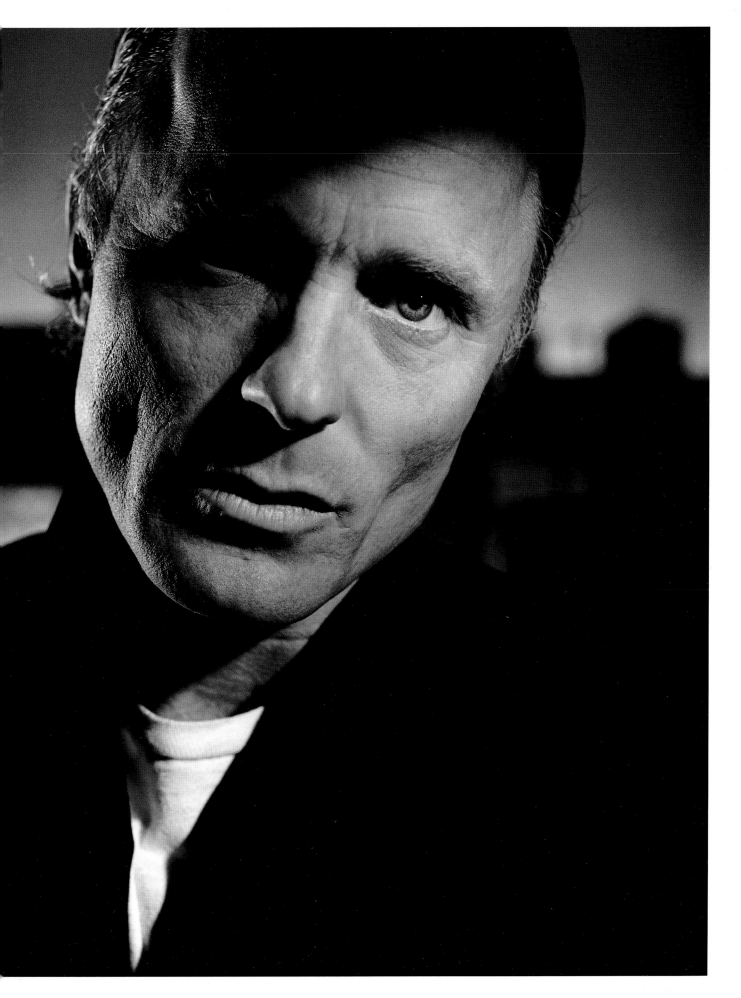

EDWARD MAXEY
Julian Sands *1989*

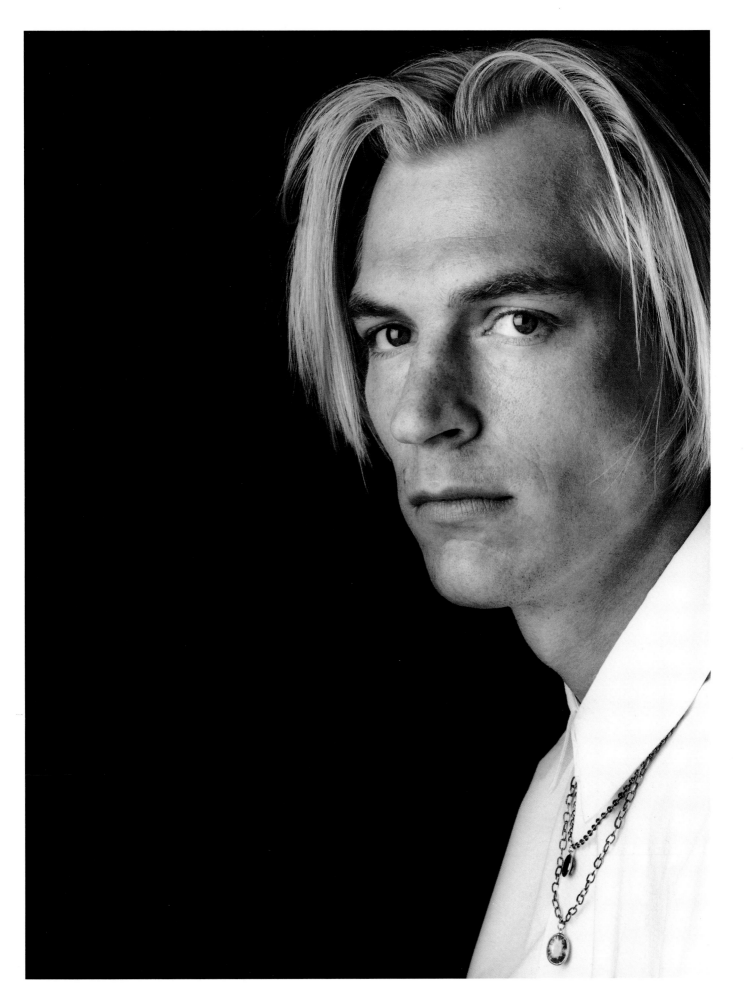

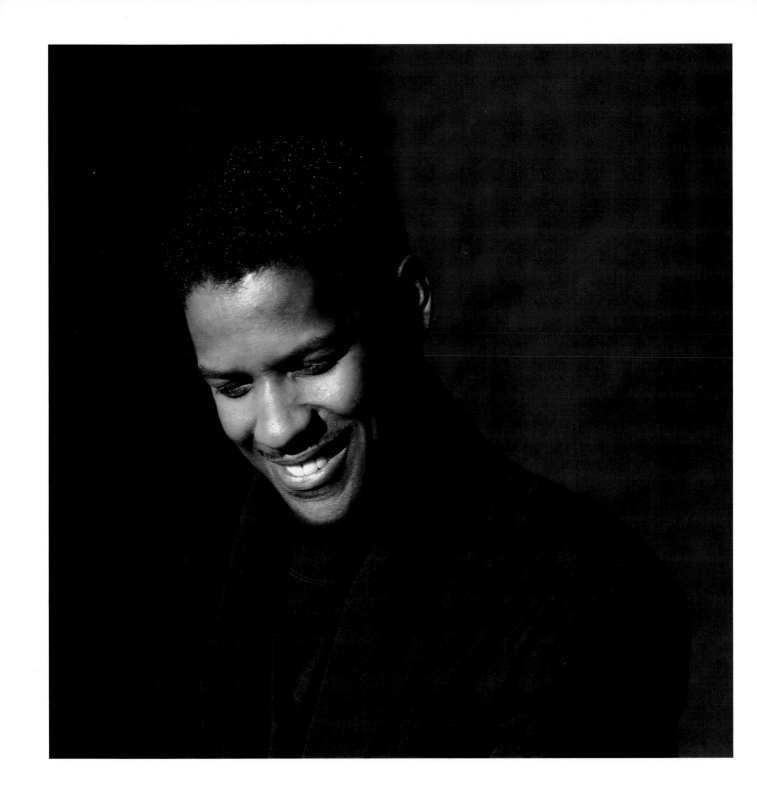

JEFFREY HENSON SCALES
Denzel Washington *1990*

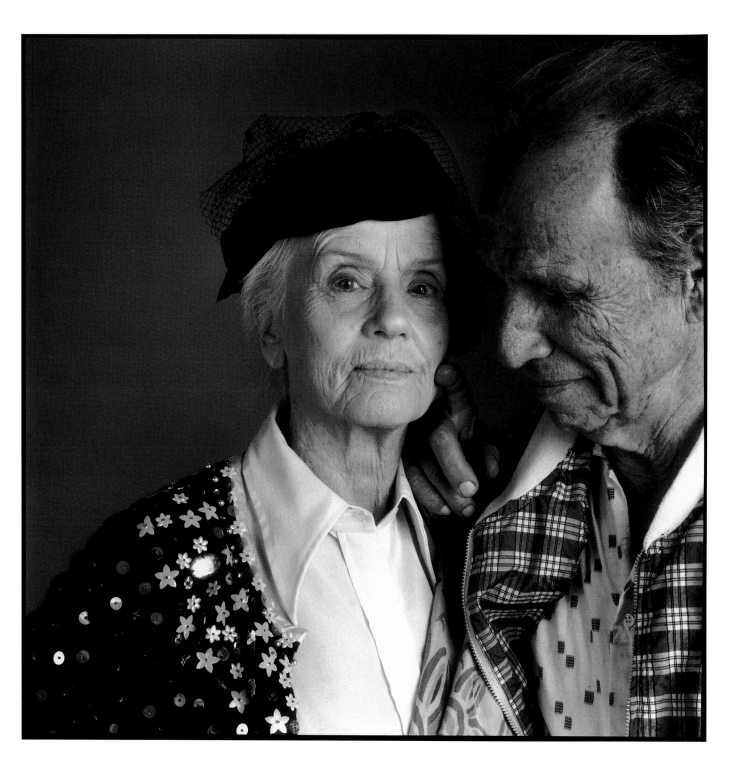

MARY ELLEN MARK
Jessica Tandy & Hume Cronyn *1986*

PAGE 142: LARA ROSSIGNOL
William Baldwin *1991*

PAGE 143: CHRIS BUCK
Raul Julia *1989*

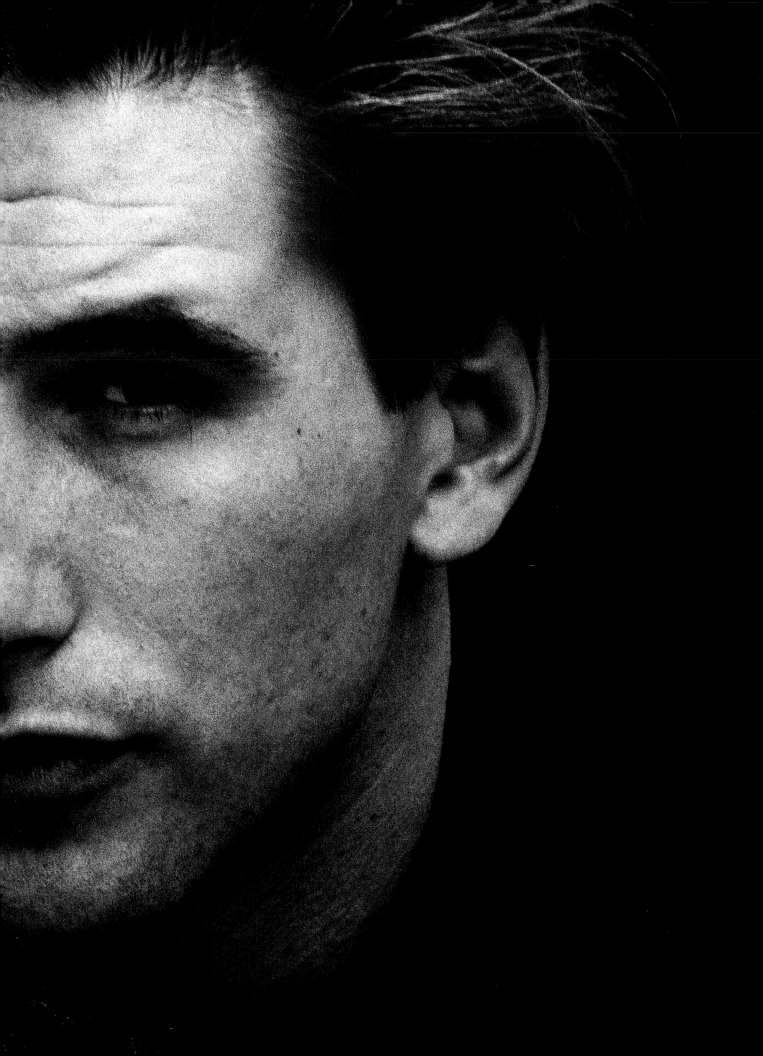

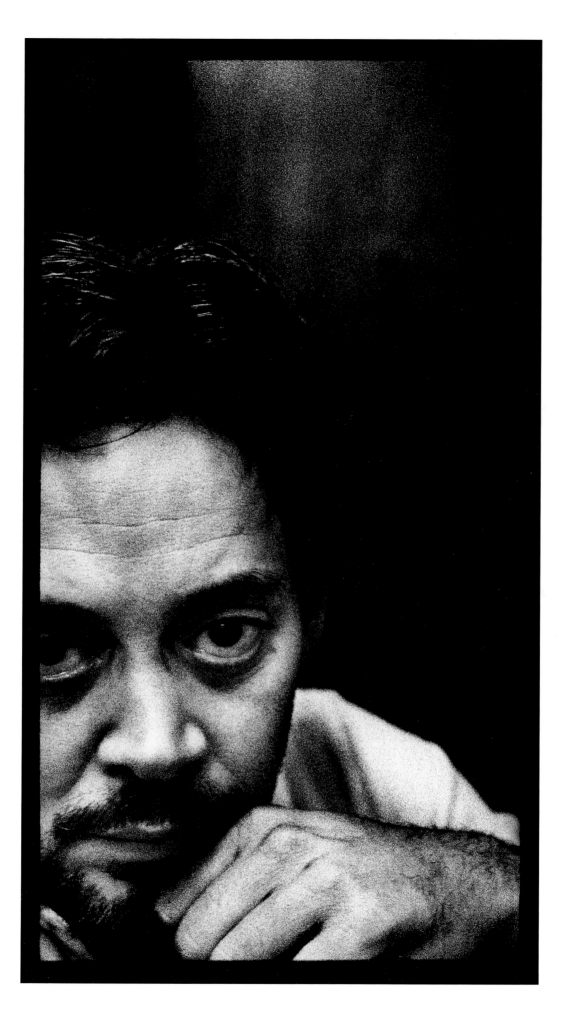

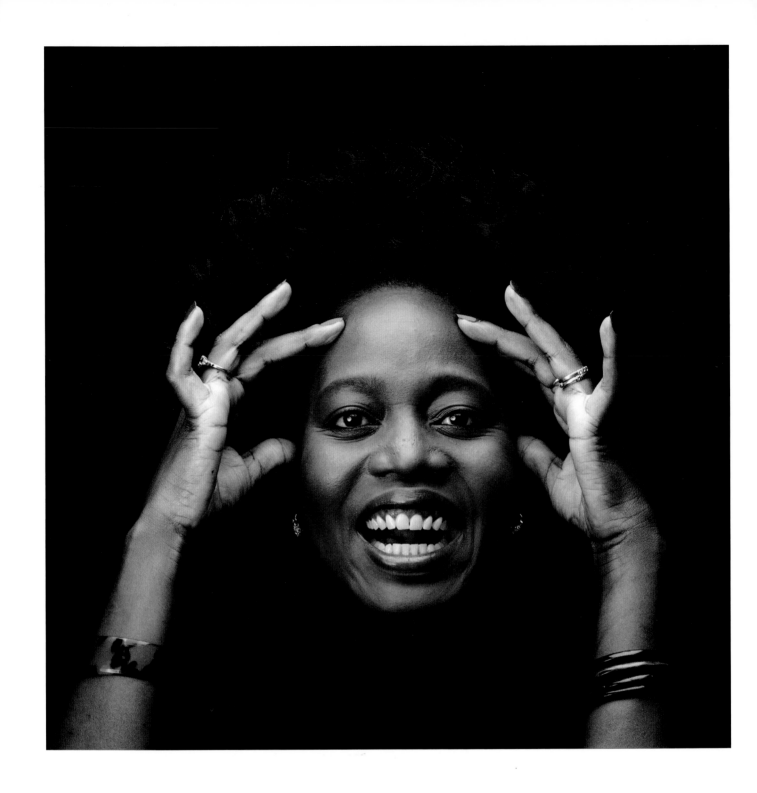

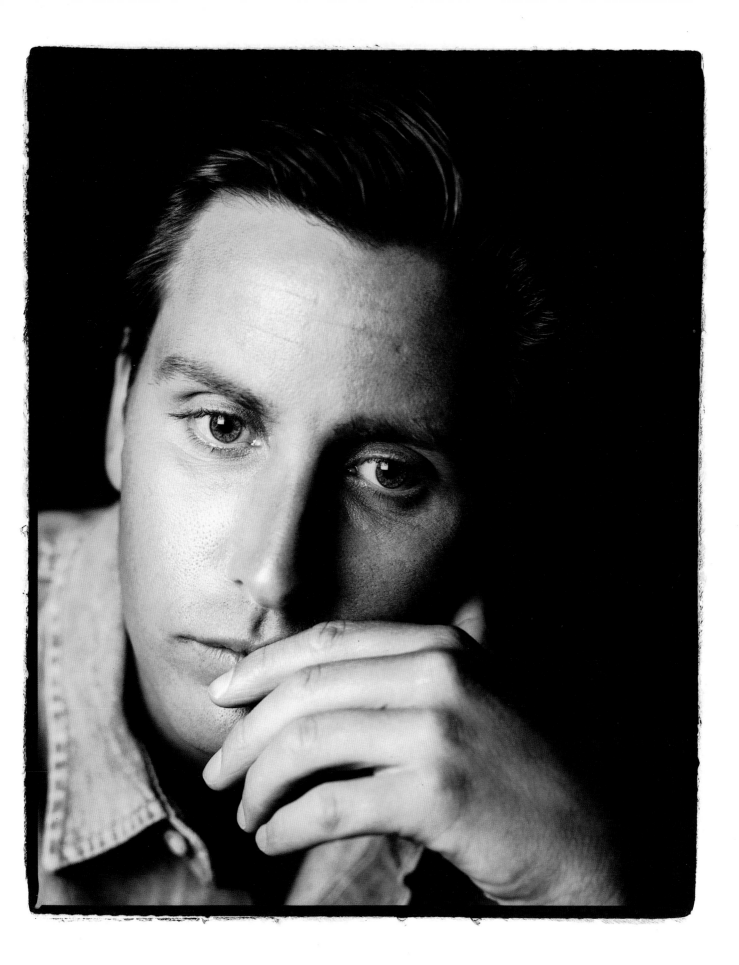

EIKA AOSHIMA
Emilio Estevez *1990*

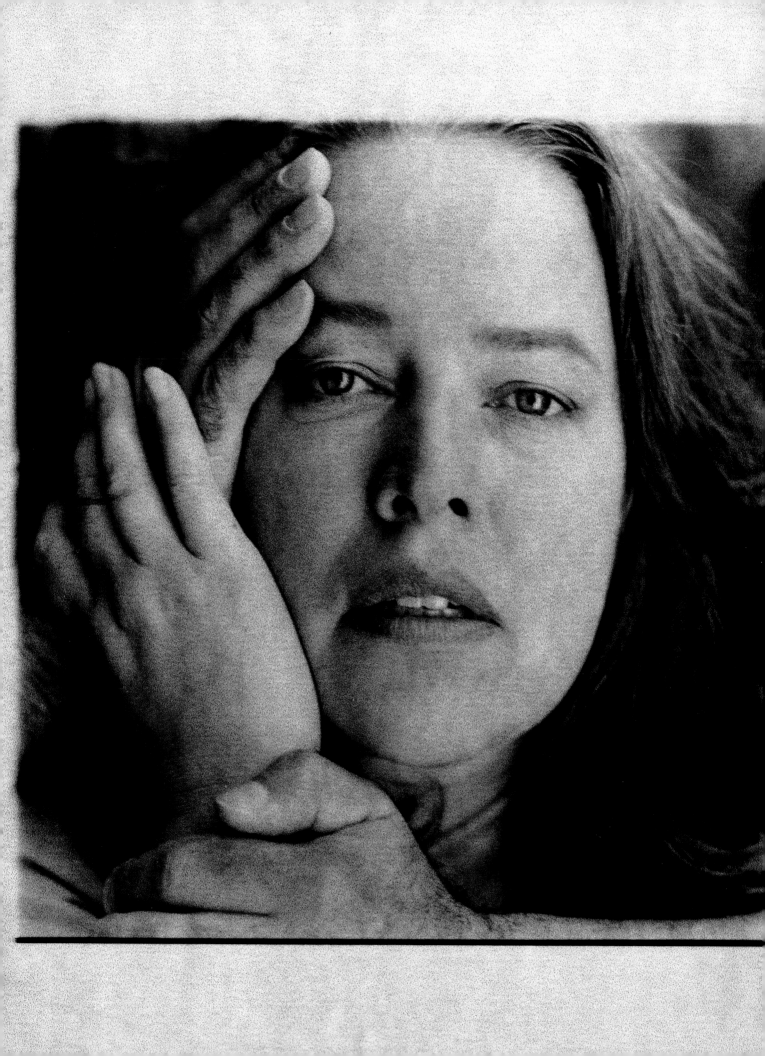

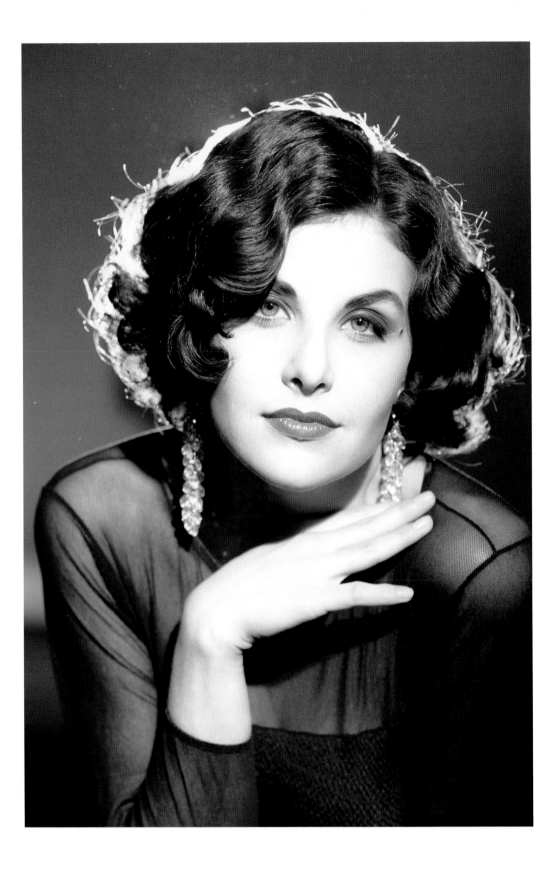

ALBERT SANCHEZ
Sherilyn Fenn *1990*

OPPOSITE: SHEILA METZNER
David Lynch *1988*

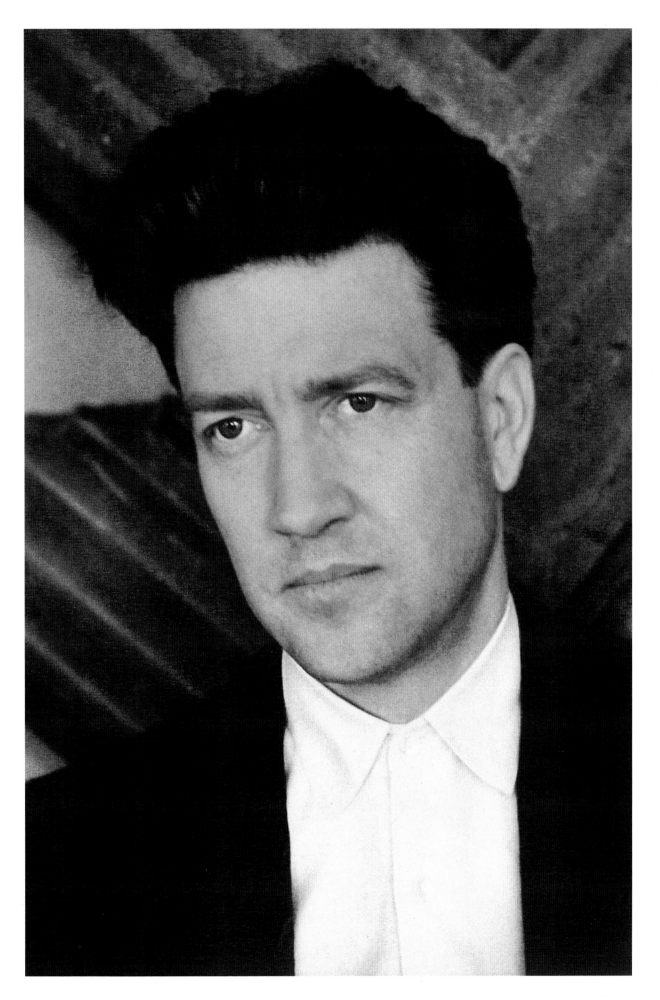

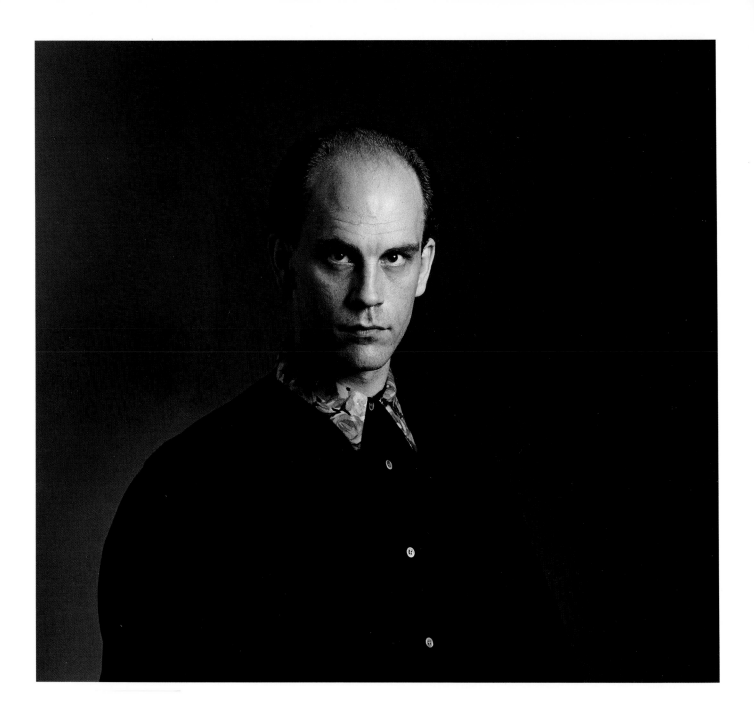

TIMOTHY GREENFIELD-SANDERS
John Malkovich *1988*

OPPOSITE: ALBERT SANCHEZ
Anthony Hopkins *1990*

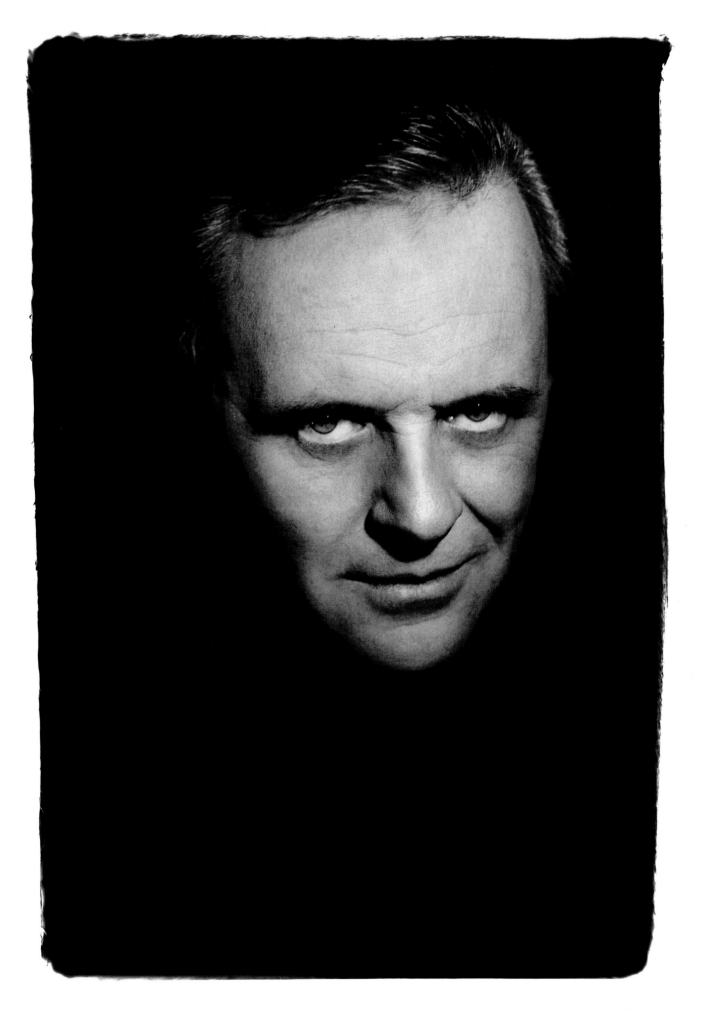

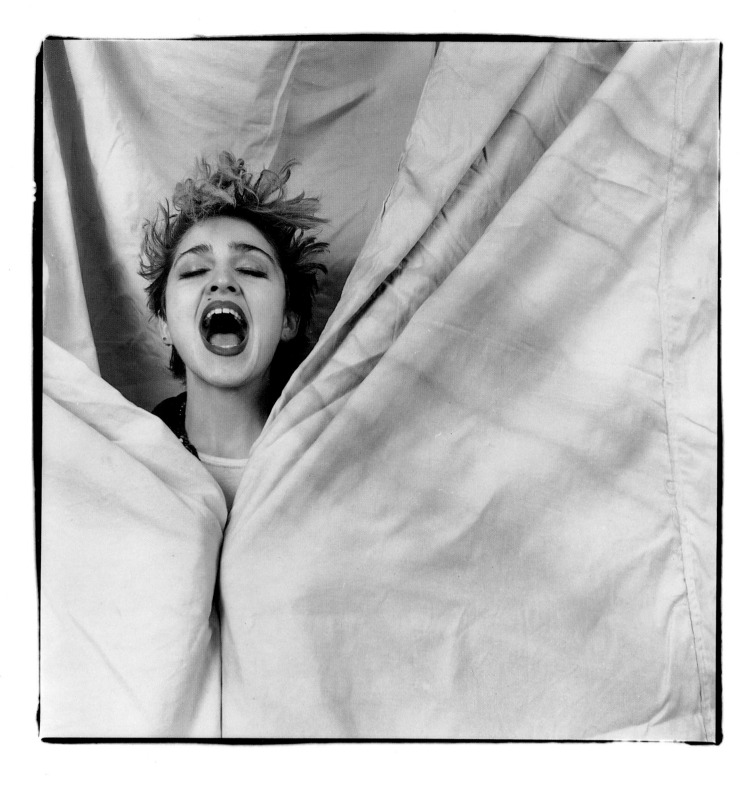

LAURA LEVINE
Madonna *1982*

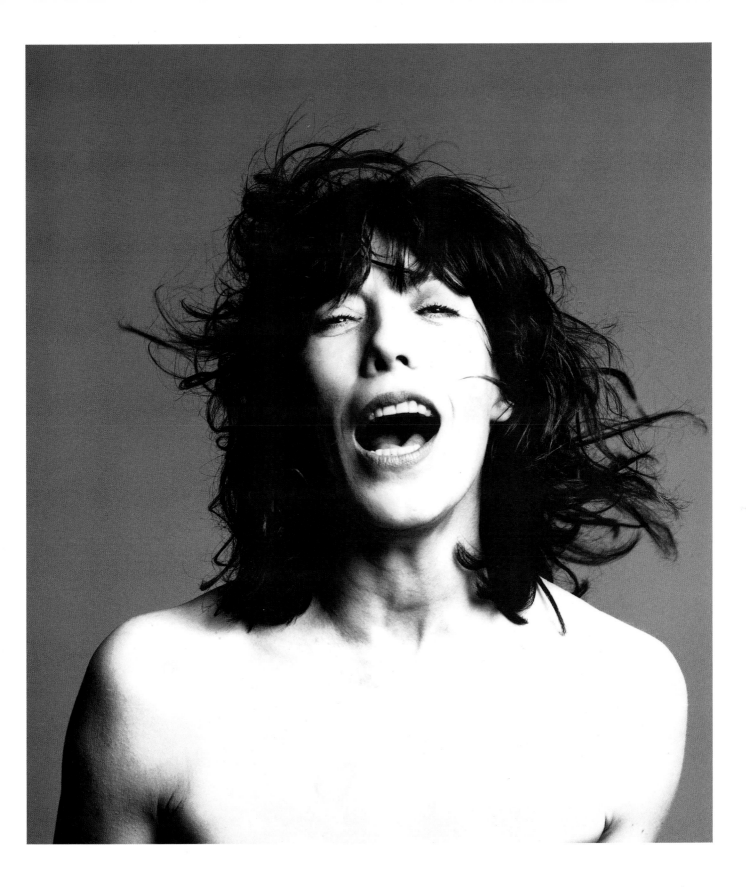

ALBERT SANCHEZ
Lily Tomlin *1991*

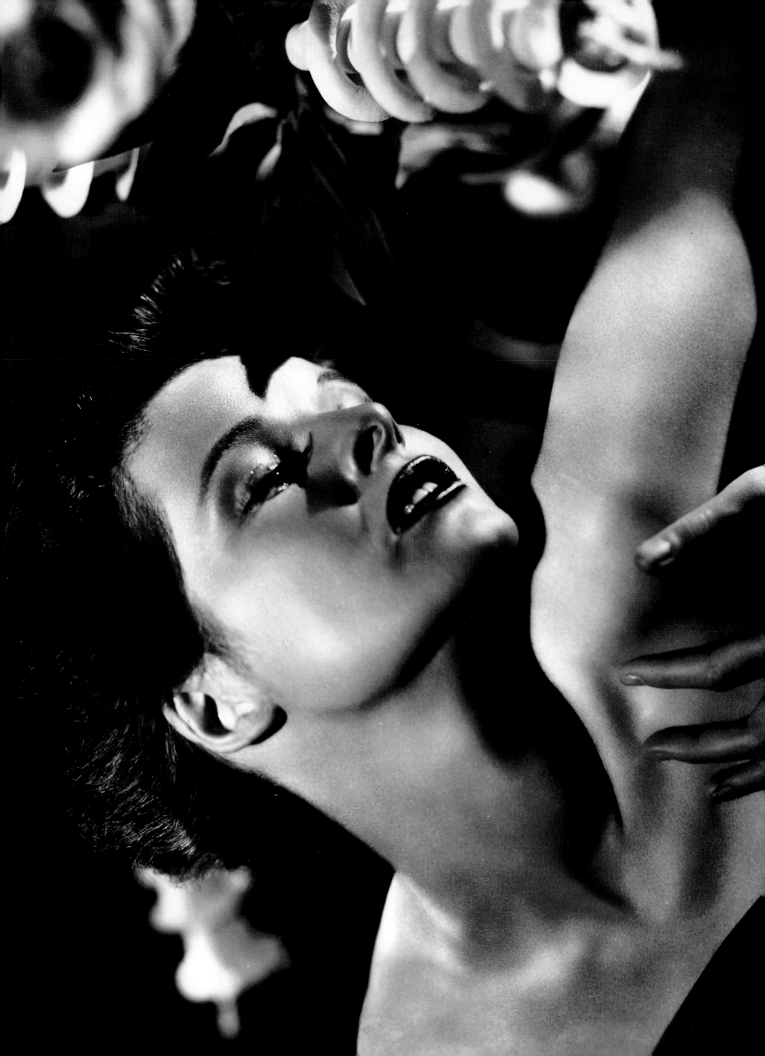

THEY STILL HAVE FACES

ERNEST BACHRACH
Katharine Hepburn *1933*

loria Swanson was right: they did have faces then. And how perfect they were. The young Katharine Hepburn had such perfection. Gorgeous and talented, the camera loved every angle and gesture, every move of her graceful arms. Cary Grant was the epitome of glamorous perfection. They had star quality—glamour—the ability to embody an ideal and wear it beautifully.

Thankfully, there are still beautiful stars today: Barbara Hershey, Sean Young, and the indomitable Jodie Foster, to single out a few. Johnny Depp has the star look, as does Andy Garcia. Before the still cameras, they transcend the everyday to become glamorous for a few fleeting moments: an illusion as deep as the imagination of the photographer and of the viewer.

GEORGE HOLZ
Barbara Hershey *1985*

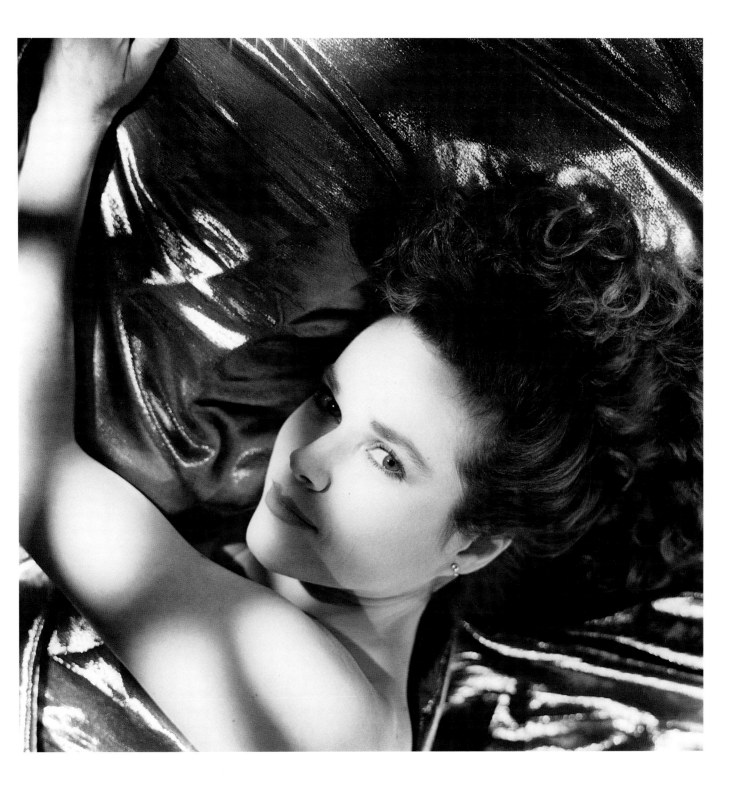

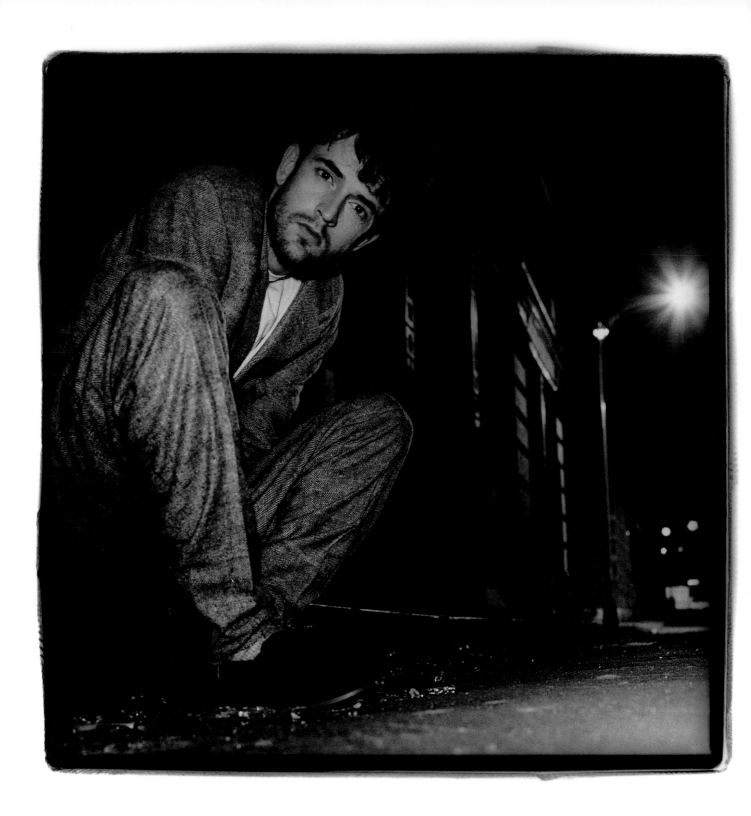

SYLVIA PLACHY
Rupert Everett *1986*

OPPOSITE: MICHAEL TIGHE
James Spader *1990*

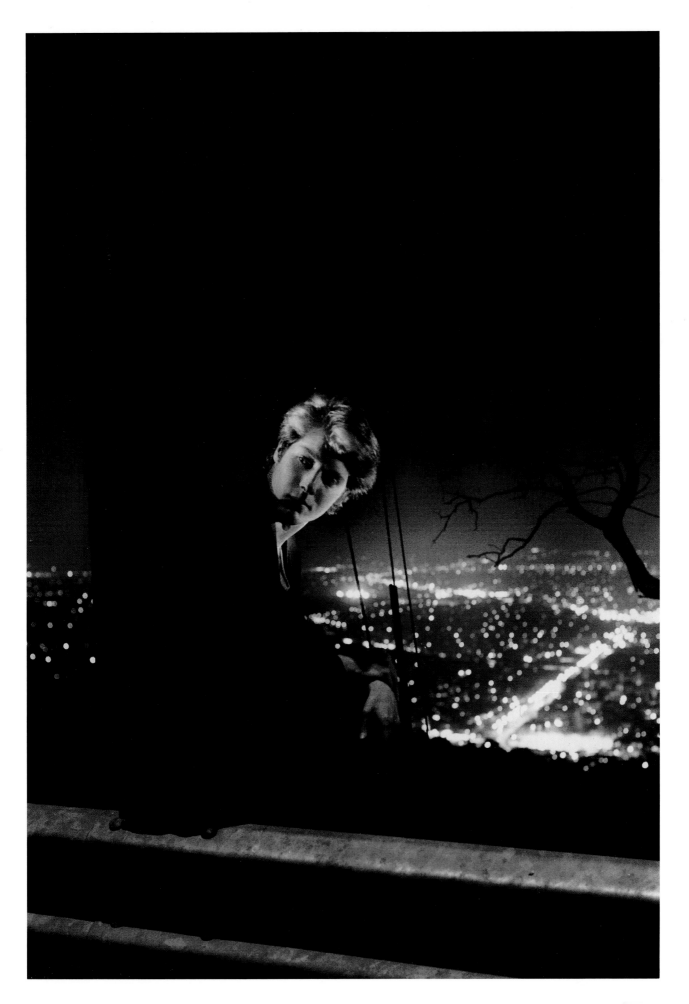

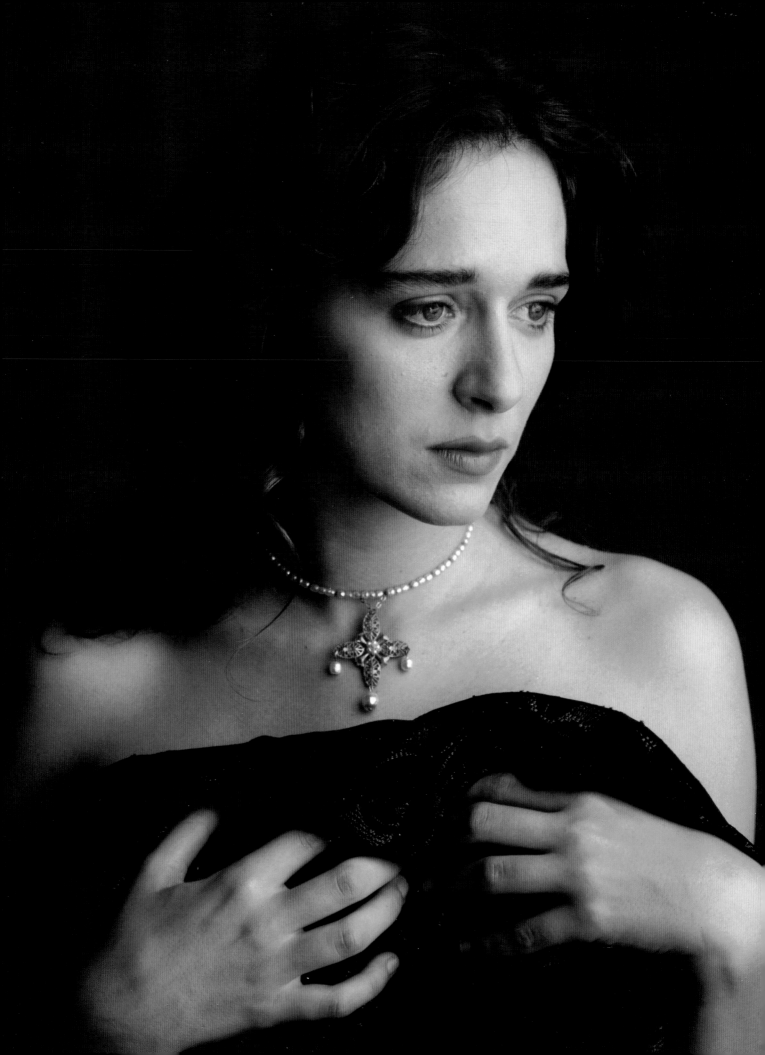

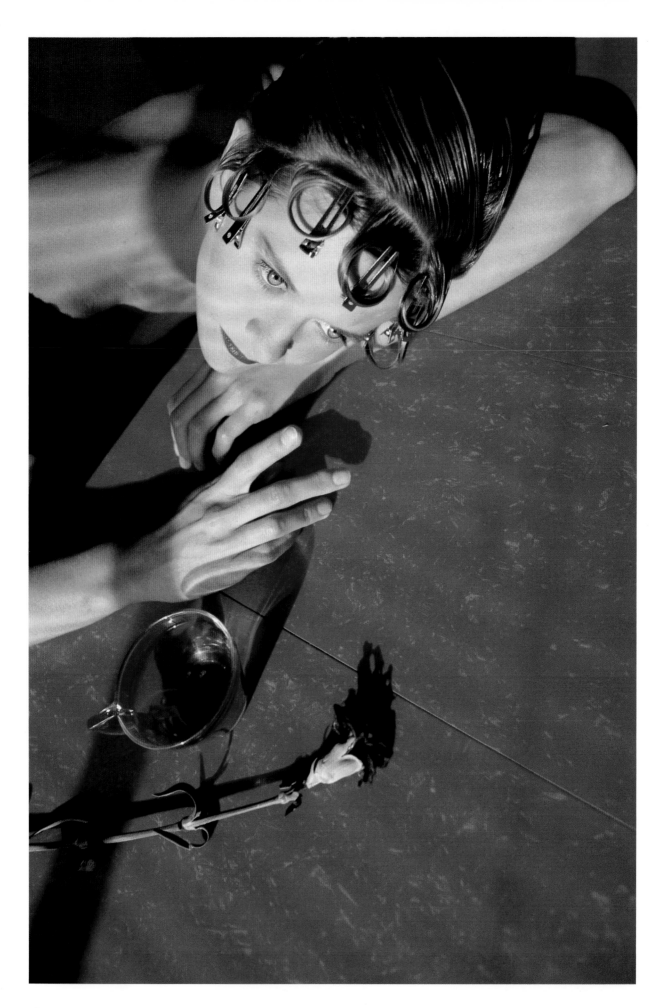

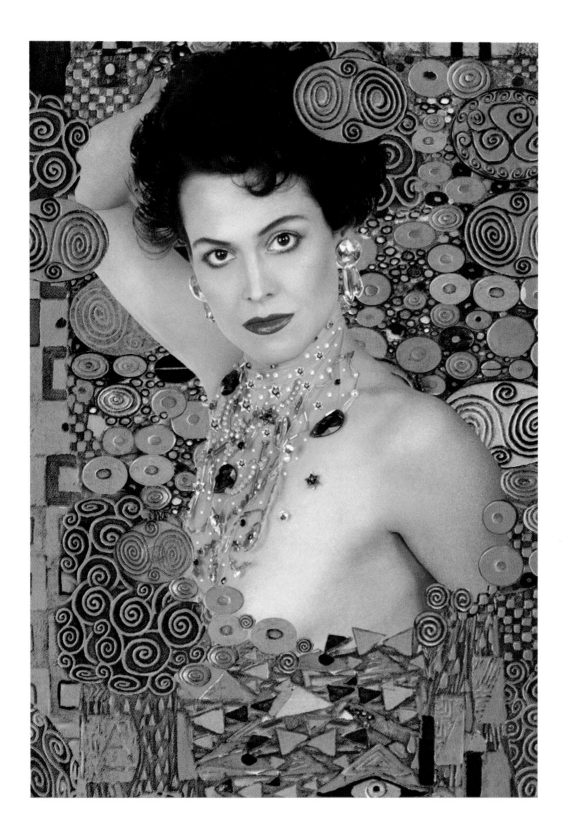

ABOVE: **RICHIE WILLIAMSON**
Sigourney Weaver *1986*

OPPOSITE: **LARA ROSSIGNOL**
Meg Ryan *1987*

PAGE 164: **LARA ROSSIGNOL**
Johnny Depp *1987*

PAGE 165: **LARA ROSSIGNOL**
Andy Garcia *1987*

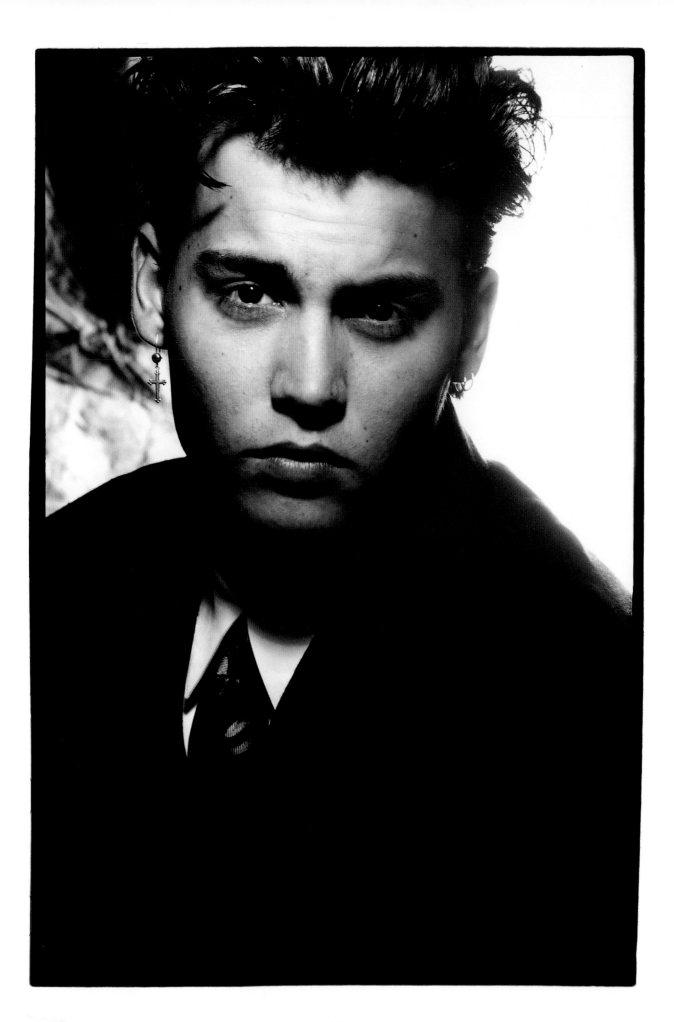

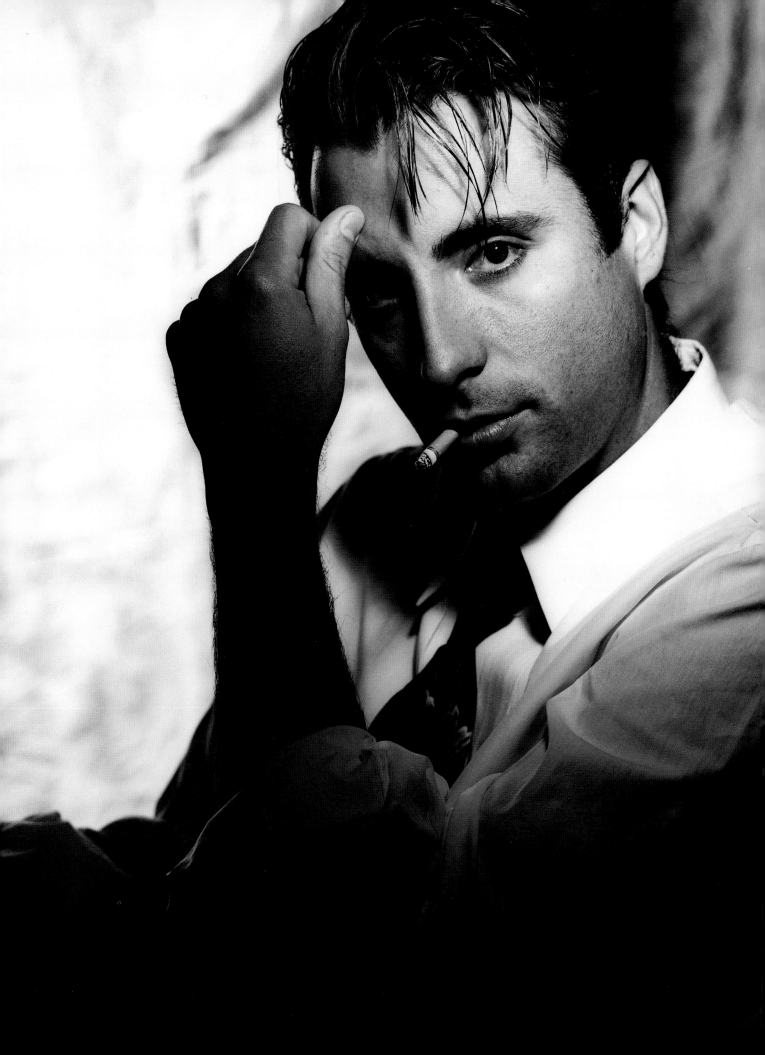

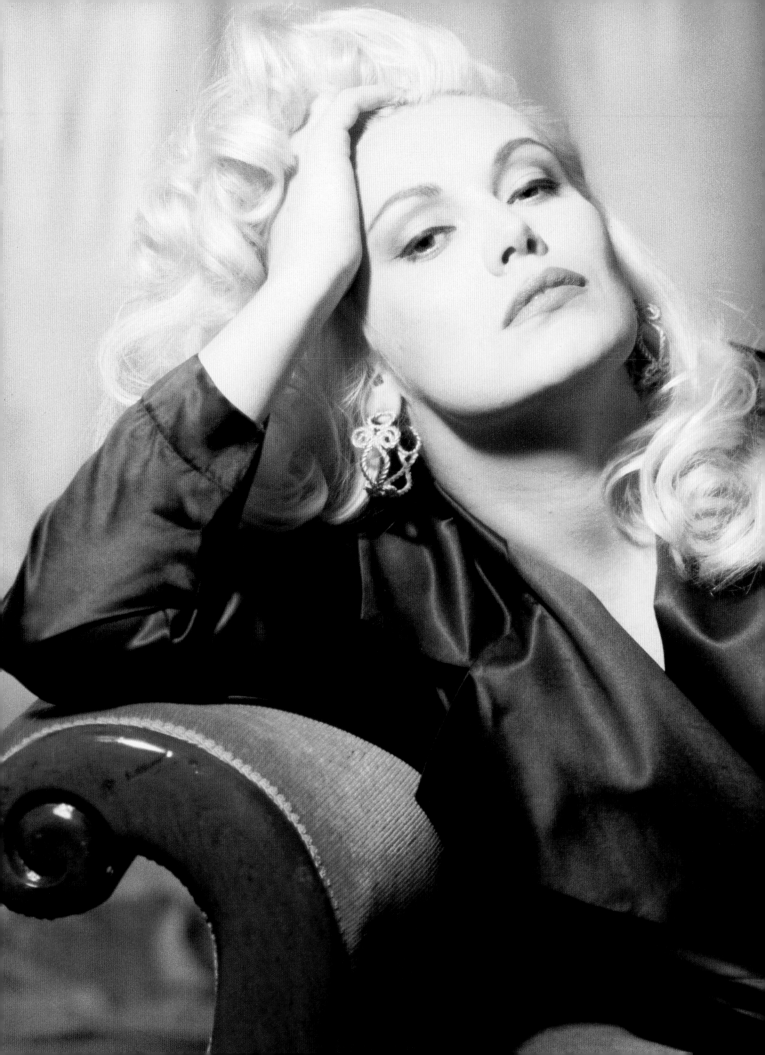

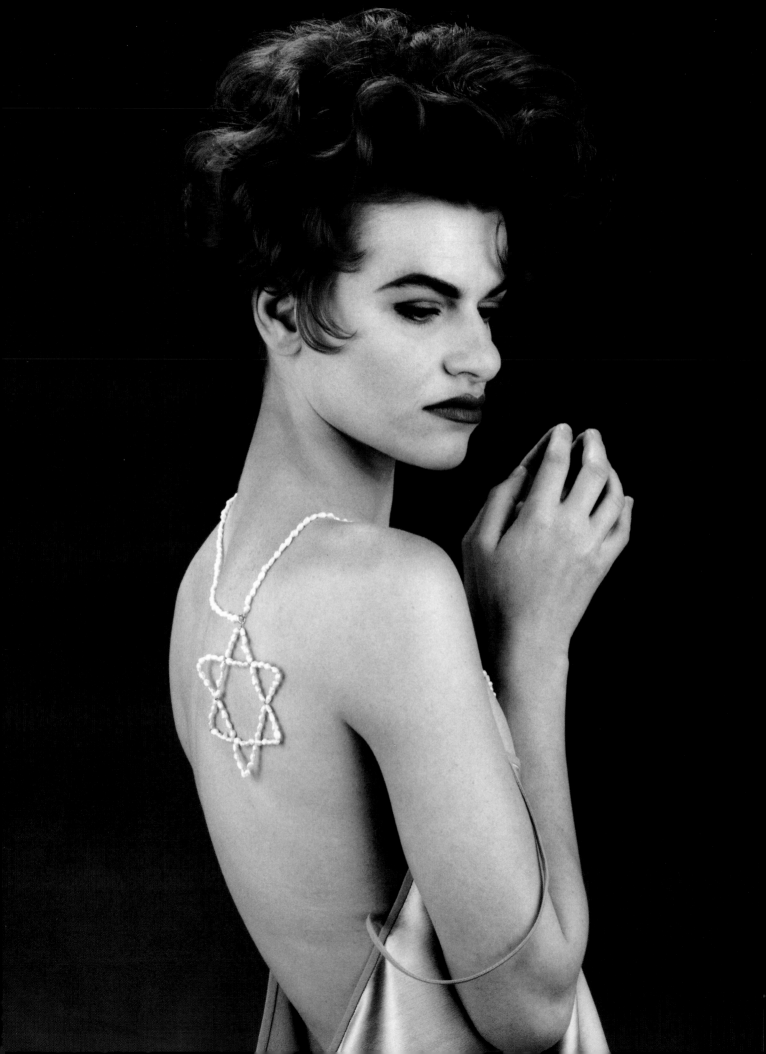

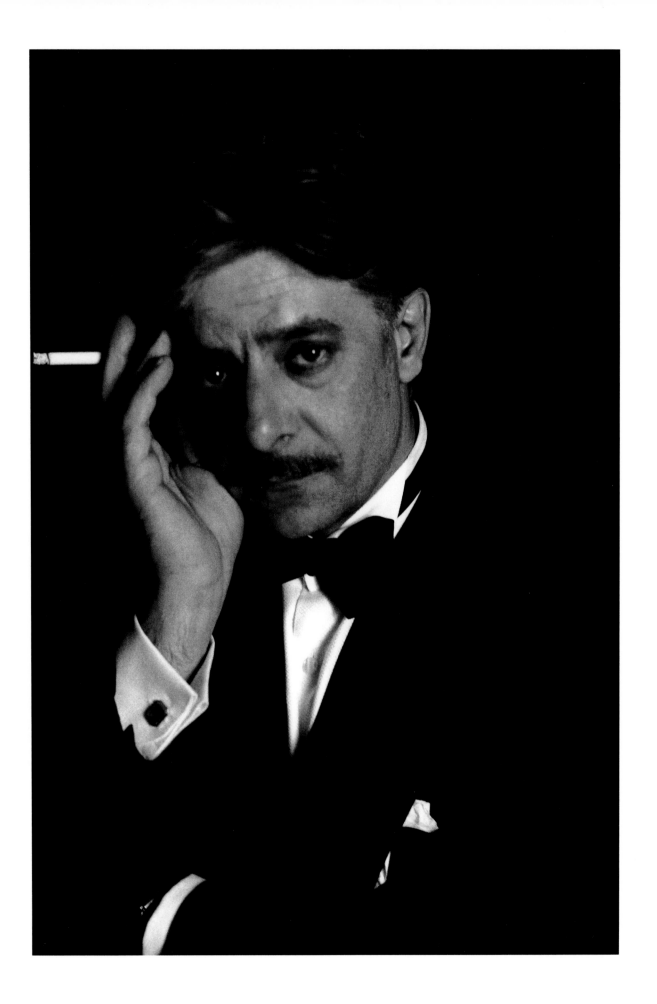

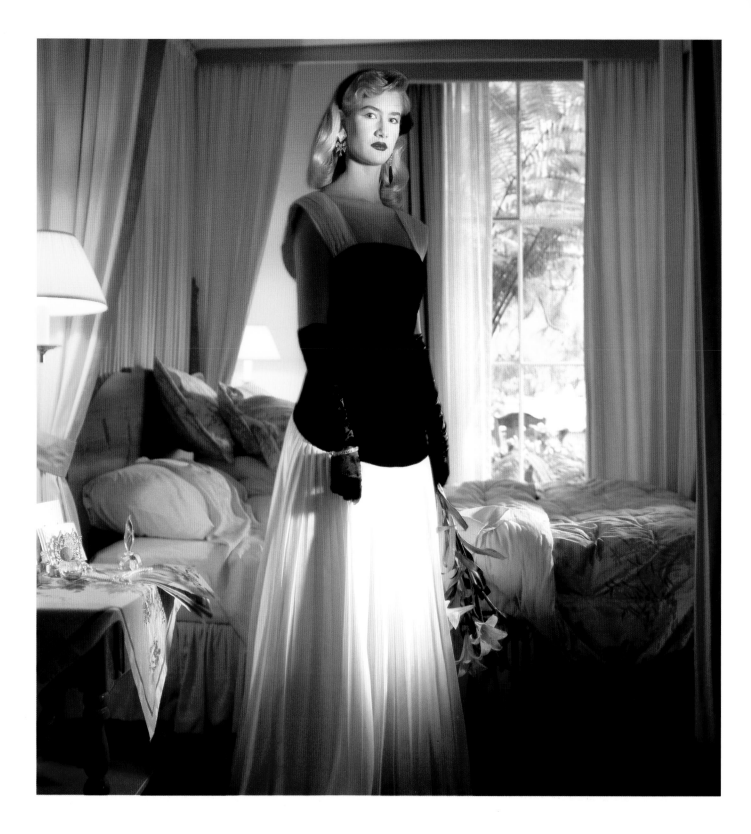

ABOVE: **LARA ROSSIGNOL**
Laura Dern *1985*

PAGE 168: **EDWARD MAXEY**
Sandra Bernhard *1990*

PAGES 166-167: **ALBERT SANCHEZ**
Cathy Moriarty *1991*

PAGE 169: **RUDI MOLACEK**
Giancarlo Giannini *1989*

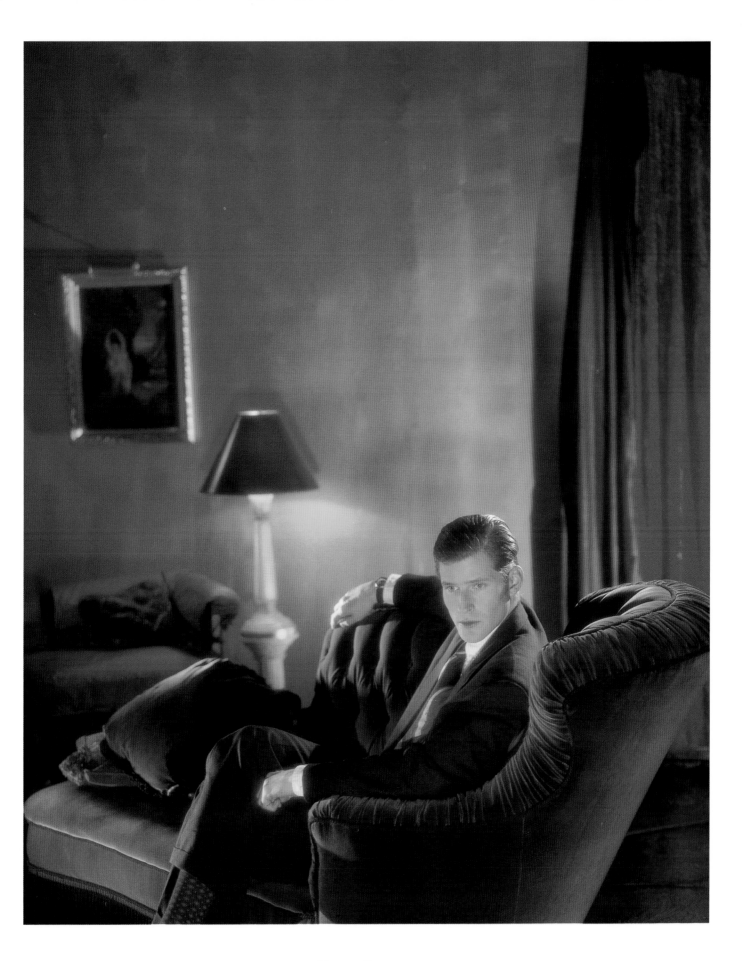

ROCKY SCHENCK
Crispin Glover *1990*

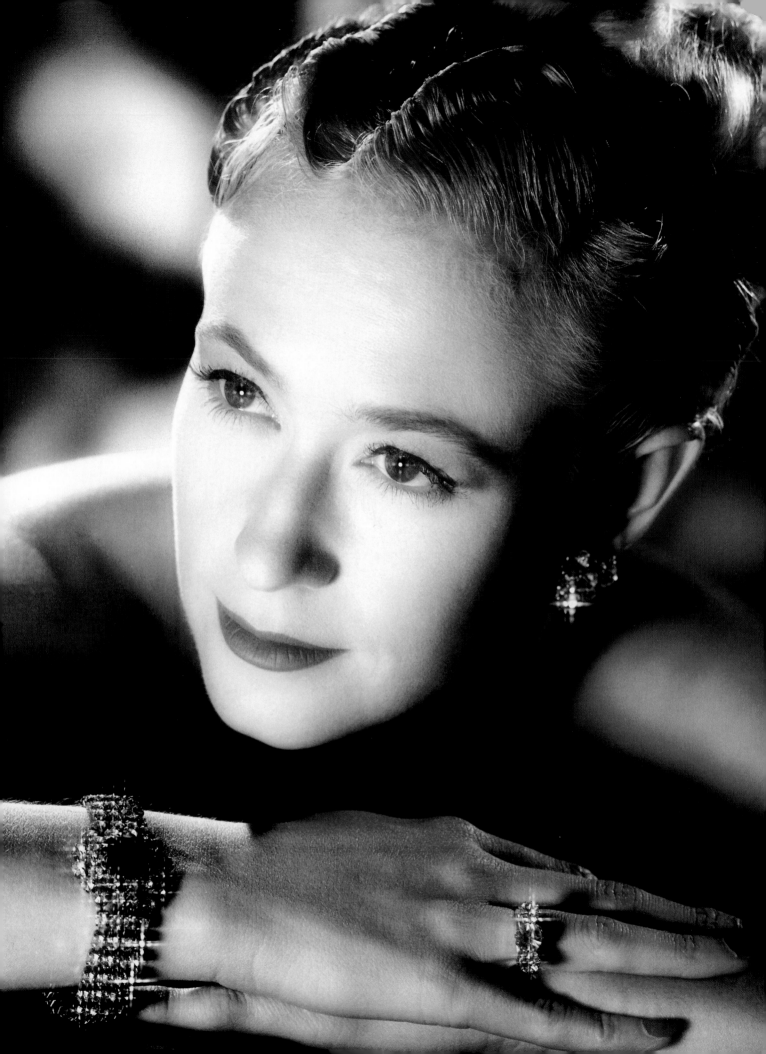

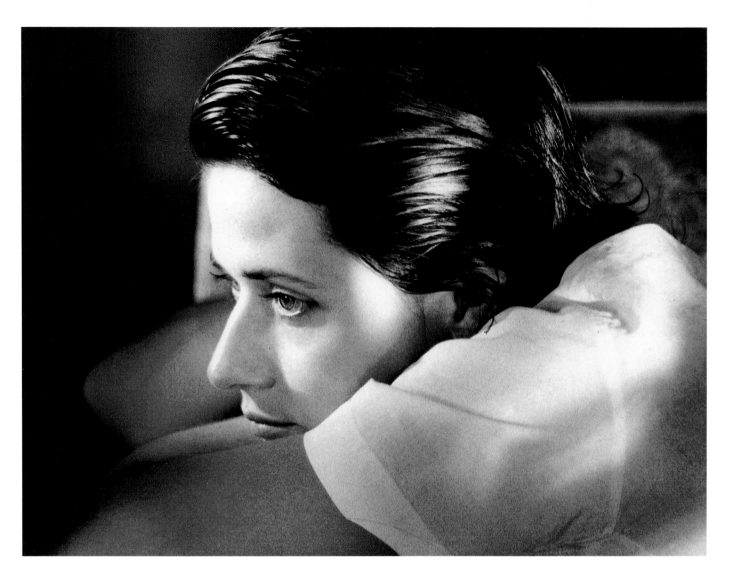

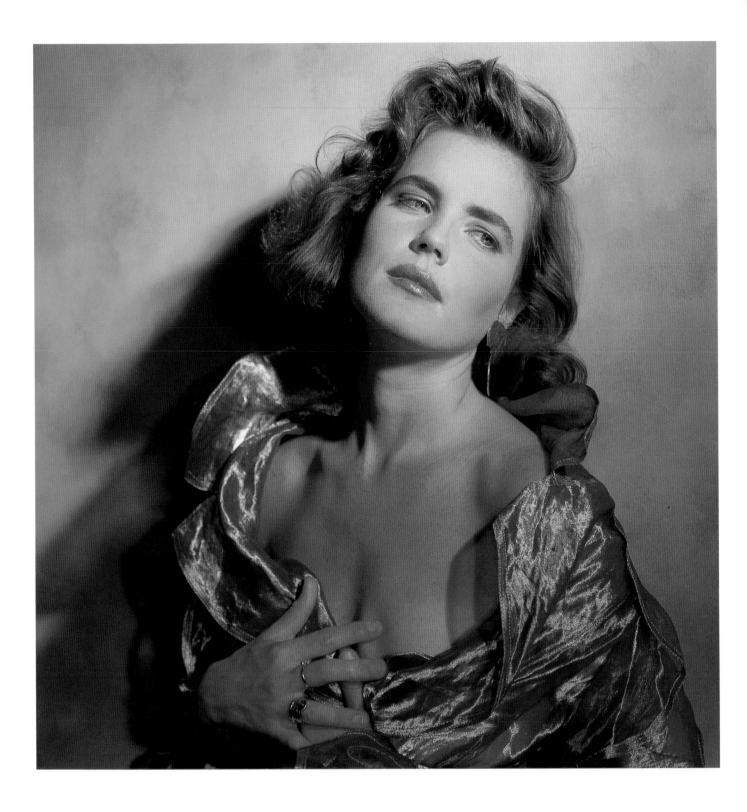

Theo Westenberger
Elizabeth McGovern *1991*

opposite: Gregory Heisler
Mary Elizabeth Mastrantonio *1986*

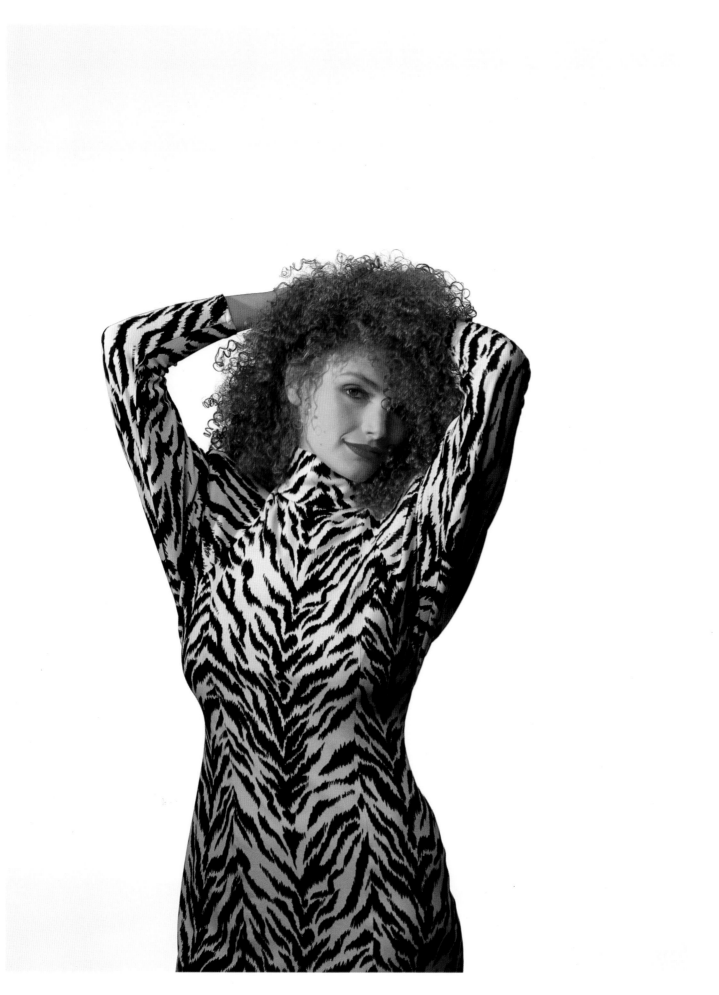

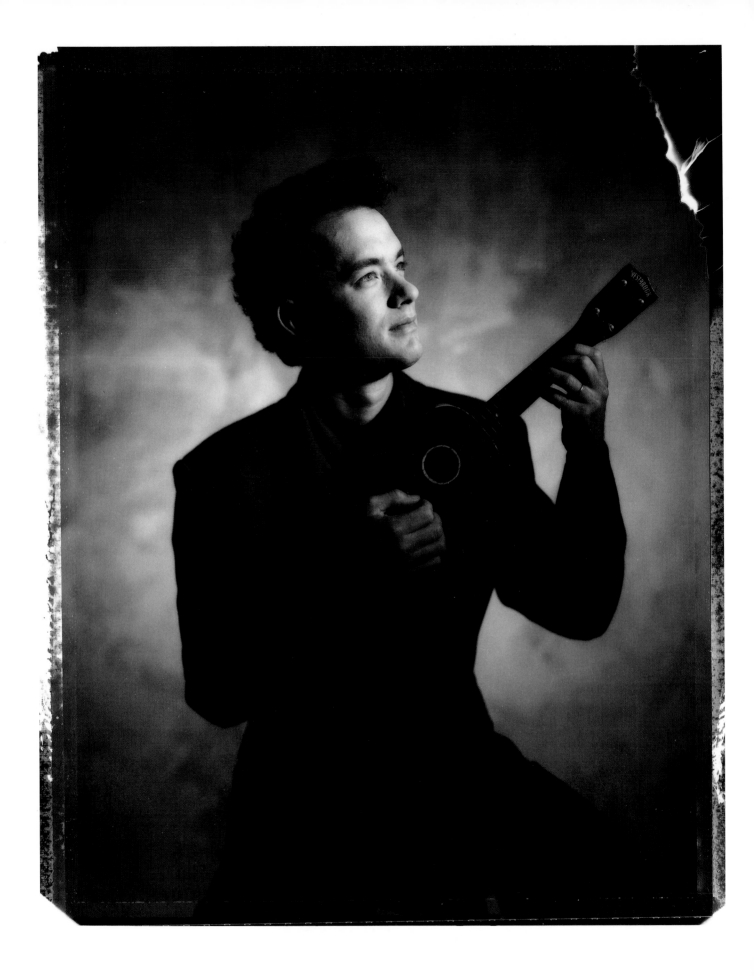

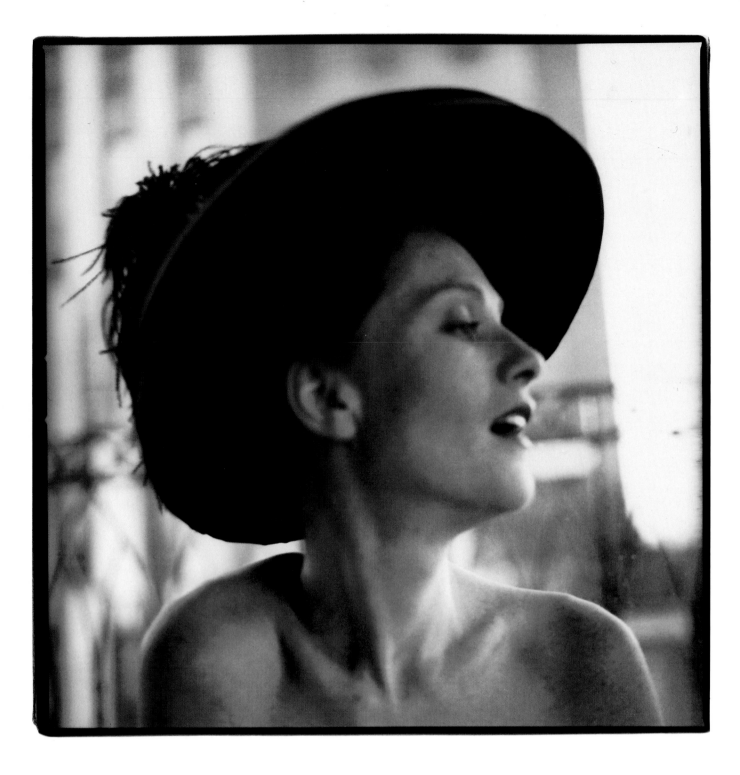

SYLVIA PLACHY
Isabelle Huppert *1986*

OPPOSITE: MARCIA LIPPMAN
Mia Sara *1991*

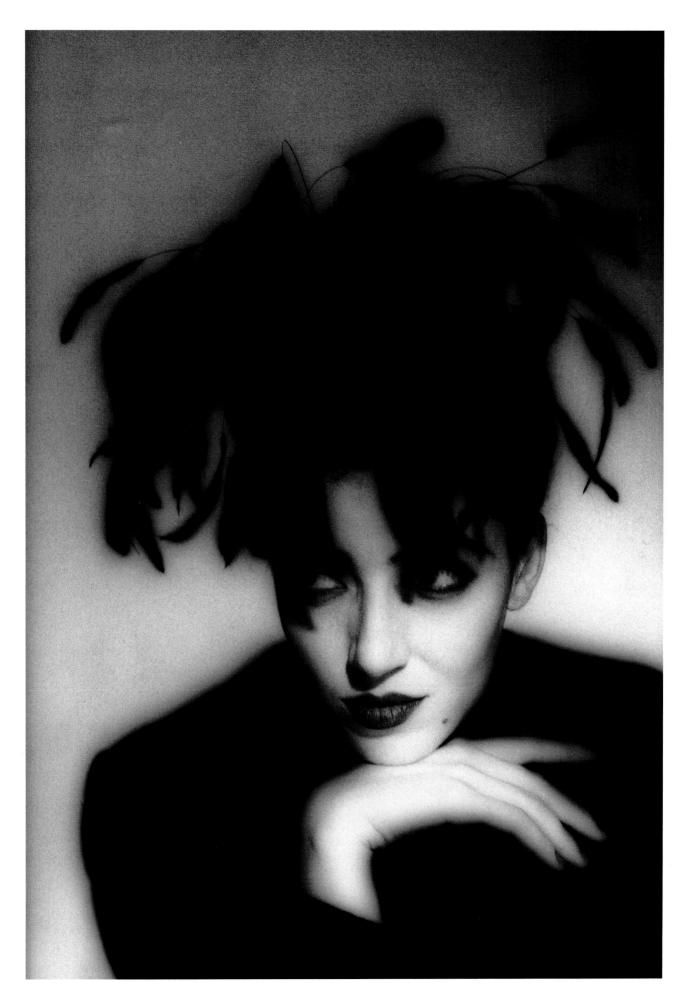

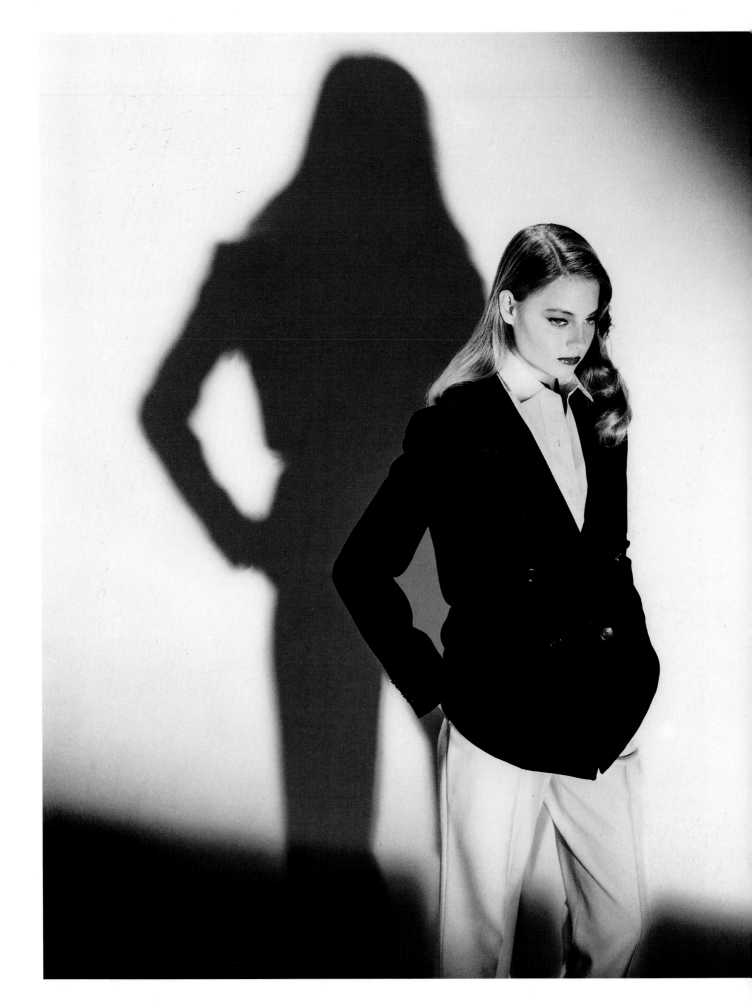

BOB KISS
Jodie Foster *1980*

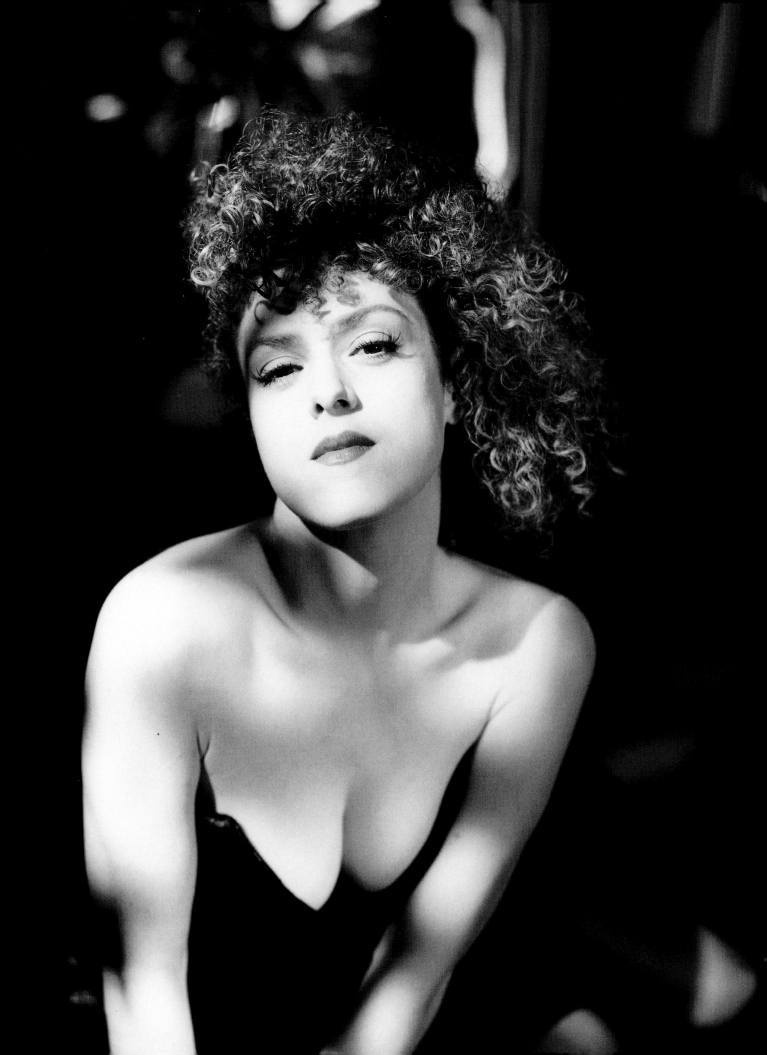

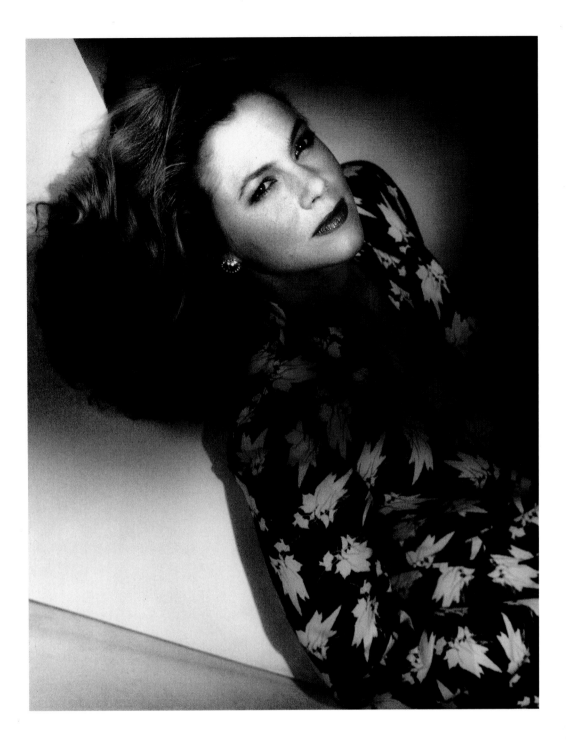

RICHARD IMRIE
Kathleen Turner *1988*

OPPOSITE: GEORGE HOLZ
Bernadette Peters *1986*

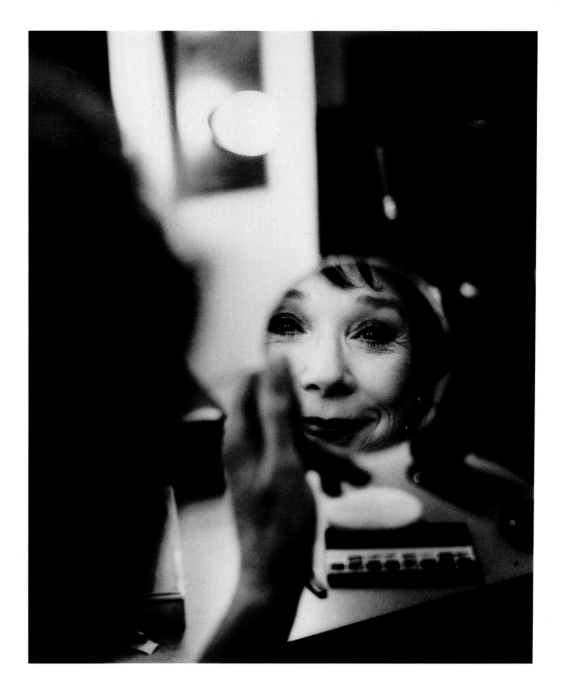

TIMOTHY WHITE
Shirley MacLaine *1991*

OPPOSITE: MICHAEL O'BRIEN
Sonia Braga *1986*

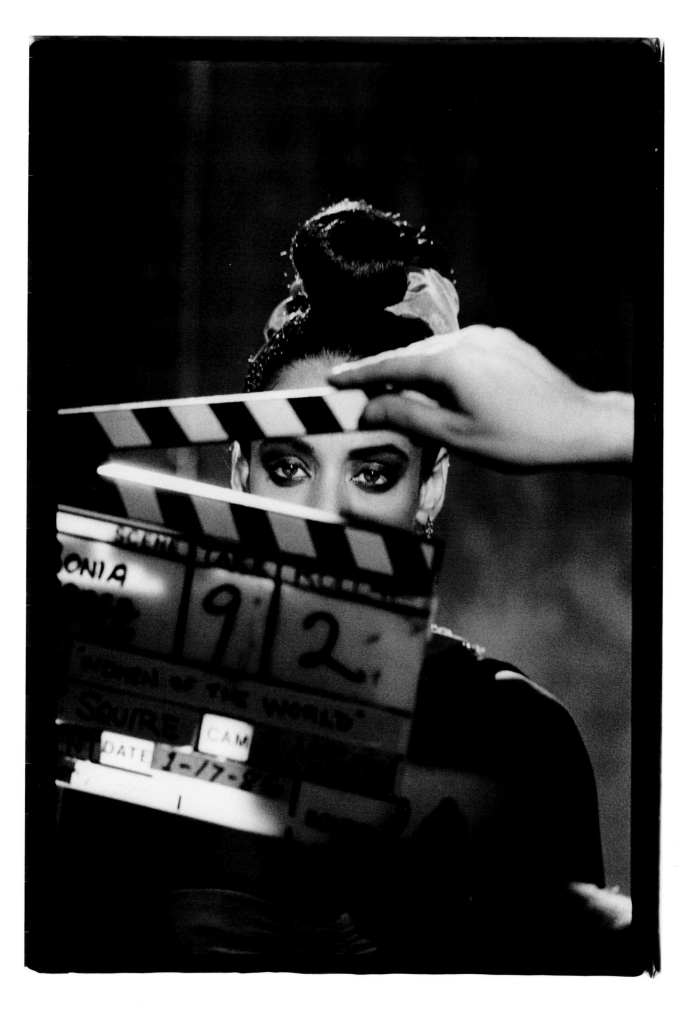

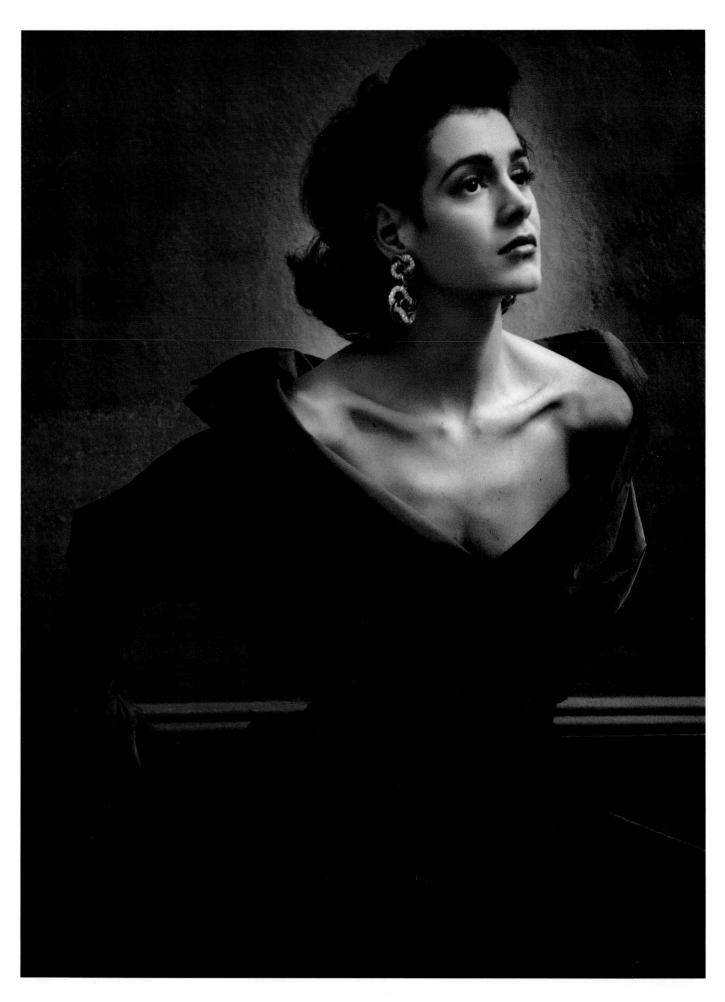

JOSEF ASTOR
Sean Young *1989*

PHOTOGRAPHERS' BIOGRAPHIES

PATRIK ANDERSSON was born in Sweden and has been living and working in New York since 1991. His portraits have been published in *Interview* and the Italian, English, and French editions of *Vogue*. (**P. 111**)

EIKA AOSHIMA moved from her native Japan to California to attend the Art Center College of Design of Pasadena. She now lives in Los Angeles and travels to photograph portraits on location. (**PP. 135, 145**)

JOSEF ASTOR was born in Ohio in 1959. He studied fine art at Syracuse University and learned photography as an apprentice in New York City and Paris. His work appears regularly in *Vanity Fair*, the *New York Times Magazine*, and other publications. Josef has exhibited work in New York at the Tom Cugliani Gallery and in Paris at the Polaris Gallery. (**PP. 7R, 30–31, 130, 186**)

ERNEST BACHRACH headed the photographic department of RKO from 1929 until the late 1950s. (**P. 154**)

ANTHONY BARBOZA was born in New Bedford, Massachusetts. He began his photographic career in 1964 with the Kamoinge Workshop, under the direction of Roy DeCarava. He is regularly featured in art publications and exhibitions. His book *Black Borders*, with text by Ntozake Shange and Steven Barboza, was published in 1980. He is currently at work on a book entitled *Piano for Days*. (**PP. 26, 53, 59**)

ANDREW BRUCKER was born in London, Ontario, Canada. He is a self-taught photographer and his work has appeared in *Rolling Stone*, the German *Manner Vogue*, and *Interview*. He lives and works in New York City. (**PP. 72, 110**)

CHRIS BUCK is a New York–based portrait photographer born in Toronto, Canada, where he began his professional career in 1988. His work can be seen in *Entertainment Weekly, Lear's*, the *Village Voice, Re/Search*, and *New York* magazine. (**PP. 82, 143**)

CLARENCE SINCLAIR BULL was born in Sun River, Montana, in 1896. He became the head of the stills department at MGM in 1924 and he stayed until his retirement in 1961. He died in 1979. (**P. 13**)

CHRIS CALLIS is a native Californian who has been working in New York since 1974. He graduated from the Art Center College of Design in Pasadena, California, and his photographs have been seen in *Vogue, Esquire, Rolling Stone,* and the *New York Times.* (P. 117)

ROBERT COBURN was born in 1900 in Choteau, Montana. From 1929 to 1934 he was a still photographer at RKO. From 1935 to 1940 he was codirector of the Goldwyn Portrait Gallery. He moved to Columbia in 1941. (P. 106)

MARK CONTRATTO is a graduate of Parsons School of Design. He was born in Salt Lake City, Utah, and resides in New York. His portraits have been published in *Interview, Paper,* and Spanish *Vogue.* (P. 29)

KENN DUNCAN was born in 1928 in Spring Lake, New Jersey. He was a major dance, theater, and fashion photographer through the 1970s and 1980s. His books include *Nudes, More Nudes,* and *Red Shoes.* He had many one-man and group national and international exhibitions, and his portraits are in many permanent collections. He died July 27, 1986. (P. 27)

MARION ETTLINGER was born in New York and is based in New York City. Her portrait photography has appeared in a variety of publications in the U.S., Europe, and the Far East. (PP. 47, 81)

BOB FRAME was born and raised in Chicago. Based in New York, he travels the world shooting for major magazines and advertisers. His portraits have appeared in *Interview, Us, Allure,* and *L.A. Style,* and he is a contributing photographer to *Harper's Bazaar.* His work has also appeared in international editions of *Vogue.* (PP. 49, 98–99, 112)

JESSE FROHMAN was born in New York City. His portrait and fashion photography has appeared in *Vogue, Vanity Fair, Interview, Details, Rolling Stone, Spin, The Face,* and *Entertainment Weekly.* He is currently working on a book of portraits of rap stars. (P. 46)

SUSAN GRAY was born in Chadds Ford, Pennsylvania, and is based in New York. Her work has appeared in major publications and has been used by leading corporations. She is represented by SPG International Agency in New York, and is currently working on *Writers on Directors: A Personal Photographic Study of Hollywood Directors,* with essays by America's foremost writers. (P. 124)

TIMOTHY GREENFIELD-SANDERS was born in Miami Beach, Florida, and has a B.A. in art history from Columbia University and an M.F.A. in film from the American Film Institute. He has exhibited at the Leo Castelli and Mary Boone galleries in New York, and his work is in the collections of the National Portrait Gallery, the Museum of Modern Art, the Metropolitan Museum of Art, and the Whitney Museum of American Art. Greenfield-Sanders had a major retrospective at the Modern Art Museum of Ft. Worth, Texas, in 1992. (PP. 61, 65, 75, 78, 113, 150, 160)

MARK HANAUER was born and raised in Los Angeles. He started photography in high school in the 1960s, and his portraits have been published in *Rolling Stone, GQ, Playboy,* and the *Graphis* books. He was among the photographers included in *Rolling Stone: The Photographs.* (PP. 93, 97, 122, 133, 176)

GREGORY HEISLER is a thirty-seven-year-old New York–based photographer interpreting a broad range of subjects. His photographs have been seen in *Life, Time, Connoisseur,* and the *New York Times.* He was a guest speaker at the Smithsonian Institution's "Masters of Still Photography" lecture series. (PP. 54, 136–37, 144, 175)

GEORGE HOLZ is a native of Oak Ridge, Tennessee, and a graduate of the Art Center College of Design in Pasadena, California. His work has appeared in leading magazines around the world. He is the 1991 Grammy winner for best album package, Suzanne Vega's *Days of Open Hand.* (PP. 36, 56, 109, 157, 182)

DENNIS HOPPER was born in Dodge City, Kansas. "I took these photos on the run because they—the actors— asked me to. I like them. I hope you do too. I know these guys—sort of." (PP. 74, 125)

GEORGE HURRELL was born in 1904 in Cincinnati, Ohio, and was head of the MGM Portrait Gallery from 1930 to 1933. He was at Warner Bros. in 1938 and at Columbia in 1942. (PP. 15, 18, 50)

RICHARD IMRIE lives and works both abroad and in New York. His portraits have appeared in many American as well as foreign publications. (P. 183)

LEN IRISH was born in Omaha, Nebraska. His portrait photography has appeared in the *New York Times, Interview, Rolling Stone,* and *Vanity Fair.* He lives and works in New York. (P. 146)

DEAN JANOFF was born in Brooklyn, New York, and attended the School of Visual Arts. He has been working in New York for more than seventeen years, involved in almost every aspect of the visual arts, from set design at Studio 54 to graphics and photography. He now uses the computer as an integral part of the whole design process. (P. 63)

PAUL JASMIN was born in Helena, Montana. He studied painting in school and later became a self-taught photographer. His fashion photography has appeared in many Condé Nast publications as well as *Rolling Stone* and *Interview.* He has also done many advertising campaigns for Bloomingdale's and Jhane Barnes. (P. 45)

SUSAN JOHANN was born in New York City. She began acting, then turned to photography in the mid-1980s. Her work has appeared in the *New York Times, New York* magazine, *Detour,* and *Paper.* She has shot film stills for several major motion-picture projects. She is currently working on a book of portraits of contemporary playwrights. (PP. 44, 96, BACK FLAP)

CAROLYN JONES was born in Lancaster, Pennsylvania, and began to take an interest in photography at the age of thirteen. After graduating from the Si Newhouse School of Public Communications at Syracuse University in 1978, and completing related studies in London, she began her work in New York as an assistant to Hiro. In 1981, Carolyn established a New York City studio where she has moved from fashion to portrait photography. A list of her clients includes *Esquire, Lear's, Interview, Spy, Self, Seventeen, Mademoiselle, GQ,* Italian *Vogue,* and Italian *Vanity Fair.* (PP. 6R, 73)

BILL KING was a painter and self-taught photographer. He was educated in the arts and traveled extensively, opening photography studios in London and New York. He was one of the world's foremost fashion and advertising photographers of the 1970s and 1980s. His photographs of famous models and celebrities graced the covers and pages of the most distinguished magazines in the world. In their elegance, these photographs brought a sensual and youthful energy and movement to the printed page. (P. 104)

BOB KISS has had his portrait photography published in *Interview*, British, German, and French *Vogues* and has been a fashion and advertising photographer from 1974 to the present. After seven years of training in theater direction and filmmaking, he is currently pursuing an additional career as a director and a director of photography for films and commercials. He divides his time between his residences in Barbados and Manhattan. (PP. 180–81)

STEVEN KLEIN was born in Providence, Rhode Island. He graduated from the Rhode Island School of Design with a B.F.A. in painting. He lives and works in New York City and is a frequent contributor to Italian *Vogue*, British *Vogue*, *Interview*, *Rolling Stone*, *Details*, and British *Elle*. (PP. 76, 80, 105)

ANTONIN KRATOCHVIL is a Czech-born American based in New York. He travels around the world shooting reportage and celebrities. He was named International Center of Photography's 1991 Photojournalist of the Year and his portraits and essays have been published in such magazines as the *New York Times Magazine*, *Rolling Stone*, *Condé Nast's Traveler*, *Entertainment Weekly*, *L.A. Times*, and *Details*. (PP. 7L, 120)

MARCUS LEATHERDALE is a fine-art photographer living in New York. He did the portraits for the hidden identities series in the original *Details* magazine. He is currently working on a book of photography of India. (PP. 48, 103)

LAURA LEVINE was born in Chinatown in New York City, and has a B.A. from Harvard. She was photo editor and chief photographer for the *New York Rocker* in the early 1980s. Since then her photography has been seen in *Rolling Stone*, *Details*, *L.A. Style*, the *New York Times*, and Italian *Vanity Fair*. (PP. 40, 57, 152)

FRANK LINDNER was born in Australia and has been living and working in America for the last seven years. His portraits have appeared in *Premiere: The Movie Magazine*, *New York Woman*, and *New York* magazine. His photography has also been seen on many record album covers. (PP. 67, 94)

MARCIA LIPPMAN is a native New Yorker who still lives and works in New York City. She teaches at Parsons School of Design and is represented by the Staley, Wise Gallery. She is currently working on a book about West Point and on an ongoing project of European statuary for her next show. (P. 179)

BLAKE LITTLE was born and raised in Seattle, Washington. He is based in Los Angeles and is a frequent contributor to *Elle*, *L.A. Style*, and *Rolling Stone*. Blake is currently working on a photography book to include nudes and celebrity portraits. (P. 37)

CHRIS MAKOS was born in Lowell, Massachusetts. After an apprenticeship with Man Ray he began a long association with Andy Warhol and *Interview* magazine. His photographs have been published internationally. His books include *White Trash* (1977) and *Warhol: A Personal Photographic Memoir*. (P. 10)

ROBERT MAPPLETHORPE was born in 1948 in Floral Park, New York. Between 1963 and 1970 he studied painting and sculpture at the Pratt Institute, Brooklyn. While attending art school he became interested in images and was especially attracted to the prohibited pictures in the Times Square sex shops. In 1972 he began shooting with a Polaroid. He had his first one-man show in 1978 at the Robert Miller Gallery, New York. A retrospective book of his career will be published in the fall of 1992. Before his death in 1989 he had established The Robert Mapplethorpe Foundation, Inc., which provides funds for institutional programs of photography and for medical research in the area of AIDS. (PP. 21, 89, 126)

MARY ELLEN MARK was born in Philadelphia, Pennsylvania. She is a renowned photojournalist. Her books include *Photographs of Mother Teresa's Missions of Charity in Calcutta, Streetwise*, and the recent *Mary Ellen Mark: 25 Years*. She is the recipient of several National Endowment for the Arts grants as well as many photojournalism awards. (PP. 17, 41, 90, 91, 92, 95, 141)

EDWARD MAXEY was born in New York, where he continues to reside and work. Although his photography has appeared in such publications as *Interview* and *Mirabella*, he concentrates mainly on his fine-art work, which has been exhibited in New York, London, Los Angeles, and Japan. Maxey is represented by the James Danziger Gallery in New York. (PP. 88, 139, 168)

SHEILA METZNER took up photography after a career in advertising at DDB Needham Worldwide Inc. Her work has appeared in *Vogue, Vanity Fair, HG*, and many international magazines. Her commercial clients include, among others, Fendi, Shiseido Cosmetics, Elizabeth Arden, and Ralph Lauren. Her second monograph, *Color*, was published by Twin Palms in 1991. (PP. 116, 149)

RUDI MOLACEK was born January 3, 1948, in Kindberg, Austria. At twenty-eight he bought his first camera and moved to New York from Milan. He is a self-taught photographer and was a professor of applied arts in Vienna from 1985 to 1991. His portraits have appeared in *Interview* and international editions of *Vogue*. (PP. 24–25, 169, BACK JACKET)

JEFFERY NEWBURY was raised on a dairy farm in Wisconsin. A commercial photographer for six years, he has also been a cranberry picker, a garbage man, and a union painter. His photography is equally diverse and includes publication in *L.A. Style, Macworld, Elle, Rolling Stone*, and *Esquire*. He sometimes calls his photographic approach "controlled experimentation," which he applies to subjects as varied as high technology, fashion, and portraiture. (PP. 6L, 22)

HELMUT NEWTON was born in Berlin, and his nationality is Australian. At the age of sixteen he apprenticed with the fashion photographer Yva. During the early 1960s and 1970s he contributed regularly to *Vogue, Elle, Marie Claire, Jardin des Modes*, American *Playboy, Nova, Queen*, and *Stern*. He resides in Monte Carlo, Monaco. (PP. 23, 134)

MICHAEL O'BRIEN is currently working with writer Holly Brubock on a book project on the subject of drag, to be published by Turtle Bay Books. Before beginning his photography career in New York City, he taught photography at Kenyon College and prior to that studied photography at Yale with Walker Evans. (**PP.** 28, 32, 43, 185)

FRANK W. OCKENFELS₃ is based in New York City and spends a great deal of time on assignment in Los Angeles and elsewhere, nationally and abroad. He received a B.A. degree from New York's School of Visual Arts. His portraits have appeared in *Rolling Stone, Time, Vanity Fair*, and *Esquire*, and he has worked for many record labels as well as advertisers. (**PP.** 71, 121, 132)

SYLVIA PLACHY was born in Budapest, Hungary. Her photography appears regularly in the *Village Voice* and many other publications. A retrospective of her photography titled *Unguided Tour* was published by Aperture in 1990. Her work is in the permanent collections of the Museum of Modern Art and the Metropolitan Museum of Art and she has had many one-person shows internationally. She resides in New York. (**PP.** 100, 115, 158, 178)

EUGENE ROBERT RICHEE was born in 1895 in Denver, Colorado, and was Paramount's production still photographer from 1923 to 1941. In 1942 he was at MGM and from 1947 to 1950 at Warner Bros. (**P.** 13)

LARA ROSSIGNOL grew up in southern California and graduated from the Art Center College of Design in 1985. She moved to New York, where she now lives, in 1988. Her portraits have appeared in numerous publications, including British *Elle, GQ, Interview*, and *Mirabella*. She also shoots fashion for clients such as Bloomingdale's and Max Factor and has published a 1950s pin up calendar called *Twelve Months of Glamour*. (**PP.** 34, 83, 84–85, 131, 142, 162, 164, 165, 170)

ALBERT SANCHEZ was born in Los Angeles. A self-taught photographer, he has been shooting for the last ten years. His work has appeared in *Interview, Esquire, Manipulator, L.A. Style*, and *Paper*. (**PP.** 35, 55, 127, 148, 151, 153, 166–67)

JEFFREY HENSON SCALES was born in San Francisco. A self-taught photographer, he began taking photographs at age thirteen. His first published work was in *Time*, when he was fourteen. His portraits have appeared in *Vanity Fair, American Film*, and *Italia*. His work is collected by the Museum of Modern Art and the Schomberg Center for Research in Black Culture in New York City. He is currently working on a book of young black men called *The Young Men Series*. (**PP.** 77, 140)

ROCKY SCHENCK was born in Dripping Springs, Texas. He started photography in 1973. He produces still photography and miscellaneous videos and short films. (**PP.** 123, 171, 172)

MARK SELIGER was born in Amarillo, Texas. He has done work for *Rolling Stone* and Warner Bros. records. (**P.** 102)

CHIP SIMONS was born in Clearwater, Florida, and was brought up all around the United States, including Pennsylvania, and the suburbs of New York City. He graduated from the University of New Mexico in 1982. Living and working in New York City for the past ten years, he has had his "different" brand of photography published in many magazines, including *Interview, Rolling Stone, Forbes, Runner's World,* and *Health,* and he has done advertisements for Hasselblad, Nikon, Weight Watcher's, and American Express. (**P. 66**)

EDWARD STEICHEN was born in Luxembourg in 1879. From 1923 to 1937 he was chief photographer for Condé Nast publications. He made many trips from New York to Los Angeles to photograph the stars during Hollywood's golden years. He died in 1973. (**P. 9**)

BERT STERN was born in New York and raised in Brooklyn. He got his first camera at age nineteen. He was an art director of a small fashion magazine and became a professional photographer after he was discharged from the army in 1953. He is currently working on books and shows, and takes photographs for most major publications in the U.S. and Europe. (**P. 2**)

JEFFREY THURNHER was born and raised in Newport, California. His portraits have appeared in *Vanity Fair, Interview, Vogue,* and *Entertainment Weekly.* (**PP. 33, 38–39, 87, 101**)

MICHAEL TIGHE was born in New York. (**PP. 114, 159, 173**)

SCOTTY WELLBOURNE was a portrait photographer for Warner Bros. from 1941 to 1945, when he set up a stills department at the short-lived production company Enterprise. (**P. 1**)

THEO WESTENBERGER was born in Pasadena, California. She received her M.F.A. in photography at Pratt Institute in New York. Her photos have been in shows at the Metropolitan Museum of Art, Smithsonian Institution, International Center of Photography, and in Nikon House's The Best of *Life:* Favorite Photographs from 1978–1991 exhibit in 1991. She has also won awards from World Press Photo and the Advertising Photographers of America. Her principal clients include *Us, Life, Time, Newsweek, Sports Illustrated,* and *Premiere: The Movie Magazine.* She has also done special photography on numerous Hollywood movies. She is currently working on a book on Hollywood. (**PP. 58, 62, 79, 118–19, 174**)

TIMOTHY WHITE grew up in New Jersey and admits it freely. (**PP. 64, 69, 70, 128, 184, 216**)

RICHIE WILLIAMSON was born in DeQueen, Arkansas, and received a B.A. from the University of Texas. He has been living and working in New York City for the last twenty years. Originally an illustrator, he now claims photography as his main vocation. Recently he has incorporated the computer into his photography. According to Williamson, "The computer is the great sampler for the imagination, a palette for all visual media, the prefect canvas for the communication of ideas." (**PP. 63, 163, FRONT JACKET**)

FILMOGRAPHIES

Filmographies
compiled by Tom Gallagher

ABBREVIATION KEY

AA (Academy Award)

AA:BA (Academy Award best actor/actress)

AA:BSA (Academy Award best supporting actor/actress)

ACT (actor/actress)

CO-PROD, CO-DIR, etc. (co-producer, co-director, etc.)

DIR (director)

DOCU (documentary)

ED (editor)

EXEC PROD (executive producer)

NARR (narrator)

PROD (producer)

PROD DES (production designer)

SET DEC (set decoration)

SP (screenplay)

UNCRED (uncredited)

ALEC BALDWIN, PP. 66, 110
(Alexander Raye Baldwin III)
b. April 3, 1958, Massapequa, New York
Forever, Lulu *1987*
She's Having a Baby *1988*
Beetlejuice *1988*
Talk Radio *1988*
Married to the Mob *1988*
Working Girl *1988*
Great Balls of Fire! *1989*
The Hunt for Red October *1990*
Miami Blues *1990*
Alice *1990*
The Marrying Man *1991*
Glengarry Glen Ross *1992*
Prelude to a Kiss *1992*

STEPHEN BALDWIN, P. 83
b. 1964, Massapequa, New York
The Beast *1988*
Born on the Fourth of July *1989*
The Bridge *1992*

WILLIAM BALDWIN, P. 142
b. 1963, Massapequa, New York
Born on the Fourth of July *1989*
Internal Affairs *1990*
Flatliners *1990*
Backdraft *1991*
Three of Hearts *1993*

ELLEN BARKIN, P. 43
b. April 16, 1954, Bronx, New York
Diner *1982*
Daniel *1983*
Eddie and the Cruisers *1983*
Tender Mercies *1983*
Enormous Changes at the Last Minute *1983*
The Adventures of Buckaroo Banzai Across the Eighth Dimension *1984*
Harry and Son *1984*
Terminal Choice *1985*
Desert Bloom *1986*
Down By Law *1986*
The Big Easy *1987*
Siesta *1987*
Made in Heaven *1987*
Sea of Love *1989*
Johnny Handsome *1989*
Switch *1991*
Into the West *1992*
Mac *1992*
Man Trouble *1992*
This Boy's Life *1993*

KATHY BATES, P. 146
b. June 18, 1948, Memphis, Tennessee
Taking Off *1971*
Straight Time *1978*
Come Back to the 5 and Dime, Jimmy Dean, Jimmy Dean *1982*
Two of a Kind *1983*
The Morning After *1986*
Arthur 2: On the Rocks *1988*
Signs of Life *1989*
High Stakes *1989*
Men Don't Leave *1990*
Dick Tracy *1990*
White Palace *1990*
Misery *1990* (**AA:BA**)
A, Play in the Fields of the Lord *1991*
Fried Green Tomatoes *1991*
Shadows and Fog *1992*
The Road to Mecca *1992*
Used People *1992*

ANNETTE BENING, P. 133
b. May 29, 1958, Topeka, Kansas
The Great Outdoors *1988*
Valmont *1989*
Postcards From the Edge *1990*
The Grifters *1990*
Guilty By Suspicion *1991*
Regarding Henry *1991*
Bugsy *1991*

SANDRA BERNHARD, PP. 105, 168
b. June 6, 1955, Flint, Michigan
Cheech and Chong's Nice Dreams *1981*
The King of Comedy *1983*
Sesame Street Presents Follow That Bird *1985*
The Whoopee Boys *1986*
Casual Sex? *1988*
Track 29 *1988*

195

SANDRA BERNHARD *(continued)*
Heavy Petting *1989*
Without You I'm Nothing (**& SP**) *1990*
Truth or Dare *1991*
Hudson Hawk *1991*

ERIC BOGOSIAN, P. 63
b. April 24, 1953, Woburn, Massachusetts
Born in Flames *1982*
Special Effects *1984*
Talk Radio (**& CO-SP**) *1988*
Suffering Bastards *1990*
Sex, Drugs, Rock & Roll (**& SP**) *1991*

LORRAINE BRACCO, P. 173
b. 1955, Brooklyn, New York
Duos sur Canapes *1979*
Camorra *1986*
The Pick-Up Artist *1987*
Someone to Watch Over Me *1987*
Sing *1989*
The Dream Team *1989*
On a Moonlit Night *1989*
GoodFellas *1990*
Switch *1991*
Medicine Man *1992*
Radio Flyer *1992*
Talent for the Game *1992*
Traces of Red *1992*

SONIA BRAGA, P. 185
b. 1951, Maringa, Parana, Brazil
The Main Road *1968*
A Moreninha *1969*
Captain Bandeira vs. Dr. Moura Brasil
 1970
Mestica The Indomitable Slave *1972*
The Couple *1974*
Dancin' Days *1978*
Doña Flor and Her Two Husbands *1978*
Lady on the Bus *1978*
I Love You *1981*
Gabriela *1983*
Kiss of the Spider Woman *1985*
The Milagro Beanfield War *1988*
Moon Over Parador *1988*
The Rookie *1990*

JEFF BRIDGES, P. 41
b. December 4, 1949, Los Angeles,
California
The Company She Keeps *1950*
Halls of Anger *1970*
The Last Picture Show *1971*
Fat City *1972*
Bad Company *1972*
The Last American Hero *1973*

The Iceman Cometh *1973*
Lolly Madonna XXX *1973*
Thunderbolt and Lightfoot *1974*
Rancho Deluxe *1975*
Hearts of the West *1975*
Stay Hungry *1976*
King Kong *1976*
Somebody Killed Her Husband *1978*
Winter Kills *1979*
The American Success Company *1979*
Heaven's Gate *1980*
Cutter's Way *1981*
Kiss Me Goodbye *1982*
The Last Unicorn (**VOICE**) *1982*
Tron *1982*
Against All Odds *1984*
Starman *1984*
Jagged Edge *1985*
8 Million Ways to Die *1986*
The Morning After *1986*
Nadine *1987*
Tucker: The Man and His Dream *1988*
The Fabulous Baker Boys *1989*
Cold Feet *1989*
See You in the Morning *1989*
Texasville *1990*
The Fisher King *1991*
American Heart *1992*
The Vanishing *1993*

GABRIEL BYRNE, P. 65
b. 1950, Dublin, Ireland
On a Paving Stone Mounted *1978*
The Outsider *1979*
Excalibur *1981*
Reflections *1983*
Wagner *1983*
Hanna K. *1983*
The Keep *1983*
Defence of the Realm *1985*
Gothic *1986*
Lionheart *1987*
Siesta *1987*
Julia and Julia *1987*
Hello Again *1987*
A Soldier's Tale *1988*
The Courier *1988*
Diamond Skulls/Dark Obsession *1989*
Miller's Crossing *1990*
Shipwrecked/Haakon Haakonson *1990*
Cool World *1992*
Into the West *1992*

NICOLAS CAGE, PP. 84–85
(Nicholas Coppola)
b. January 7, 1964, Long Beach,
California
Fast Times at Ridgemont High *1982*
Rumble Fish *1983*
Valley Girl *1983*
Racing With the Moon *1984*
The Cotton Club *1984*
Birdy *1984*
The Boy in Blue *1986*
Peggy Sue Got Married *1986*
Raising Arizona *1987*
Moonstruck *1987*
Vampire's Kiss *1989*
Never on Tuesday *1989*
Time to Kill/Tempo di Uccidere/Short
 Cut *1989*
Fire Birds *1990*
Wild at Heart *1990*
Zandalee *1992*
Honeymoon in Vegas *1992*
Red Rock West *1992*
Amos and Andrew *1993*

MAXWELL CAULFIELD, P. 27
b. November 23, 1959, Glasgow, Scotland
Grease 2 *1982*
Electric Dreams *1984*
The Boys Next Door *1985*
Mind Games *1989*
Sundown: The Vampire in Retreat *1990*
Fatal Sky *1990*
Exiled *1992*

CHER, P. 26
(Cherilyn Sarkisian)
b. May 20, 1946, El Centro, California
Wild on the Beach *1965*
Good Times *1967*
Chastity *1969*
Come Back to the 5 and Dime, Jimmy
 Dean, Jimmy Dean *1982*
Silkwood *1983*
Mask *1985*
The Witches of Eastwick *1987*
Suspect *1987*
Moonstruck (**AA:BA**) *1987*
Mermaids *1990*
The Player *1992*

GLENN CLOSE, P. 109
b. March 19, 1947, Greenwich,
Connecticut
The World According to Garp *1982*
The Big Chill *1983*
The Stone Boy *1984*

The Natural *1984*
Greystoke: The Legend of Tarzan, Lord
 of the Apes (VOICE) *1984*
Maxie *1985*
Jagged Edge *1985*
Fatal Attraction *1987*
Light Years (VOICE) *1988*
Dangerous Liaisons *1988*
Immediate Family *1989*
Reversal of Fortune *1990*
Hamlet *1990*
Meeting Venus *1991*
Hook (UNBILLED BIT) *1991*
Once Upon a Forest (VOICE) *1992*

HARRY CONNICK, JR., P. 81

b. 1967, New Orleans, Louisiana
Memphis Belle *1990*
Little Man Tate *1991*

KEVIN COSTNER, P. 70

*b. January 18, 1955, Los Angeles,
California*
Sizzle Beach, U.S.A. *1974 (released 1986)*
Shadows Run Black *1981 (released 1986)*
Chasing Dreams *1981 (released 1989)*
Frances *1982*
Night Shift *1982*
Stacy's Knights *1983*
Testament *1983*
Table for Five *1983*
The Gunrunner *1983*
Fandango *1985*
Silverado *1985*
American Flyers *1985*
The Untouchables *1987*
No Way Out *1987*
Bull Durham *1988*
Field of Dreams *1989*
Revenge (& EXEC PROD) *1989*
Dances with Wolves (& DIR [AA], CO-PROD)
 1990
Robin Hood: Prince of Thieves *1991*
JFK *1991*
Truth or Dare *1991*
The Bodyguard *1992*

JOAN CRAWFORD, P. 15

(Lucille Fay Le Sueur)
b. March 23, 1904, San Antonio, Texas
d. 1977
Lady of the Night *1925*
Proud Flesh *1925*
Pretty Ladies *1925*
Old Clothes *1925*
The Only Thing *1925*
Sally, Irene and Mary *1925*

The Boob *1926*
Paris *1926*
Tramp, Tramp, Tramp *1926*
The Taxi Dancer *1927*
Winners of the Wilderness *1927*
The Understanding Heart *1927*
The Unknown *1927*
Twelve Miles Out *1927*
Spring Fever *1927*
The Law of the Range *1928*
West Point *1928*
Rose Marie *1928*
Across to Singapore *1928*
Dream of Love *1928*
Four Walls *1928*
Our Dancing Daughters *1928*
The Duke Steps Out *1929*
Hollywood Revue of 1929 *1929*
Our Modern Maidens *1929*
Untamed *1929*
Montana Moon *1930*
Our Blushing Brides *1930*
Paid *1931*
Dance, Fools, Dance *1931*
Laughing Sinners *1931*
This Modern Age *1931*
Possessed *1931*
Grand Hotel *1932*
Letty Lynton *1932*
Rain *1932*
Today We Live *1933*
Dancing Lady *1933*
Sadie McKee *1934*
Chained *1934*
Forsaking All Others *1934*
No More Ladies *1935*
I Live My Life *1935*
The Gorgeous Hussy *1936*
Love on the Run *1936*
The Last of Mrs. Cheyney *1937*
The Bride Wore Red *1937*
Mannequin *1937*
The Shining Hour *1938*
Ice Follies of 1939 *1939*
The Women *1939*
Strange Cargo *1940*
Susan and God *1940*
A Woman's Face *1941*
When Ladies Meet *1941*
They All Kissed the Bride *1942*
Reunion in France *1942*
Above Suspicion *1943*
Hollywood Canteen *1944*
Mildred Pierce (AA:BA) *1945*
Humoresque *1946*
Possessed *1947*
Daisy Kenyon *1947*

Flamingo Road *1949*
It's a Great Feeling *1949*
The Damned Don't Cry *1950*
Harriet Craig *1950*
Goodbye, My Fancy *1951*
This Woman Is Dangerous *1952*
Sudden Fear *1952*
Torch Song *1953*
Johnny Guitar *1954*
Female on the Beach *1955*
Queen Bee *1955*
Autumn Leaves *1956*
The Story of Esther Costello *1957*
The Best of Everything *1959*
What Ever Happened to Baby Jane? *1962*
The Caretakers *1963*
Strait-Jacket *1964*
I Saw What You Did *1965*
Berserk! *1967*
Trog *1970*

HUME CRONYN, P. 141

b. July 18, 1911, London, Ontario, Canada
Shadow of a Doubt *1943*
Phantom of the Opera *1943*
The Cross of Lorraine *1943*
Lifeboat *1944*
The Seventh Cross *1944*
Main Street After Dark *1944*
The Sailor Takes a Wife *1945*
A Letter for Evie *1945*
The Green Years *1946*
The Postman Always Rings Twice *1946*
Ziegfeld Follies *1946*
The Secret Heart (NARR) *1946*
The Beginning or the End *1947*
Brute Force *1947*
The Bride Goes Wild *1948*
Rope (CO-SP ONLY) *1948*
Top o' the Morning *1949*
Under Capricorn (CO-SP ONLY) *1949*
People Will Talk *1951*
Crowded Paradise *1956*
Sunrise at Campobello *1960*
Cleopatra *1963*
Hamlet *1964*
The Arrangement *1969*
Gaily, Gaily *1969*
There Was a Crooked Man *1970*
Conrack *1974*
The Parallax View *1974*
Honky Tonk Freeway *1981*
Rollover *1981*
The World According to Garp *1982*
Impulse *1984*
Brewster's Millions *1985*
Cocoon *1985*

HUME CRONYN (continued)
*batteries not included 1987
Cocoon: The Return 1988

WILLEM DAFOE, PP. 6 R; 73; 80
b. July 22, 1955, Appleton, Wisconsin
The Loveless 1981
New York Nights 1981 (released 1983)
The Hunger 1983
The Communists Are Comfortable (And Three Other Stories) 1984
Streets of Fire 1984
Roadhouse 66 1984
To Live and Die in L.A. 1985
Platoon 1986
Off Limits 1988
The Last Temptation of Christ 1988
Mississippi Burning 1988
Born on the Fourth of July 1989
Triumph of the Spirit 1989
Cry-Baby 1990
Wild at Heart 1990
Flight of the Intruder 1991
Light Sleeper 1992
White Sands 1992
Body of Evidence 1993

ROBERT DE NIRO, P. 77
b. August 17, 1943, New York, New York
The Wedding Party 1963 (released 1969)
Greetings 1968
Sam's Song 1969 (re-released in 1979, with new footage, as The Swap)
Hi, Mom! 1970
Bloody Mama 1970
Jennifer on My Mind 1971
Born to Win 1971
The Gang That Couldn't Shoot Straight 1971
Bang the Drum Slowly 1973
Mean Streets 1973
The Godfather, Part II (AA:BSA) 1974
Taxi Driver 1976
The Last Tycoon 1976
1900 1976
New York, New York 1977
The Deer Hunter 1978
Raging Bull (AA:BA) 1980
True Confessions 1981
The King of Comedy 1983
Once Upon a Time in America 1984
Falling in Love 1984
Brazil 1985
The Mission 1986
Angel Heart 1987
The Untouchables 1987
*Midnight Run 1988

Jacknife 1989
We're No Angels (& EXEC PROD) 1989
Stanley & Iris 1990
GoodFellas 1990
Awakenings 1990
Guilty By Suspicion 1991
Backdraft 1991
Cape Fear 1991
Mad Dog and Glory 1992
Night and the City 1992
Mistress 1992
This Boy's Life 1993

JOHNNY DEPP, P. 164
b. June 9, 1963, Owensboro, Kentucky
A Nightmare on Elm Street 1984
Private Resort 1985
Platoon 1986
Cry-Baby 1990
Edward Scissorhands 1990
Freddy's Dead: The Final Nightmare 1991
American Dreamers/Out of This World/The Arrowtooth Waltz 1992

LAURA DERN, P. 170
b. 1966, Los Angeles, California
Foxes 1980
Ladies and Gentlemen, The Fabulous Stains 1981
Teachers 1984
Mask 1985
Smooth Talk 1985
Blue Velvet 1986
Haunted Summer 1988
Fat Man and Little Boy 1989
Wild at Heart 1990
Rambling Rose 1991

MATT DILLON, PP. 10, 112
b. February 18, 1964, New Rochelle, New York
Over the Edge 1979
Little Darlings 1980
My Bodyguard 1980
Liar's Moon 1981
Tex 1982
The Outsiders 1983
Rumble Fish 1983
The Flamingo Kid 1984
Target 1985
Rebel 1985
Native Son 1986
The Big Town 1987
Kansas 1988
Bloodhounds of Broadway 1989
Drugstore Cowboy 1989

A Kiss Before Dying 1991
Singles 1992
The Saint of Fort Washington 1993
Golden Gate 1993

ROBERT DOWNEY, JR., P. 122
b. April 4, 1965, New York, New York
Pound 1970
Greaser's Palace 1972
Up the Academy 1980
America 1982 (released 1986)
Baby, It's You 1982
Firstborn 1984
Tuff Turf 1985
Weird Science 1985
To Live and Die in L.A. 1985
Back to School 1986
Less Than Zero 1987
The Pick-Up Artist 1987
Johnny Be Good 1988
Rented Lips 1988
1969 1988
That's Adequate 1989
True Believer 1989
Chances Are 1989
Air America 1990
Too Much Sun 1991
Soapdish 1991
Charlie 1992

CARY ELWES, P. 130
b. October 26, 1962, London, England
Another Country 1984
Oxford Blues 1984
The Bride 1985
Lady Jane 1985
The Princess Bride 1987
Maschenka 1987
Glory 1989
Never on Tuesday 1989
Days of Thunder 1990
Hot Shots! 1991
Bram Stoker's "Dracula" 1992
Leather Jackets 1992

EMILIO ESTEVEZ, P. 145
b. May 12, 1962, New York, New York
Tex 1982
The Outsiders 1983
Nightmares 1983
Repo Man 1984
The Breakfast Club 1985
St. Elmo's Fire 1985
That Was Then . . . This Is Now (& SP) 1985
Maximum Overdrive 1986
Wisdom (& DIR, SP) 1986

Stakeout 1987
Young Guns 1988
Never on Tuesday 1989
Men At Work (& DIR) 1990
Young Guns II 1990
Freejack 1992
Bombay/Mighty Ducks 1992

RUPERT EVERETT, P. 158
b. 1959, Norfolk, England
Real Life 1983
Another Country 1984
Dance with a Stranger 1985
Duet for One 1986
Chronicle of a Death Foretold 1986
The Right Hand Man 1987
Hearts of Fire 1987
The Gold-Rimmed Glasses/Gli Occhiali
 d'Oro 1987
Haunted Summer 1988
Tolerance 1989
The Comfort of Strangers 1991
Inside Monkey Zetterland 1992

FARRAH FAWCETT, P. 78
b. February 2, 1947, Corpus Christi, Texas
Love Is a Funny Thing 1969
Myra Breckinridge 1970
Logan's Run 1976
Somebody Killed Her Husband 1978
Sunburn 1979
Saturn 3 1980
Cannonball Run 1981
Extremities 1986
See You in the Morning 1989

SHERILYN FENN, P. 46
b. Detroit, Michigan
The Wild Life 1984
Just One of the Guys 1985
The Wraith 1986
Zombie High 1987
Two Moon Junction 1988
Crime Zone 1988
True Blood 1989
Wild at Heart 1990
Backstreet Dreams 1990
Ruby 1992
Diary of a Hitman 1992
Of Mice and Men 1992
Desire and Hell at the Sunset Motel 1992
Three of Hearts 1993

ERROL FLYNN, P. 50
b. June 20, 1909, Hobart, Tasmania
d. 1959
In the Wake of the Bounty 1933
Murder at Monte Carlo 1935
The Case of the Curious Bride 1935
Don't Bet on Blondes 1935
Captain Blood 1935
The Charge of the Light Brigade 1936
Green Light 1937
The Prince and the Pauper 1937
Another Dawn 1937
The Perfect Specimen 1937
The Adventures of Robin Hood 1938
The Sisters 1938
Four's a Crowd 1938
The Dawn Patrol 1938
Dodge City 1939
The Private Lives of Elizabeth and
 Essex 1939
Virginia City 1940
The Sea Hawk 1940
Santa Fe Trail 1940
Footsteps in the Dark 1941
Dive Bomber 1941
They Died With Their Boots On 1941
Desperate Journey 1942
Gentleman Jim 1942
Edge of Darkness 1943
Thank Your Lucky Stars 1943
Northern Pursuit 1943
Uncertain Glory 1944
Objective, Burma! 1945
San Antonio 1945
Never Say Goodbye 1946
Cry Wolf 1947
Escape Me Never 1947
Silver River 1948
Adventures of Don Juan 1948
It's a Great Feeling 1949
That Forsyte Woman 1949
Montana 1950
Rocky Mountain 1950
Kim 1950
Hello God 1951
Adventures of Captain Fabian (& SP)
 1951
Maru Maru 1952
Against All Flags 1952
The Master of Ballantrae 1953
Crossed Swords/Il Maestro di Don
 Giovanni 1954
Lilacs in the Spring/Let's Make Up 1954
The Dark Avenger/The Warriors 1955
King's Rhapsody 1955
Istanbul 1956
The Big Boodle 1957

The Sun Also Rises 1957
Too Much, Too Soon 1958
The Roots of Heaven 1958
Cuban Rebel Girls (& CO-PROD, SP) 1959

BRIDGET FONDA, P. 117
b. 1964, Los Angeles, California
Aria 1988
You Can't Hurry Love 1988
Scandal 1989
Shag: The Movie 1989
Strapless 1989
Frankenstein Unbound 1990
The Godfather, Part III 1990
Drop Dead Fred 1991
Doc Hollywood 1991
Iron Maze 1991
Out of the Rain 1991
Leather Jackets 1992
Singles 1992
Single White Female 1992
Bodies, Rest and Motion 1993

HARRISON FORD, P. 64
b. July 13, 1942, Chicago, Illinois
Dead Heat on a Merry-Go-Round 1966
Luv 1967
A Time for Killing/The Long Ride
 Home 1967
Journey to Shiloh 1968
Getting Straight 1970
American Graffiti 1973
The Conversation 1974
Star Wars 1977
Heroes 1977
Force 10 from Navarone 1978
Hanover Street 1979
Apocalypse Now 1979
More American Graffiti 1979
The Frisco Kid 1979
The Empire Strikes Back 1980
Raiders of the Lost Ark 1981
Blade Runner 1982
Return of the Jedi 1983
Indiana Jones and the Temple of Doom
 1984
Witness 1985
The Mosquito Coast 1986
Frantic 1988
Working Girl 1988
Indiana Jones and the Last Crusade
 1989
Presumed Innocent 1990
Regarding Henry 1991
Patriot Games 1992

DANNY GLOVER (*continued*)
Silverado *1985*
The Color Purple *1985*
Lethal Weapon *1987*
Bat 21 *1988*
Lethal Weapon 2 *1989*
To Sleep With Anger (**& CO-EXEC PROD**) *1990*
Predator 2 *1990*
Flight of the Intruder *1991*
A Rage in Harlem *1991*
Pure Luck *1991*
Grand Canyon *1991*
Lethal Weapon 3 *1992*
The Saint of Fort Washington *1993*

VALERIA GOLINO, P. 160
A Joke of Destiny *1983*
Blind Date *1984*
My Dearest Son/Figlio Mio Infinitamente Caro *1985*
Little Fires/Piccoli Fuochi *1985*
Dumb Dicks/Asilo di Polizia *1986*
Love Story/Storia d'Amore *1986*
Last Summer in Tangiers/L'été dernier à Tanger *1987*
The Gold-Rimmed Glasses/Gli Occhiali d'Oro *1987*
Three Sisters/Paura e Amore *1988*
Big Top Pee-wee *1988*
Rain Man *1988*
Torrents of Spring *1989*
Il y a des Jours . . . et des Lunes *1990*
The King's Whore *1990*
Traces of an Amorous Life/Tracce di una vita amorosa *1990*
Hot Shots! *1991*
Year of the Gun *1991*

MELANIE GRIFFITH, P. 45
b. *August 9, 1957, New York, New York*
Smile *1975*
Night Moves *1975*
The Drowning Pool *1976*
One on One *1977*
Joyride *1977*
Roar *1981*
Underground Aces *1981*
Fear City *1984*
Body Double *1984*
Something Wild *1986*
Cherry 2000 *1986* (released *1988*)
The Milagro Beanfield War *1988*
Stormy Monday *1988*
Working Girl *1988*
In the Spirit *1990*
Pacific Heights *1990*

The Bonfire of the Vanities *1990*
Paradise *1991*
Shining Through *1992*
Close to Eden *1992*
Born Yesterday *1993*

ANTHONY MICHAEL HALL, P. 123
b. *April 14, 1968, Boston, Massachusetts*
Six Pack *1982*
National Lampoon's Vacation *1983*
Sixteen Candles *1984*
The Breakfast Club *1985*
Weird Science *1985*
Out of Bounds *1986*
Johnny Be Good *1988*
Edward Scissorhands *1990*
Into the Sun *1992*
Upworld *1992*

TOM HANKS, P. 176
b. *July 9, 1956, Concord, California*
He Knows You're Alone *1981*
Splash *1984*
Bachelor Party *1984*
The Man with One Red Shoe *1985*
Volunteers *1985*
The Money Pit *1986*
Nothing in Common *1986*
Every Time We Say Goodbye *1986*
Dragnet *1987*
Big *1988*
Punchline *1988*
The 'Burbs *1989*
Turner & Hooch *1989*
Joe Versus the Volcano *1990*
The Bonfire of the Vanities *1990*
Radio Flyer *1992*
A League of Their Own *1992*

ED HARRIS, PP. 136–37
b. *November 28, 1950, Tenafly, New Jersey*
Coma *1978*
Borderline *1980*
Knightriders *1981*
Creepshow *1982*
The Right Stuff *1983*
Under Fire *1983*
Swing Shift *1984*
Places in the Heart *1984*
A Flash of Green *1984*
Alamo Bay *1985*
Sweet Dreams *1985*
Code Name: Emerald *1985*
Walker *1987*
To Kill a Priest *1988*
Jacknife *1989*

The Abyss *1989*
State of Grace *1990*
China Moon *1992*
Glengarry Glen Ross *1992*

KATHARINE HEPBURN, P. 154
b. *November 9, 1907, Hartford, Connecticut*
A Bill of Divorcement *1932*
Christopher Strong *1933*
Morning Glory (**AA:BA**) *1933*
Little Women *1933*
Spitfire *1934*
The Little Minister *1934*
Break of Hearts *1935*
Alice Adams *1935*
Sylvia Scarlet *1936*
Mary of Scotland *1936*
A Woman Rebels *1936*
Quality Street *1937*
Stage Door *1937*
Bringing Up Baby *1938*
Holiday *1938*
The Philadelphia Story *1940*
Woman of the Year *1942*
Keeper of the Flame *1942*
Stage Door Canteen *1943*
Women in Defense (**NARR**) *1943*
Dragon Seed *1944*
Without Love *1945*
Undercurrent *1946*
Sea of Grass *1947*
Song of Love *1947*
State of the Union *1948*
Adam's Rib *1949*
The African Queen *1951*
Pat and Mike *1952*
Summertime/Summer Madness *1955*
The Rainmaker *1956*
The Iron Petticoat *1956*
Desk Set *1957*
Suddenly, Last Summer *1959*
Long Day's Journey Into Night *1962*
Guess Who's Coming to Dinner (**AA:BA**) *1967*
The Lion in Winter (**AA:BA**) *1968*
The Madwoman of Chaillot *1969*
The Trojan Women *1971*
A Delicate Balance *1973*
Rooster Cogburn *1975*
Olly, Olly, Oxen Free *1978*
On Golden Pond (**AA:BA**) *1981*
Grace Quigley/The Ultimate Solution of Grace Quigley *1985*

Where the Day Takes You *1992*
Rich in Love *1992*
Twin Peaks: Fire Walk With Me *1992*
The Trial *1993*

SHIRLEY MACLAINE, PP. 184, 216
(Shirley MacLean Beaty)
b. April 24, 1934, Richmond, Virginia
The Trouble with Harry *1955*
Artists and Models *1955*
Around the World in 80 Days *1956*
Hot Spell *1958*
The Matchmaker *1958*
The Sheepman *1958*
Some Came Running *1958*
Ask Any Girl *1959*
Career *1959*
Can-Can *1960*
The Apartment *1960*
Ocean's Eleven *1960*
All in a Night's Work *1961*
Two Loves *1961*
My Geisha *1962*
The Children's Hour *1962*
Two for the Seesaw *1962*
Irma La Douce *1963*
What a Way to Go! *1964*
John Goldfarb, Please Come Home *1965*
The Yellow Rolls-Royce *1965*
Gambit *1966*
Woman Times Seven *1967*
The Bliss of Mrs. Blossom *1968*
Sweet Charity *1969*
Two Mules for Sister Sara *1970*
Desperate Characters *1971*
The Possession of Joel Delaney *1972*
The Year of the Woman (**DOCU**) *1973*
The Other Half of the Sky: A China
 Memoir (**DOCU; PROD, CO-DIR**) *1975*
Sois belle et tais-toi *1977*
The Turning Point *1977*
Being There *1979*
Loving Couples *1980*
A Change of Seasons *1980*
Terms of Endearment (**AA:BA**) *1983*
Cannonball Run II *1984*
Madame Sousatzka *1988*
Steel Magnolias *1989*
Waiting for the Light *1990*
Postcards From the Edge *1990*
Defending Your Life *1991*
Used People *1992*

MADONNA, P. 152
(Madonna Louise Ciccone)
b. August 16, 1958, Bay City, Michigan
A Certain Sacrifice *1985* (filmed
 1978–1981)
Vision Quest *1985*
Desperately Seeking Susan *1985*
Shanghai Surprise *1986*
Who's That Girl? *1987*
Bloodhounds of Broadway *1989*
Dick Tracy *1990*
Truth or Dare (**& EXEC PROD**) *1991*
Shadows and Fog *1992*
A League of Their Own *1992*
Body of Evidence *1993*

VIRGINIA MADSEN, P. 111
b. 1963, Winnetka, Illinois
Class *1983*
Dune *1984*
Electric Dreams *1984*
Creator *1985*
Fire With Fire *1986*
Modern Girls *1986*
Zombie High *1987*
Slamdance *1987*
Mr. North *1988*
Hot to Trot *1988*
Heart of Dixie *1989*
The Hot Spot *1990*
Highlander II: The Quickening *1991*
Becoming Colette *1992*
Candyman *1992*

ANN MAGNUSON, PP. 57, 172
b. 1956, Charleston, West Virginia
Vortex *1982*
The Hunger *1983*
Desperately Seeking Susan *1985*
Sleepwalk *1986*
Making Mr. Right *1987*
A Night in the Life of Jimmy Reardon
 1988
Mondo New York *1988*
Tequila Sunrise *1988*
Checking Out *1989*
Heavy Petting *1989*
Love at Large *1990*

JOHN MALKOVICH, PP. 76, 150
b. December 9, 1953, Christopher, Illinois
The Killing Fields *1984*
Places in the Heart *1984*
Eleni *1985*
Making Mr. Right *1987*
The Glass Menagerie *1987*
Empire of the Sun *1987*

Miles From Home *1988*
Dangerous Liaisons *1988*
The Accidental Tourist (**CO-EXEC PROD
 ONLY**) *1988*
The Sheltering Sky *1990*
Queens Logic *1991*
The Object of Beauty *1991*
Shadows and Fog *1992*
We're Back (**VOICE**) *1992*
Jennifer 8 *1992*
Of Mice and Men *1992*

MARY STUART MASTERSON, P. 132
b. 1967, New York, New York
The Stepford Wives *1975*
Heaven Help Us *1985*
At Close Range *1986*
My Little Girl *1986*
Some Kind of Wonderful *1987*
Gardens of Stone *1987*
Mr. North *1988*
Chances Are *1989*
Immediate Family *1989*
Funny About Love *1990*
Fried Green Tomatoes *1991*
Married to It *1992*
Mad at the Moon *1992*

MARY ELIZABETH MASTRANTONIO, P. 175
b. November 17, 1958, Oak Park, Illinois
Scarface *1983*
The Color of Money *1986*
Slamdance *1987*
The January Man *1989*
The Abyss *1989*
Fools of Fortune *1990*
Class Action *1991*
Robin Hood: Prince of Thieves *1991*
White Sands *1992*
Consenting Adults *1992*

DEBI MAZAR, P. 40
GoodFellas *1990*
Jungle Fever *1991*
Little Man Tate *1991*
In the Soup *1992*
Inside Monkey Zetterland *1992*

BETTE MIDLER, P. 59
*b. December 1, 1945, raised Honolulu,
Hawaii*
Hawaii *1966*
The Divine Mr. J. *1974*
The Rose *1979*
Divine Madness *1980*
Jinxed *1982*
Down and Out in Beverly Hills *1986*
Ruthless People *1986*

Parenthood 1989
I Love You to Death 1990
Tune in Tomorrow . . . 1990
Point Break 1991
Bill & Ted's Bogus Journey 1991
My Own Private Idaho 1991
Bram Stoker's "Dracula" 1992

CHRISTINA RICCI, P. 90
b. 1980, Montclair, New Jersey
Mermaids 1990
The Hard Way 1991
The Addams Family 1991

MOLLY RINGWALD, P. 54
b. February 14, 1968, Rosewood,
California
Tempest 1982
P.K. and the Kid 1982 (released 1987)
Spacehunter: Adventures in the
 Forbidden Zone 1983
Sixteen Candles 1984
The Breakfast Club 1985
Pretty in Pink 1986
The Pick-Up Artist 1987
King Lear 1987
For Keeps 1988
Fresh Horses 1988
Strike It Rich 1990
Betsy's Wedding 1990

ERIC ROBERTS, PP. 28, 98–99
b. April 18, 1956, Biloxi, Mississippi
King of the Gypsies 1978
Raggedy Man 1981
Star 80 1983
The Pope of Greenwich Village 1984
The Coca-Cola Kid 1985
Runaway Train 1985
Nobody's Fool 1986
Blood Red 1986 (released 1989)
Rude Awakening 1989
Options 1989
Best of the Best 1989
The Ambulance/Into Thin Air 1990
Lonely Hearts 1991
By the Sword 1991
Final Analysis 1992

JULIA ROBERTS, PP. 98–99
b. October 28, 1967, Smyrna, Georgia
Blood Red 1986 (released 1989)
Satisfaction 1988
Mystic Pizza 1988
Steel Magnolias 1989
Pretty Woman 1990
Flatliners 1990

Sleeping With the Enemy 1991
Dying Young 1991
Hook 1991
The Player 1992

ISABELLA ROSSELLINI, PP. 49, 104
b. June 18, 1952, Rome, Italy
A Matter of Time 1976
The Meadow/Il Prato 1979
Il Pap'Occhio 1981
White Nights 1985
Blue Velvet 1986
Red Riding Hood 1987
Tough Guys Don't Dance 1987
Siesta 1987
Zelly and Me 1988
Cousins 1989
Wild at Heart 1990
Les Dames Galantes 1991
The Pickle 1992
Death Becomes Her 1992
Siege of Venice 1992
The Innocent 1993

MEG RYAN, P. 162
b. November 19, 1961, Fairfield,
Connecticut
Rich and Famous 1981
Amityville 3-D 1983
Top Gun 1986
Armed and Dangerous 1986
Innerspace 1987
D.O.A. 1988
Promised Land 1988
The Presidio 1988
When Harry Met Sally . . . 1989
Joe Versus the Volcano 1990
The Doors 1991
Prelude to a Kiss 1992
Sirens 1992

WINONA RYDER, P. 35
(Winona Horowitz)
b. October 1971, Winona, Minnesota
Lucas 1986
Square Dance 1987
Beetlejuice 1988
1969 1988
Heathers 1989
Great Balls of Fire! 1989
Mermaids 1990
Welcome Home, Roxy Carmichael 1990
Edward Scissorhands 1990
Night on Earth 1991
Bram Stoker's "Dracula" 1992
The Age of Innocence 1993

JULIAN SANDS, P. 139
b. 1958, Yorkshire, England
Privates on Parade 1982
The Killing Fields 1984
Oxford Blues 1984
After Darkness 1985
The Doctor and the Devils 1985
A Room with a View 1985
Gothic 1986
Siesta 1987
Vibes 1988
Wherever You Are 1988
Tennessee Nights 1989
Manika: The Girl Who Lived Twice 1989
Arachnophobia 1990
Warlock 1991
Night Sun/Il Sole anche di notte 1990
Wicked/Cattiva 1991
Impromptu 1991
Naked Lunch 1991
Husbands and Lovers 1992
Grand Isle 1992
Turn of the Screw 1992

MIA SARA, P. 179
b. 1968, Brooklyn, New York
Legend 1985
Ferris Bueller's Day Off 1986
The Long Lost Friend 1987
Apprentice to Murder 1988
Shadows in the Storm 1989
Any Man's Death 1990
By the Sword 1991
Close to Eden 1992

SUSAN SARANDON, P. 128
(nee Tomaling)
b. October 4, 1946, New York, New York
Joe 1970
Lady Liberty 1971
Lovin' Molly 1974
The Front Page 1974
The Great Waldo Pepper 1975
The Rocky Horror Picture Show 1975
Dragonfly/One Summer Love 1976
Crash/Checkered Flag or Crash 1977
The Great Smokey Roadblock/The Last
 of the Cowboys (& CO-PROD) 1977
The Other Side of Midnight 1977
Pretty Baby 1978
King of the Gypsies 1978
Something Short of Paradise 1979
Loving Couples 1980
Atlantic City 1981
Tempest 1982
The Hunger 1983
In Our Hands (DOCU) 1984

SUSAN SARANDON (continued)
The Buddy System 1984
Compromising Positions 1985
The Witches of Eastwick 1987
Bull Durham 1988
Sweet Hearts Dance 1988
The January Man 1989
A Dry White Season 1989
Through the Wire (DOCU; NARR) 1990
White Palace 1990
Thelma & Louise 1991
Light Sleeper 1992
The Player 1992
Bob Roberts 1992
Lorenzo's Oil 1992

ARNOLD SCHWARZENEGGER, P. 62
b. July 30, 1947, Graz, Austria
Hercules Goes Bananas/Hercules in
 New York (as Arnold Strong) 1970
The Long Goodbye 1973
Stay Hungry 1976
Pumping Iron 1977
Scavenger Hunt 1979
The Villain 1979
Conan the Barbarian 1982
Conan the Destroyer 1984
The Terminator 1984
Red Sonja 1985
Commando 1985
Raw Deal 1986
Predator 1987
Running Man 1987
Red Heat 1988
Twins 1988
Total Recall 1990
Kindergarten Cop 1990
Terminator 2: Judgment Day 1991

ADRIENNE SHELLY, P. 82
b. Queens, New York
Trust 1990
The Unbelievable Truth 1991
Stepkids 1992
Hold Me, Thrill Me, Kiss Me 1992

CYBILL SHEPHERD, P. 23
b. February 18, 1950, Memphis, Tennessee
The Last Picture Show 1971
The Heartbreak Kid 1972
Daisy Miller 1974
At Long Last Love 1975
Taxi Driver 1976
Special Delivery 1976
Silver Bears 1978
The Lady Vanishes 1979
The Return 1981

Chances Are 1989
Texasville 1990
Alice 1990
Once Upon a Crime 1992
Married to It 1992

WESLEY SNIPES, P. 87
b. 1962, Orlando, Florida
Streets of Gold 1986
Wild Cats 1986
Cry From the Mountain 1987
Major League 1989
King of New York 1990
Mo' Better Blues 1990
New Jack City 1991
Jungle Fever 1991
White Men Can't Jump 1992
The Waterdance 1992
Passenger 57 1992
Money Men 1993

SISSY SPACEK, P. 71
(Mary Elizabeth Spacek)
b. December 25, 1949, Quitman, Texas
Trash (EXTRA) 1970
Prime Cut 1972
Ginger in the Morning 1973
Badlands 1973
Phantom of the Paradise (SET DEC ONLY)
 1974
Carrie 1976
Welcome to L.A. 1977
3 Women 1977
Heart Beat 1979
Coal Miner's Daughter (AA:BA) 1980
Raggedy Man 1981
Missing 1982
The Man with Two Brains (VOICE) 1983
The River 1984
Marie 1985
Violets Are Blue 1986
'Night, Mother 1986
Crimes of the Heart 1986
The Long Walk Home 1990
JFK 1991
Hard Promises 1992

JAMES SPADER, P. 159
b. February 7, 1960, Boston,
Massachusetts
Endless Love 1981
The New Kids 1985
Tuff Turf 1985
Pretty in Pink 1986
Mannequin 1987
Wall Street 1987
Less Than Zero 1987

Baby Boom 1987
Jack's Back 1988
The Rachel Papers 1989
sex, lies, and videotape 1989
Bad Influence 1990
White Palace 1990
True Colors 1991
Storyville 1992
Bob Roberts 1992
The Music of Chance 1993

SYLVESTER STALLONE, P. 92
b. July 6, 1946, New York, New York
(as actor, and as noted)
Party at Kitty and Studs 1970
 (re-released as The Italian Stallion)
Bananas 1971
Rebel 1972 (re-edited and re-released
 as A Man Called . . . Rainbo)
The Lords of Flatbush 1974
No Place to Hide 1975
The Prisoner of Second Avenue 1975
Capone 1975
Death Race 2000 1975
Farewell, My Lovely 1975
Cannonball 1976
Rocky (& SP) 1976
F.I.S.T. (& CO-SP) 1978
Paradise Alley (& DIR, SP) 1978
Rocky II (& DIR, SP) 1979
Nighthawks 1981
Victory 1981
Rocky III (& DIR, SP) 1982
First Blood (& CO-SP) 1982
Staying Alive (CAMEO; PROD, DIR, CO-SP) 1983
Rhinestone (& CO-SP) 1984
Rambo: First Blood Part II (& CO-SP)
 1985
Rocky IV (& SP) 1985
Cobra (& SP) 1986
Over the Top (& CO-SP) 1987
Rambo III (& CO-SP) 1988
Lock Up 1989
Tango & Cash 1989
Rocky V (& SP) 1990
Oscar 1991
Stop! or My Mom Will Shoot 1992
Cliffhanger 1993

HARRY DEAN STANTON, P. 135
b. July 14, 1926, Lexington, Kentucky
Revolt at Fort Laramie 1957
Tomahawk Trail 1957
The Proud Rebel 1958
Pork Chop Hill 1959
The Adventures of Huckleberry Finn
 1960

A Dog's Best Friend 1960
Hero's Island 1962
The Man From the Diner's Club 1963
Ride in the Whirlwind 1966
The Hostage 1967
A Time for Killing/The Long Ride
 Home 1967
Cool Hand Luke 1967
Day of the Evil Gun 1968
The Miniskirt Mob 1968
Kelly's Heroes 1970
Rebel Rousers 1970
Cisco Pike 1971
Two-Lane Blacktop 1971
Face to the Wind/Count Your
 Bullets/Cry for Me, Billy 1972
Pat Garrett and Billy the Kid 1973
Dillinger 1973
Zandy's Bride 1974
Where the Lilies Bloom 1974
Cockfighter 1974
The Godfather, Part II 1974
Rancho Deluxe 1975
Farewell, My Lovely 1975
Rafferty and the Gold Dust Twins 1975
Win, Place or Steal 1975
92 in the Shade 1975
The Missouri Breaks 1976
Renaldo and Clara 1978
Straight Time 1978
Alien 1979
The Rose 1979
Wise Blood 1979
Deathwatch 1980
The Black Marble 1980
Private Benjamin 1980
UFOria 1980 (released 1986)
Escape From New York 1981
One From the Heart 1982
Young Doctors in Love 1982
Tough Enough 1983
Christine 1983
Repo Man 1984
Paris, Texas 1984
Red Dawn 1984
The Bear 1984
One Magic Christmas 1985
Fool for Love 1985
The Care Bears Movie (VOICE) 1985
Pretty in Pink 1986
Slamdance 1987
Stars and Bars 1988
Mr. North 1988
The Last Temptation of Christ 1988
Twister 1988
Dream a Little Dream 1989
The Fourth War 1990

Wild at Heart 1990
Motion and Emotion (DOCU) 1990
Twin Peaks: Fire Walk With Me 1992
Payoff 1992
Man Trouble 1992

ERIC STOLTZ, P. 124
b. 1961, American Samoa
Fast Times at Ridgemont High 1982
Lucky 13/Running Hot 1984
Surf II 1984
The Wild Life 1984
The New Kids 1985
Code Name: Emerald 1985
Mask 1985
Some Kind of Wonderful 1987
Lionheart 1987
Sister, Sister 1987
Haunted Summer 1988
Manifesto 1988
The Fly II 1989
Say Anything . . . 1989
Memphis Belle 1990
Money 1991
The Waterdance 1992
Bodies, Rest and Motion 1993

MERYL STREEP, PP. 118–19
(Mary Louise Streep)
June 22, 1949, Summit, New Jersey
Julia 1977
The Deer Hunter 1978
Manhattan 1979
The Seduction of Joe Tynan 1979
Kramer vs. Kramer (AA:BSA) 1979
The French Lieutenant's Woman 1981
Still of the Night 1982
Sophie's Choice (AA:BA) 1982
Silkwood 1983
In Our Hands (DOCU) 1984
Falling in Love 1984
Plenty 1985
Out of Africa 1985
Heartburn 1986
Ironweed 1987
A Cry in the Dark 1988
She-Devil 1989
Postcards From the Edge 1990
Defending Your Life 1991
Death Becomes Her 1992

BARBARA SUKOWA, P. 96
b. February 2, 1950, Bremen, Germany
Frauen in New York 1977
Berlin Alexanderplatz 1980
Marianne and Julianne 1981
Un Dimanche de Flics 1982

Lola 1982
Equateur 1983
Rosa Luxemburg 1986
The Lovers/Die Verliebten 1987
The Sicilian 1987
The Return 1990
L'Africana 1991
Voyager 1991
Zentropa 1991

DONALD SUTHERLAND, P. 89
b. July 17, 1934, St. John,
New Brunswick, Canada
The World 10 Times Over/Pussycat
 Alley 1963
Castle of the Living Dead 1964
Dr. Terror's House of Horrors 1965
Die! Die! My Darling/Fanatic 1965
Morgan!/Morgan — A Suitable Case for
 Treatment (VOICE) 1965
The Bedford Incident 1965
Promise Her Anything 1966
The Dirty Dozen 1967
Billion Dollar Brain 1967
Oedipus the King 1968
Sebastian 1968
Interlude 1968
Joanna 1968
The Split 1968
Start the Revolution Without Me 1970
Act of the Heart 1970
M*A*S*H 1970
Kelly's Heroes 1970
Alex in Wonderland 1970
Little Murders 1971
Klute 1971
Johnny Got His Gun 1971
F.T.A. (& CO-PROD, CO-DIR, CO-SP) 1972
Steelyard Blues (& EXEC PROD) 1973
Lady Ice 1973
Alien Thunder/Dan Candy's Law 1973
Don't Look Now 1973
S*P*Y*S 1974
The Day of the Locust 1975
Murder on the Bridge 1975
La Spirale (NARR) 1975
Fellini's Casanova 1976
End of the Game/Deception 1976
The Eagle Has Landed 1976
1900 1976
The Kentucky Fried Movie 1977
The Disappearance 1977
Blood Relatives 1978
National Lampoon's Animal House 1978
Invasion of the Body Snatchers 1978
Murder by Decree 1979
The Great Train Robbery 1979

DONALD SUTHERLAND *(continued)*
Bear Island *1979*
A Man, a Woman and a Bank *1979*
Nothing Personal *1980*
Ordinary People *1980*
Gas *1981*
Eye of the Needle *1981*
Threshold *1981*
A War Story (NARR) *1982*
Max Dugan Returns *1983*
Hotel de la Paix *1983*
Crackers *1984*
Ordeal by Innocence *1984*
Heaven Help Us *1985*
Revolution *1985*
The Long Lost Friend *1987*
The Wolf at the Door *1987*
The Rosary Murders *1987*
Apprentice to Murder *1988*
Lost Angels *1989*
A Dry White Season *1989*
Lock Up *1989*
Bethune: The Making of a Hero *1990*
Eminent Domain *1990*
Backdraft *1991*
Buster's Bedroom *1991*
JFK *1991*
Scream of Stone *1991*
Buffy the Vampire Slayer *1992*

KIEFER SUTHERLAND, P. 103
b. December 18, 1966, London, England
Max Dugan Returns *1983*
The Bay Boy *1984*
At Close Range *1986*
Crazy Moon *1986*
Stand By Me *1986*
The Lost Boys *1987*
The Killing Time *1987*
Bright Lights, Big City *1988*
1969 *1988*
Promised Land *1988*
Young Guns *1988*
Renegades *1989*
Flashback *1990*
Chicago Joe and the Showgirl *1990*
Flatliners *1990*
Young Guns II *1990*
The Nutcracker Prince (VOICE) *1990*
Article 99 *1992*
A Few Good Men *1992*
The Vanishing *1993*

PATRICK SWAYZE, P. 131
b. August 18, 1952, Houston, Texas
Skatetown, U.S.A. *1979*
The Outsiders *1983*
Uncommon Valor *1983*
Red Dawn *1984*
Grandview, U.S.A. *1984*
Youngblood *1986*
Dirty Dancing *1987*
Steel Dawn *1987*
Tiger Warsaw *1988*
Road House *1989*
Next of Kin *1989*
Ghost *1990*
Point Break *1991*
City of Joy *1992*

JESSICA TANDY, P. 141
b. June 7, 1909, London, England
The Indiscretions of Eve *1932*
Murder in the Family *1938*
The Seventh Cross *1944*
The Valley of Decision *1945*
Dragonwyck *1946*
The Green Years *1946*
Forever Amber *1947*
A Woman's Vengeance *1948*
September Affair *1951*
The Desert Fox *1951*
The Light in the Forest *1958*
Hemingway's Adventures of a Young
 Man *1962*
The Birds *1963*
Butley *1974*
Honky Tonk Freeway *1981*
Still of the Night *1982*
The World According to Garp *1982*
Best Friends *1982*
The Bostonians *1984*
Cocoon *1985*
*batteries not included *1987*
The House on Carroll Street *1988*
Cocoon: The Return *1988*
Driving Miss Daisy (AA:BA) *1989*
Fried Green Tomatoes *1991*
Used People *1992*

UMA THURMAN, PP. 30–31, 116
b. April 29, 1970, Boston, Massachusetts
Kiss Daddy Good Night *1987*
Johnny Be Good *1988*
Dangerous Liaisons *1988*
The Adventures of Baron Munchausen
 1989
Where the Heart Is *1990*
Henry & June *1990*
Final Analysis *1992*

Jennifer 8 *1992*
Mad Dog and Glory *1992*

LILY TOMLIN, P. 153
(Mary Jean Tomlin)
b.September 1, 1939, Detroit, Michigan
Nashville *1975*
The Late Show *1977*
Moment by Moment *1978*
9 to 5 *1980*
The Incredible Shrinking Woman *1981*
All of Me *1984*
Lily Tomlin (DOCU) *1986*
Big Business *1988*
The Search for Signs of Intelligent Life
 in the Universe (& CO-SP) *1991*
Shadows and Fog *1992*
The Player *1992*

JOHN TRAVOLTA, P. 58
b. February 18, 1954, Englewood,
New Jersey
The Devil's Rain *1975*
Carrie *1976*
Saturday Night Fever *1977*
Grease *1978*
Moment by Moment *1978*
Urban Cowboy *1980*
Blow Out *1981*
Staying Alive *1983*
Two of a Kind *1983*
Perfect *1985*
The Experts *1989*
Look Who's Talking *1989*
Chains of Gold (& CO-SP) *1989*
Look Who's Talking Too *1990*
Shout *1991*

KATHLEEN TURNER, P. 183
(Mary Kathleen Turner)
b. June 19, 1954, Springfield, Missouri
Body Heat *1981*
The Man With Two Brains *1983*
Romancing the Stone *1984*
Crimes of Passion *1984*
A Breed Apart *1984*
Prizzi's Honor *1985*
The Jewel of the Nile *1985*
Peggy Sue Got Married *1986*
Julia and Julia *1987*
Switching Channels *1988*
Who Framed Roger Rabbit? (VOICE) *1988*
The Accidental Tourist *1988*
The War of the Roses *1989*
V.I. Warshawski *1991*
House of Cards *1992*

JOHN TURTURRO, P. 61
b. February 28, 1957, Brooklyn,
New York
Raging Bull 1980
Exterminator II 1984
The Flamingo Kid 1984
Desperately Seeking Susan 1985
To Live and Die in L.A. 1985
Hannah and Her Sisters 1986
Gung Ho 1986
Off Beat 1986
The Color of Money 1986
The Sicilian 1987
Five Corners 1988
Do the Right Thing 1989
Backtrack 1989 (released 1992)
Miller's Crossing 1990
Men of Respect 1990
Mo' Better Blues 1990
State of Grace 1990
Jungle Fever 1991
Barton Fink 1991
Brain Donors 1992
Mac (& DIR, SP) 1992

JEAN-CLAUDE VAN DAMME, P. 44
b. 1961, Brussels, Belgium
No Retreat, No Surrender 1986
Bloodsport 1987
Black Eagle 1988
Marquis 1989 (released 1992)
Kickboxer 1989
Cyborg 1989
Death Warrant 1990
Lionheart 1990
Double Impact 1991
Universal Soldier 1992
Crossing the Line/Pals 1993

DENZEL WASHINGTON, P. 140
b. December 28, 1954, Mt. Vernon,
New York
Carbon Copy 1981
A Soldier's Story 1984
Power 1986
Cry Freedom 1987
For Queen and Country 1988
The Mighty Quinn 1989
Glory (AA:BSA) 1989
Heart Condition 1990
Mo' Better Blues 1990
Ricochet 1991
Mississippi Masala 1992
Malcolm X 1992

SIGOURNEY WEAVER, PP. 79, 163
(Susan Weaver)
b. October 8, 1949, New York, New York
Madman 1977
Annie Hall 1977
Alien 1979
Eyewitness 1981
The Year of Living Dangerously 1983
Deal of the Century 1983
Ghostbusters 1984
One Woman or Two 1985
Aliens 1986
Half Moon Street 1986
Gorillas in the Mist 1988
Working Girl 1988
Helmut Newton: Frames From the Edge
 (DOCU) 1989
Ghostbusters II 1989
Alien³ 1992
1492 1992

JOHNNY WEISSMULLER, P. 18
(Peter John Weissmuller)
b. June 2, 1904, Windber, Pennsylvania
d. 1984
Glorifying the American Girl 1929
Tarzan, the Ape Man 1932
Tarzan and His Mate 1934
Hollywood Party 1934
Tarzan Escapes 1936
Tarzan Finds a Son! 1939
Tarzan's Secret Treasure 1941
Tarzan's New York Adventure 1942
Stage Door Canteen 1943
Tarzan Triumphs 1943
Tarzan's Desert Mystery 1943
Tarzan and the Amazons 1945
Swamp Fire 1946
Tarzan and the Leopard Woman 1946
Tarzan and the Huntress 1947
Tarzan and the Mermaids 1948
Jungle Jim 1948
The Lost Tribe 1949
Captive Girl 1950
Mark of the Gorilla 1950
Pigmy Island 1950
Fury of the Congo 1951
Jungle Manhunt 1951
Voodoo Tiger 1952
Jungle Jim in the Forbidden Land 1952
Savage Mutiny 1953
Valley of the Headhunters 1953
Killer Ape 1953
Jungle Man-Eaters 1954
Cannibal Attack 1954
Jungle Moon Men 1955
Devil Goddess 1955

The Phynx 1970
Won Ton Ton, the Dog Who Saved
 Hollywood 1976

JOANNE WHALLEY-KILMER, P. 127
b. 1964, Manchester, England
Pink Floyd the Wall 1982
No Surrender 1985
Dance with a Stranger 1985
The Good Father 1986
To Kill a Priest 1988
Willow 1988
Scandal 1989
Kill Me Again 1989
Navy SEALS 1990
Shattered 1991
The Big Man 1991
Storyville 1992

DIANNE WIEST, P. 126
b. March 28, 1948, Kansas City, Missouri
It's My Turn 1980
I'm Dancing as Fast as I Can 1982
Independence Day 1983
Footloose 1984
Falling in Love 1984
The Purple Rose of Cairo 1985
Hannah and Her Sisters (AA:BSA) 1986
Radio Days 1987
The Lost Boys 1987
September 1987
Bright Lights, Big City 1988
Cookie 1989
Parenthood 1989
Edward Scissorhands 1990
Little Man Tate 1991

ROBIN WILLIAMS, P. 102
b. July 21, 1952, Chicago, Illinois
Can I Do It . . . Til I Need Glasses?
 1977 (re-edited & re-released 1979)
Popeye 1980
The World According to Garp 1982
The Survivors 1983
Moscow on the Hudson 1984
The Best of Times 1986
Club Paradise 1986
Good Morning, Vietnam 1987
The Adventures of Baron Munchausen
 1989
Dead Poets Society 1989
Cadillac Man 1990
Awakenings 1990
Dead Again 1991
The Fisher King 1991
Hook 1991
Shakes the Clown 1992

ROBIN WILLIAMS (*continued*)

FernGully . . . The Last Rainforest
 (VOICE) *1992*

Toys *1992*

DEBRA WINGER, P. 134

b.May 17, 1955, Cleveland, Ohio

Slumber Party '57 *1977*

Thank God It's Friday *1978*

French Postcards *1979*

Urban Cowboy *1980*

E.T. The Extra-Terrestrial (VOICE) *1982*

Cannery Row *1982*

An Officer and a Gentleman *1982*

Mike's Murder *1982 (released 1984)*

Terms of Endearment *1983*

Legal Eagles *1986*

Made in Heaven *1987*

Black Widow *1987*

Betrayed *1988*

Everybody Wins *1990*

The Sheltering Sky *1990*

Wilder Napalm *1992*

ALFRE WOODARD, P. 144

b. November 8, 1953, Tulsa, Oklahoma

Remember My Name *1978*

H.E.A.L.T.H./Health *1979*

Cross Creek *1983*

Extremities *1986*

Scrooged *1988*

Miss Firecracker *1989*

Grand Canyon *1991*

Rich in Love *1992*

The Gun in Betty Lou's Handbag *1992*

SEAN YOUNG, PP. 7R, 186

b. November 20, 1959, Louisville, Kentucky

Jane Austen in Manhattan *1980*

Stripes *1981*

Blade Runner *1982*

Young Doctors in Love *1982*

Dune *1984*

Baby . . . Secret of the Lost Legend *1985*

No Way Out *1987*

Wall Street *1988*

The Boost *1988*

Cousins *1989*

Fire Birds *1990*

A Kiss Before Dying *1991*

Love Crimes *1992*

Once Upon a Crime *1992*

Sketch Artist *1992*

Forever *1992*

ACKNOWLEDGMENTS

This book could never have happened without an awful lot of wonderful people. I salute all of them.

To Greg Porto and his first vision of *Shooting Stars* as a book. This project was his dream.

To my designer Paul Zakris for making this book so beautiful. To Sarah Longacre for being the most incredible photo editor an author could ever dream of working with. For her constant blessed enthusiasm and care. And to Jose Pouso and Jeremiah Bogert for their encouragement. To Andy Stewart for his immediate positive response the first time he saw this project. To Ann Campbell, my wonderful editor. And to Leslie Stoker for the lunch. It saved my life.

To my agent Joy Harris for never thinking I was crazy. And to her assistant Paul Chung for always cheering me on.

To Robert Lantz and all the people at his office. Davene, Lawrence, Kathrine, Albert, and Mary. For their comments and advice.

To all the photographers for opening their portfolios and giving me so much of their time. And, for always making me feel like I was doing something important. To their studio managers, assistants, and agents who were right there all the way.

I'd especially like to thank Lara Rossignol and the two Timothys. From the moment I showed them the project they were so enthusiastic.

To Visages, especially the incredible Julie Claire. And to Laura Hinds and Lorraine Ramsdell. To Outline's Beatrice Caan and to Susan Arzola and Daniel Roebuck at Onyx.

To Bob Cosenza and Ben Carbonetto at the Kobal Collection. They were inspirations.

To Kim and David at *Paper* for allowing me to be late on my deadlines so I could work on the book.

And to my family and friends—Mom and Dad, my dear sister Diannah, my brothers Randy and Kendall, for always being there. To Rosemary Scala and the entire Scala family for their love and support.

To Tom Gallagher for his awesome head for details. To Volker Glaser for his calm assistance. To Michael P. for always championing me on. To Chuck Finlon and to the memory of Cristian in who's home this book took its initial shape. To Michael Berglund and Zella Jones. To David McDonough for the work on the first prototype.

To Steven Stalder, Richard Hubert, Dale Newton, Sheila Hendrickson, Gary Fast, Michael Hill, Jan Hale, Robert James, and Rocco DePaolo for all the good times they have given me. To Jane Kilpatrick for the years. To Ruth Ann Cione for the help and Rosa for her food. To Michael Hannan and Ed Betz for the memories. To Regina and Joanne for never giving up and to Brie Quinby and Evan Cowles for the friendship.

And to the big guy in the sky who keeps making everything happen.

Design by Paul Zakris

Composed in Bodoni and Gill Sans with QuarkXpress 3.0
on a Macintosh IIsi at Stewart, Tabori & Chang, New York, New York.
Output on a Linotronic L300 at The Sarabande Press, New York, New York.

Printed and bound by Toppan Printing Company, Ltd.,
Tokyo, Japan.